The Unicorn

HANDBOOK

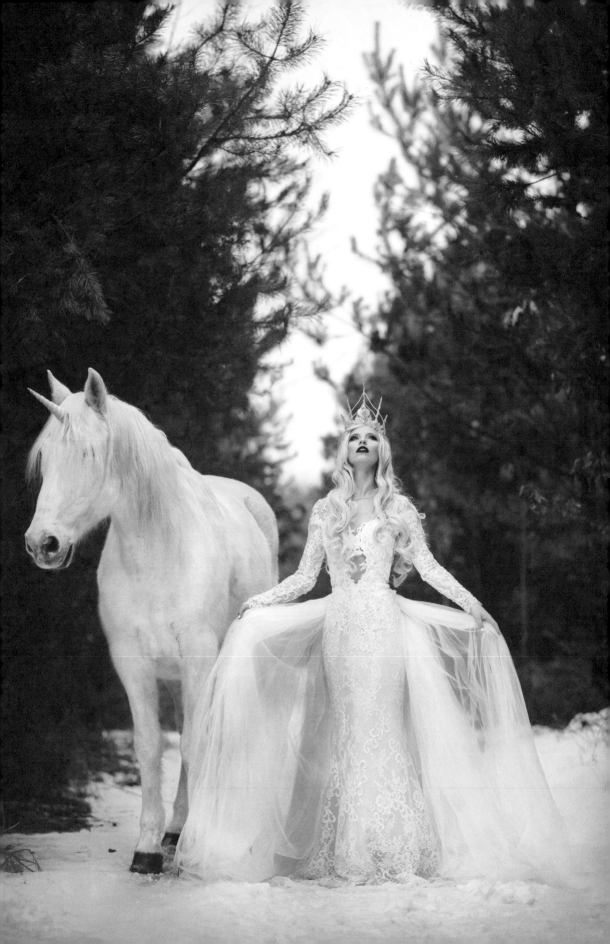

The Unicorn HANDBOOK

A Spellbinding Collection of LITERATURE, LORE, ART, RECIPES, and PROJECTS

CAROLYN TURGEON

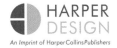

HARPER
DESIGN
An Imprint of HarperCollinsPublishers

The legs, so delicately shaped, balanced a
body wrought of finest ivory. And as
he moved, his coat shone like reflected moonlight.
High on his forehead rose the magic horn, the sign
of his uniqueness: a tower held upright
by his alert, yet gentle, timid gait.

—RAINER MARIA RILKE
"The Unicorn," from *Sonnets to Orpheus*,
translated by M. D. Herter Norton, 1942

CONTENTS

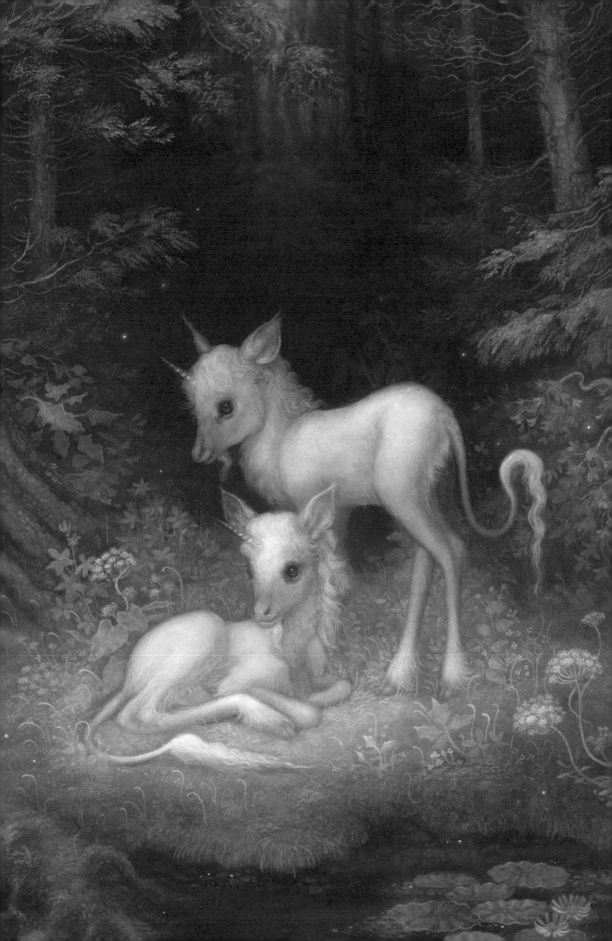

INTRODUCTION

HIS BOOK IS ABOUT A CREATURE SO WILD AND dazzling, so otherworldly yet so of this world in its most enchanting form, that you might want to bathe in purified water infused with rosemary and lavender before handling its pristine pages. Consider unplugging from your electronic appendages, and possibly even retreating from humankind altogether, before reading further. In our modern age, the unicorn may wink out from glittery pink and purple kitty cafés, toy stores, cartoons, and frothy rainbow drinks—an icon of kitsch and fizz—but actual unicorns are so fantastically pure that the human eye cannot even recognize them.

It's common knowledge that when the unicorn leaves the enchanted wood to explore the world beyond, it appears like a regular horse to humans, so you might want to look carefully at the next hooved creature or two you come across, just to see if you can detect some extra sparkle. In Peter S. Beagle's tome *The Last Unicorn* (1968), when people gaze upon a unicorn they see only an old white nag, which begs the question: How many normal-looking creatures, animals and humans alike, are actually unicorns?

Even more than the mermaid, with her come-hither sexuality, or fairies, with their mischievous penchant for whisking humans off to fairyland, the unicorn is unadulterated glamour, divinity on Earth, the purest heart of the forest—and untouchable. When unicorns deign to hang out with humans at all, they prefer to pass the time with virginal ladies—and, if possible, ones with long, lustrous hair who don't mind hanging out by streams with clear waters that glisten like diamonds or petting them and protecting them from the occasional wild-eyed hunter. Sadly, hunters have taken advantage of the unicorn's fondness for napping upon virginal laps to capture and even kill these stunning beasts.

What is a unicorn, pray tell? Proud, strong, swift, majestic, and magnificently handsome, the unicorn is a magical male animal whose name derives from the Latin words *unus* (one) and *cornu* (horn). The unicorn's ferocity makes him a formidable foe, and he is said to be the opponent of both the elephant and the lion—two of the most powerful animals on Earth. The unicorn lives alone, deep in an enchanted forest, and is rarely seen by humans. Those who have the good fortune of spying one are lucky indeed; they are also most likely virgins or enchanted beings, too.

PAGE 2: A modern-day lady and unicorn, spotted by photographer Marketa Novak.
PAGES 4–5: Unicorn Vanessa Walton wearing a horn by Jessica Antico Brasz. Photograph by Elizabeth Elder. + *OPPOSITE:* Annie Stegg, *Wildest Grace*, 2016.

The only way to tame or capture a unicorn, in fact, is to entice him with his ultimate weakness: a young woman who has never known a man (or woman), as the unicorn is downright docile in a virgin's hands. He will approach her gently, put his head in her lap, and even fall asleep.

In antiquity, there was no one single vision of what a unicorn looked like, but writers like the Greek physician Ctesias (400 BCE), in his book *Indica* (On India), and Aristotle, in *Historia animalium* (The History of Animals) (350 BCE), described one-horned animals that looked like bulls, antelopes, oryx, and dozens of other things. (For more on Ctesias and Aristotle, see page 122.)

In Europe during medieval times, the unicorn's regal bearing was considered not only aristocratic but also the embodiment of chivalric ideals, making him an essential companion for every knight. Artists of the day portrayed the unicorn as white, with an elegant and refined frame, like a fine horse yet smaller, more the size of a goat or a sheep. His mane and face are adorned with long, thick, curly clusters of silky hair. His hooves are cloven, and his tail is tufted like a lion's. His single horn is a long spiral that extends straight up from his forehead and is most often white, although in some medieval texts and illustrations it was described as gold or red, or black and white—or various combinations of these colors. In one of the most famous pieces of unicorn art, Raphael's *Portrait of a Lady with a Unicorn* (see page 75), the virginal lady cradles what appears to be a horned baby goat.

When we think of a unicorn now, the picture that most commonly comes to mind is that of a large elegant white horse with a long spiral horn on its head or perhaps, something like the white or rainbow-colored stuffed animals sparkling with glitter that populate the shelves of toy stores. But, like so many of our modern images, these visions are inspired by advertising and the movies. It's impossible to cast real unicorns, of course, as they are not only wild, making them impossible to please on set, but also so rare that their presence commands an extraordinary fee and share of the profits. This is why contemporary photographers, artists, film and television directors, and advertising creatives use horses and simply add the horn. And if employing a horse isn't in the budget, they use a goat or lamb, which fools most of the people most of the time.

But forget all that. Imagine yourself standing next to a glittering brook flowing through a deep forest glade. Here, flowering vines drape over everything like starlets on old-time chaise lounges. Branches twist, covered in moss. Sunlight spills through the leaves, bright green and shaped like hearts, to decorate the forest floor. Birds sing and foxes dart and butterflies flit about showing off the latest fashions. The brook burbles and shimmering fish rise to the surface of the water, which is so clear you can see the grassy bottom. Around you, imagine every kind of flower blooming all at once, the clean perfumed air, the bees buzzing from bulb to bulb, the riot of colors and scents. Trace your fingers upon the tree bark, step barefoot on the petals that have fallen and marked out your path. Breathe in as you enter the deep heart of the forest.

This is where you'll find a real unicorn, most likely loping gracefully about or lying in a bed of moss snacking on sweet forest berries, its head gently laid upon a virgin's lap.

Come. Let's go say hello.

—CAROLYN TURGEON

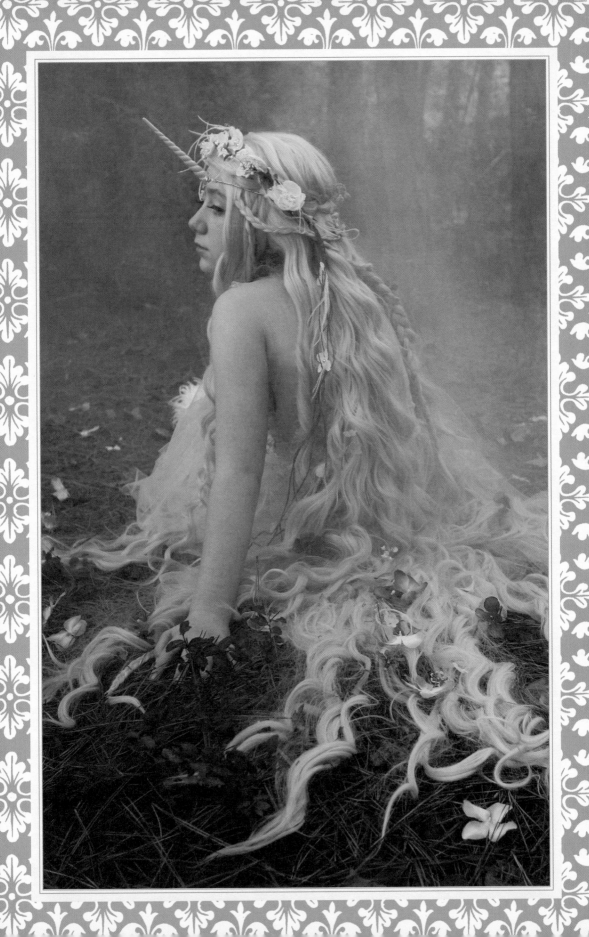

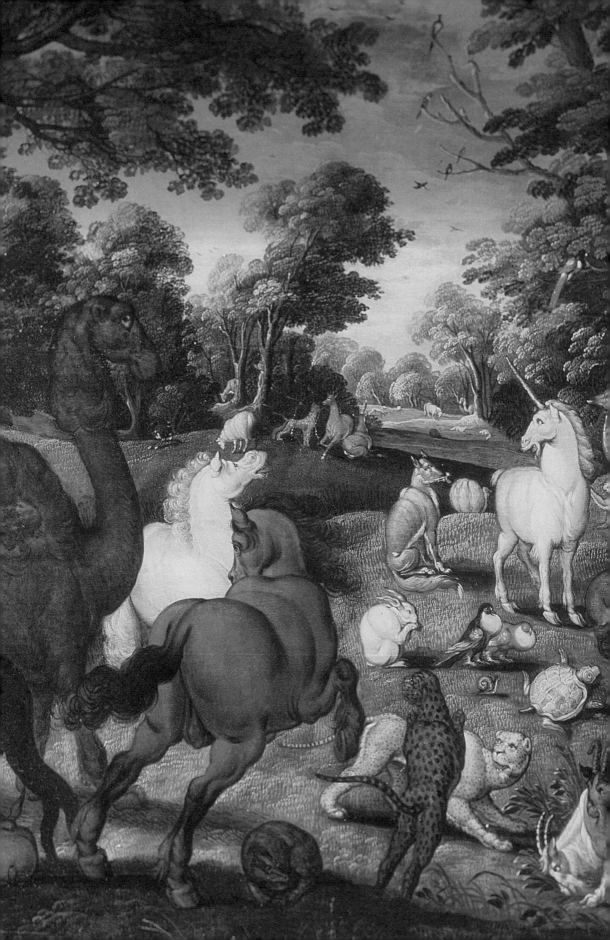

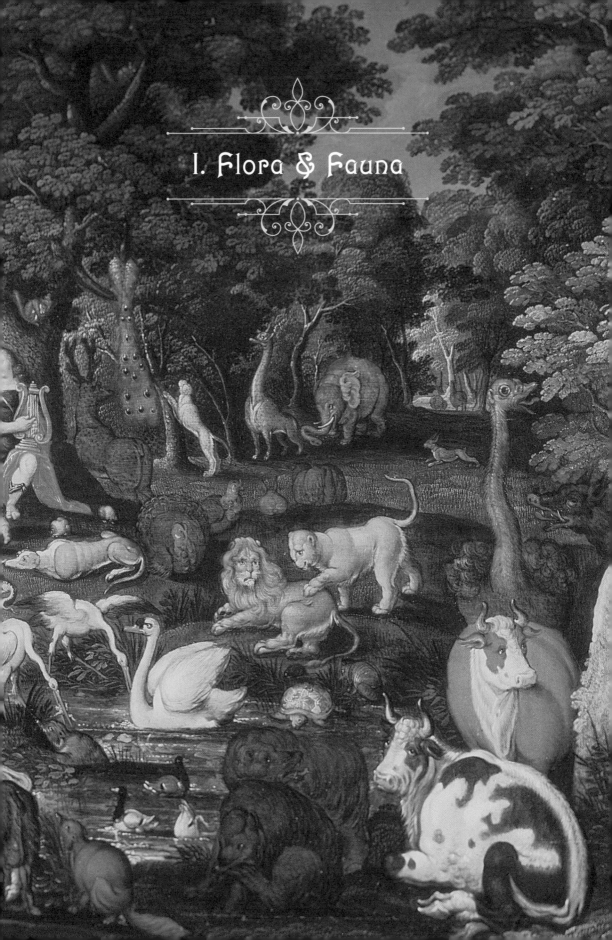

I. Flora & Fauna

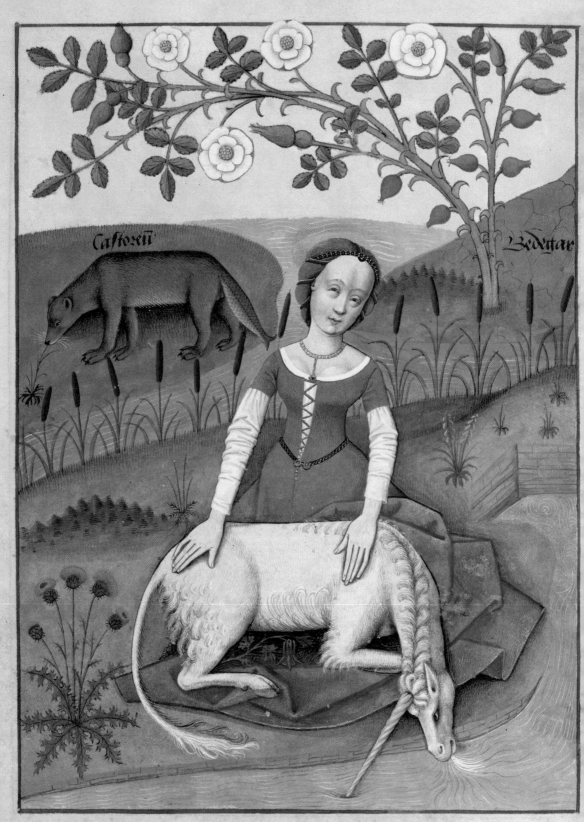

Castoreū Bedegar

The UNICORN HORN

 HE HORN OF A UNICORN IS A GREAT TREASURE, in part because of its rarity but also, more importantly, for its many wonderful properties. Powdered unicorn horn can be used as an aphrodisiac and to treat a variety of ailments. The horn can also detect poison, which often bubbles in its presence. If the horn is dipped in poisoned food or drink, it will neutralize the toxin.

Ctesias proclaimed the horn's ability to do this in his book *Indica*. As was true of many encyclopedists at a time when travel was very difficult, he learned this information secondhand while living at the Persian court for seventeen years. "There are in India certain wild asses which are as large as horses, and larger," Ctesias wrote.

> Their bodies are white, their heads dark red, and their eyes dark blue. They have a horn on the forehead which is about a foot and a half in length. The dust filed from this horn is administered in a potion as a protection against deadly drugs. The base of this horn, for some two hands'-breadth above the brow, is pure white; the upper part is sharp and of a vivid crimson; and the remainder, or middle portion, is black. Those who drink out of these horns, made into drinking vessels, are not subject, they say, to convulsions or to the holy disease [epilepsy]. Indeed, they are immune even to poisons if, either before or after swallowing such, they drink wine, water, or anything else from these beakers.

Two thousand years later, no one questioned Ctesias's description. Vessels made from unicorn horn were most valuable in the royal courts of the Middle Ages and Renaissance, when the world was rife with political plotting and power changed hands at the drop of a poison potion. Throughout history there are numerous descriptions of people owing their lives to the unicorn horn's remarkable ability to detect and neutralize poison. Spanish conquistador Álvar Núñez Cabeza de Vaca wrote in his account of a journey down the Paraguay River in 1543 that three attempts were made to poison him with arsenic—all thwarted by a piece of unicorn horn.

> While en route downriver, the officials ordered one Machín, a Biscayan, to cook up something to eat for the Governor [Cabeza de Vaca]. And after cooking some food, Machín handed it over to one Lope Duarte. These men were both cronies of the officials and of Domingo de Irala and as guilty as all the others who had taken the Governor prisoner.

PAGES 12–13: Jacob Bouttats, *Orpheus Charming the Animals*, c. 1675. + *OPPOSITE*: Illustration by French artist Robinet Testard from the fifteenth-century French translation of the Latin *The Book of Simple Medicines* by twelfth-century physician Mattheaus Platearius.

Duarte had come along as Irala's solicitor and to carry out his business on the ship, and in front of the guards and with their blessing he slipped arsenic to the Governor three times. Well, the Governor carried along with him a bottle of oil and a piece of the horn of a unicorn, and whenever he sensed he had been poisoned he used these remedies, day and night. It was a very difficult business, involving tremendous vomiting, and it pleased God that he came out of it all right.

In the book *The Treaty of the Unicorn, its wonderful properties and its use* (1573), the Italian scholar and naturalist Andrea Bacci recounted the story of a man who ate a poisoned cherry but was saved by drinking some powdered unicorn horn dissolved in wine. And the Pulitzer prize–winning American scholar and unicorn expert Odell Shepard supported this notion in his classic *The Lore of the Unicorn* (1930). He explained that Grand Inquisitor Tomás de Torquemada (1420–98) "always kept a piece of alicorn on his table as a precaution against the wiles of his numerous enemies," while "Spanish and English explorers of America [carried unicorn horn] as conscientiously as quinine is carried to-day by travelers in tropical countries."

Unicorn horn also offered renewed strength and vigor, prolonged youth, was an aphrodisiac, and could remove any contagion from the body—and continued to appear in medical and pharmaceutical textbooks into the 1700s.

German mystic Hildegard of Bingen (1098–1179) believed the entire unicorn had healing, medicinal qualities. She wrote that on the animal's head, under its horn, was a piece of metal as transparent as glass in which a man may see his face. In her medical book *Physica*, written in the 1150s, she described a cure for leprosy made from an unguent of egg yolks and powdered unicorn's liver that worked—"unless the leper in question happens to be one whom death is determined to have or else one whom God does

not wish to be cured." Also, "if a belt is made of the unicorn's hide and worn around the waist over the skin, it will preserve one from the dangers of pestilence and of fevers."

Cures in the Middle Ages often combined both bezoar (solid masses from the intestines of goats, sheep, deer, and other animals) and unicorn horn, sometimes mixed with ground pearls (a favorite medicine of Henry VIII) and staghorn. Clearly, this kind of health was reserved for the rich and powerful. Peasants made do with poultices of herbs and dung. By the 1600s, most physicians agreed that bezoar stones and powdered unicorn horn were the two most potent and all-purpose medicines to be found anywhere. In *The English Physician* (1653), English physician and botanist Nicholas Culpeper wrote, "[The] Unicorn's horn resists Poyson and the Pestilence, provokes Urine, restores lost strength, brings forth both Birth and Afterbirth."

In his 1678 textbook *The New London Dispensatory*, English physician William Salmon described unicorn horn's medicinal uses as "alexipharmick, sudorifick, cardiack, antifebritick, and cephalick." In other words, the horn counteracts poison, causes sweating, restores heart function, reduces fever, and neutralizes disorders of the head. Lest one still have doubts about the power of unicorn horn, he continued, "It potently resists Plague, Pestilence, and Poyson, expells the Measles and Small-Pox, and cures the Falling-Sickness in Children."

Was all this medicine really made of unicorn horn? Certainly, doctors, pharmacists, and their patients believed it was. But considering how rare unicorns are, how difficult they are to catch, the scarcity of virgins generally, and how often narwhal tusks were sold as unicorn horns (see "Narwhals: Not Really Unicorns of the Sea," page 53), it's likely that *some* of what passed for unicorn horn actually came from narwhals. And who knows what other trickery was afoot?

Powered unicorn horn, or what was believed to be powdered unicorn horn, was expensive but

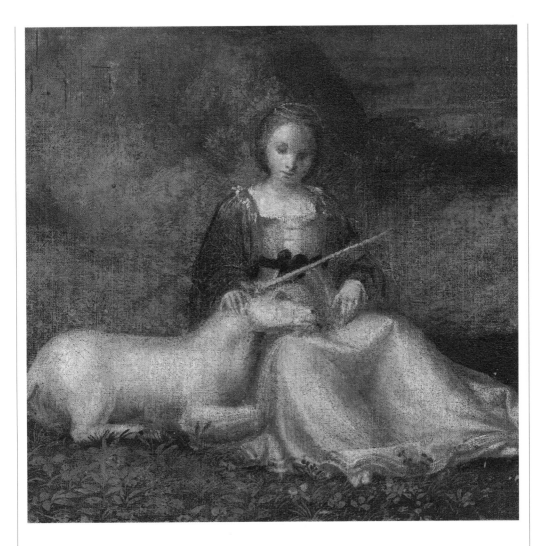

not all that difficult to find. Most apothecaries carried it. While today we think of the caduceus as the symbol of medicine, in the 1600s and 1700s pharmacists displayed a unicorn head, or simply the horn, to let people know what they were selling. Some of these figureheads still exist—especially in Hungary and the Czech Republic. The coat of arms of the Worshipful Society of Apothecaries, founded in 1617 in London and still extant today, covers all the bases when it comes to magical healing. The crest contains Apollo, the god of medicine, overpowering a dragon representing disease. On either side of the crest are two unicorns, whose healing properties were well known. Above the crest is the plumed helmet of a noble—the society's original charter granted the society the honor of displaying this symbol of nobility to underscore the society's excellence and high standards. Above that is a rhinoceros with a horn on its snout and another on its withers. Like the unicorn, powdered rhino horn was believed to have medicinal properties. The motto beneath is a passage from Ovid's *Metamorphoses*: *Opiferque per orbem dicor*, which means "Throughout the world they speak of me as a bringer of help."

Above: Artist unknown, *Woman with Unicorn*, c. 1510.

The UNICORN GARDEN

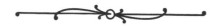

—*Jill Gleeson*

O FIND A UNICORN'S LAIR IN AN ENCHANTED wood is no easy task, so many human seekers have resorted to creating it in any way they can. One of the most successful human attempts can be found in the seven ultrafamous beloved tapestries that depict the hunt of the one-horned equine in a lush, fantastical landscape. These treasures are collectively known as the Unicorn Tapestries (you can read about them in more depth on page 133), which were made around 1500 and have long astonished visitors at the Met Cloisters in New York City. Also at the Met Cloisters is the Trie Cloister, a magical garden bursting with flowers and fruit. The garden offers approximately fifty of the one hundred species of flora depicted in the Unicorn Tapestries, which might be the closest we can get to luxuriating in the unicorn's favorite hangout.

Trie Cloister, along with two other medieval-themed gardens, was seeded and tilled in 1938, the year the Metropolitan Museum of Art's repository for Romanesque and Gothic decorative arts, sculpture, and architecture opened in Manhattan's most northerly reaches in Fort Tryon Park. Most of the plants pictured on the tapestries had been identified a few years before by New York Botanical Garden botanists E. J. Alexander and Carol Woodward, a great help to Cloisters curator James J. Rorimer, who created the gardens with Margaret Freeman.

Thanks to the botanists' research, along with their own work, Rorimer and Freeman were able to emulate the millefleur (a thousand flowers) style of

The Unicorn in Captivity tapestry with great accuracy, using many of the same species found in it, such as roses, thistle, and columbine. As Freeman wrote in her book *The Unicorn Tapestries* (1976), "flowers strewn over the background" was a look "suggesting the flowery meadow that the people of the Middle Ages liked so much."

Although the flowers in the garden combine to recall *The Hunt of the Unicorn*, as the tapestries are also collectively known, individually they have their own tales to tell. "One of my favorites is the iris, named for the Greek goddess of the rainbow," says Carly Still, assistant horticulturist at the Met Cloisters. "The timeless, bluish purple flowers of *Iris germanica* are paired with its

prominent, sword-like foliage. This structure is different from other plants, and even after the towering flowers have died back, the leaves keep presence in the garden. The fragrant root has long been used in perfumes."

Even more intoxicating is the garden's Madonna lily, which Still notes is rivaled only by the rose in power and meaning. "The fragrant, shining white flowers were associated with purity and chastity," she says, adding, "Another one of my favorites is strawberries. It's such a treat to work in the garden and eat a few tiny berries. I call them little 'starbursts' because they taste like candy. They also have a beautiful little white flower and have fantastic regenerative foliage. Strawberries, like pomegranates, were associated with fertility because of all the seeds. I think visitors are taken by surprise when they realize the strawberries are real berries."

Part of the beauty of Trie Cloister is its hardscape—the covered, open-air walkways that surround it as well as the museum's other two gardens. Each was excavated primarily from medieval French abbeys, with Trie Cloister boasting marble capitals and bases recovered from the Carmelite convent at Trie-en-Bigorre and other priories in southwest France. They imbue the site, which also features a large central fountain,

ABOVE AND PAGE 21: Two views of the Trie Cloister garden at the Met Cloisters in New York City, photographed by Steve Parke. + *PAGE 20:* A detail of the garden.

with the kind of peaceful solitude one imagines was endemic to monasteries in the Middle Ages. Radiating out from this structure, which references *The Unicorn Is Found* tapestry, are four paths crafted from travertine pavers that were created when the garden was replanted in 2016. They give a bit of form to this wild and verdant space and also recollect the quartering of gardens popular in medieval design.

Alongside these four paths sprout plants, including sea thrift, which produce delightful pink globe-like blossoms that bob gently on long stems, and Scottish harebell, a blue bell–shaped flower—so named for the legend that witches turn themselves into hares and hide among them. There are also several species of dianthus (*Dianthus gratiano-politanus, D. carthusianorum, D. petraeus*) in the garden, which are found through-out *The Unicorn in Captivity* tapestry, too.

The dianthuses' clove-scented flowers sweeten the air of the cloister and, as Still says, "the low, mat-forming

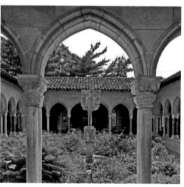

pinks creep on the edges of the stepping stones and mix with other favorites like thymes, plantains, English daisies, armerias, violets, and bellflowers. *D. carthusianorum* has slim, upright stems that grow through the grasses and add height and color to the garden. I'm always happy to see these cheer-ful flowers. I feel similarly about all the species of violets that we grow in the garden; they instantly make you feel better."

Historically correct though this lush medi-eval paddock may be, it is not precisely artistically accurate. Art from the Middle Ages frequently favored idyllic, idealized scenes, and the Unicorn Tapestries are no exception. Plants with differ-ent bloom times—for example, cherry trees and daffodils—are frequently shown at the height of fecundity together. Lead horticulturist Caleb

Leech found a way during the redesign to make it work, however, by planting the garden so that something is always in bloom, be it flowers or fruit, which helps give the space a bit of the fertile feel of *The Unicorn in Captivity* no matter the season. And so the Trie Cloister garden—wonderfully wild and evoking the medieval passion for spring and its ecstatic, unruly growth—beautifully recalls the Middle Ages' luxuriant landscapes even without the license that great art so often exhibits.

The Trie Cloister most strongly evokes the millefleur design of *The Unicorn in Captivity,* the seventh tapestry in the series, as well as *The Hunters Enter the Woods*, which is the first, but thanks to the garden's recent reimagining there are now tributes to the other tapestries within it. Because grasses are found throughout *The Hunt of the Unicorn*, Leech used what he calls "arching, dark green sedges, fine fescues, and tufts of rushes" to anchor the design. The pathways, open and inviting, are a celebra-tion of the unfurled meadows in the tapestries; similarly, the centers of the quadrants, which ever-larger shrubs and perennials lead to, summon to mind the flora found in the wall hangings' forests.

Such subtle composition paired with so much beauty means it takes time to absorb all that Trie Cloister offers. Like great art—like the tapestries themselves—an encounter with the garden must be slowly savored. "I like Trie because you start seeing things that you hadn't noticed at first," says Still. "You really see each individual flower, just as you do in the Unicorn Tapestries. Even a single flower has the ability to pull you in and make you notice it; they're so delicate and powerful. You have to look carefully. . . ."

And if you look long enough, you might spot a flash of white, a glimmering horn, among the blossoms.

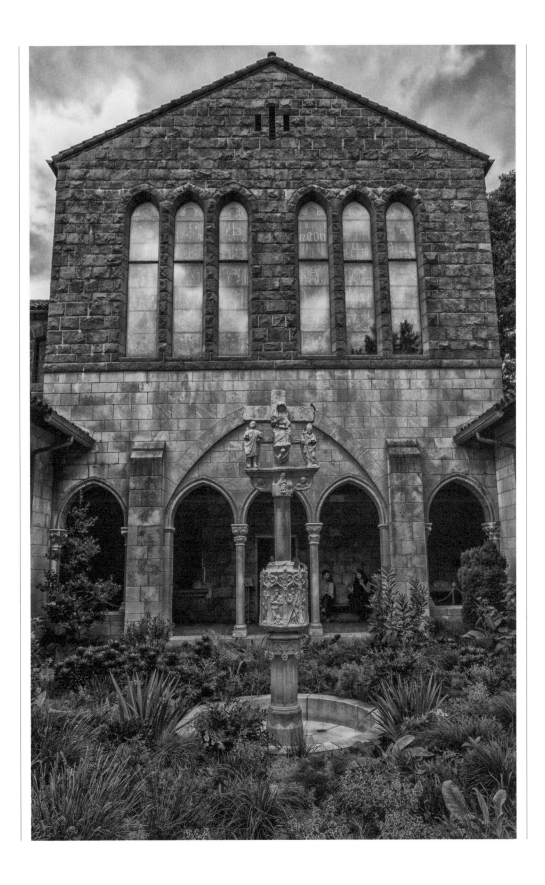

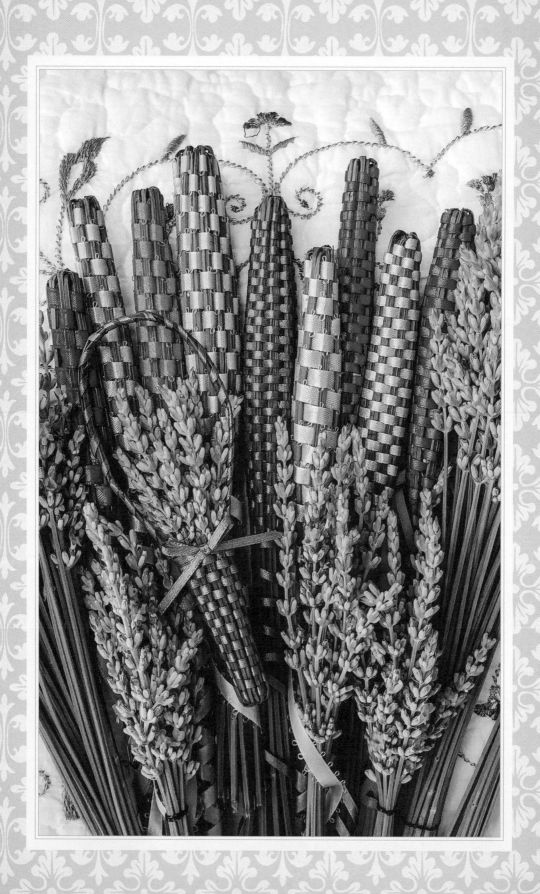

Make a Lavender Wand

—CHARLOTTE BAKER

KNOWN FOR ITS CALMING, PURIFYING EFFECTS AS WELL as its extravagant, showy beauty, lavender is pretty much the unicorn in herbal form. For this reason you might want to create one of these charming wands—made with fresh stalks of antiseptic, cleansing lavender woven with ribbon—as a talisman of sorts. They not only smell intoxicating but let any passing unicorn know that you're nearby.

TOOLS AND MATERIALS

- **Large bundle of fresh lavender, cut from your garden or purchased at a florist or farmers' market**

- **Flower snips**

- **Scissors**

- **Spool of ⅛-inch-wide satin ribbon in shades of purple and pink, or as desired**

- **Toothpicks**

> **NOTE:** Dried lavender is too brittle for this project and will break while you are working. You will be drying the lavender *after* you make the wand.

OPPOSITE: When the fragrance of the lavender wand fades, roll the woven section between your palms to release more of the oils from the buds. ✦ *ABOVE:* Herbert Schmalz, *Sweet Lavender*, 1906.

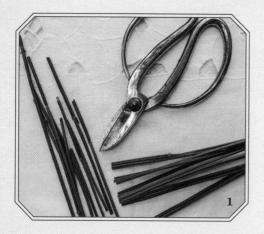

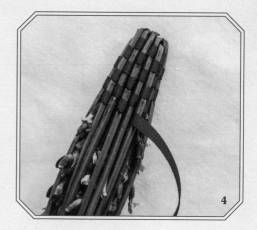

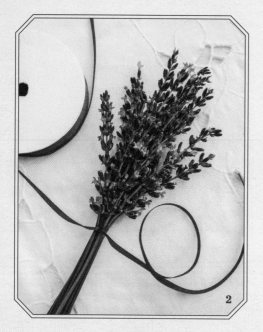

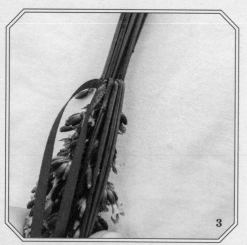

DIRECTIONS

1. If you are harvesting the lavender, cut it in the morning, after the dew has dried but before the heat of the day. The oil content is highest when the bottom flowers have begun to open and most of the lower buds are starting to show color. Cut stalks that have stems at least 12 inches long. You will need an odd number of stems for the over-under weaving pattern, so cut at least 11 stems for a full wand. Remove any leaves from the stems.

2. Gather the stems into a bundle, with the bottoms of the flower heads slightly staggered but forming a tight posy. Cut about a yard of ribbon and tie the stems together tightly just below the flowerheads, leaving a tail about 16 inches long on one side and the longer working end on the other. Secure with a square knot. Trim the ends of the lavender stems so that they're all the same length.

3. Turn the bundle upside down and begin bending the stems down over the flowers, one at a time. To ensure that the stems bend and do not break, crimp each one with your thumbnail prior to bending.

4. When all the stems are bent over and encasing the flower heads, bring the longer end of the ribbon out between two stems at the very top of the bundle and begin weaving it over one stem and under the next. For the under passes, gently pulling the stems away from the bundle makes it

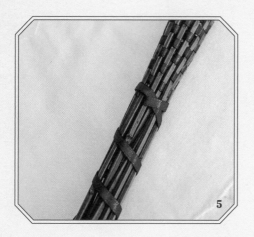

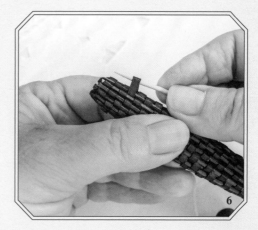

easier to place the ribbon where it needs
to be. Continue weaving, making sure
each row is pushed snugly up against the
preceding row. Keep the weaving tight by
tugging gently on the ribbon after every
under pass.

5. When you've reached the end of the bundle
 of flower heads, wrap the ribbon around
 the stems and secure it by passing the end
 of the ribbon under the wrap. Set aside in
 a warm place out of direct light for a few
 days to allow the lavender to start drying.

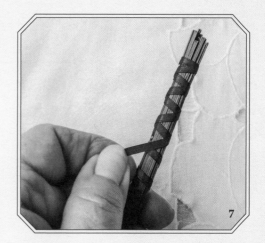

6. After several days, the lavender will shrink
 a lot as it begins to dry, and the weaving will
 have become loose. Tighten the ribbon by
 inserting a toothpick under the ribbon
 where you began weaving and gently pull-
 ing the slack out. Work your way around the
 bundle until you've reached the end of the
 weaving and the woven bundle is firm.

7. Separate the short tail of ribbon from the
 stems at the bottom of the woven section
 and hold it aside. Wrap the weaving ribbon
 tightly around the stems in a spiral to about
 an inch from the stem ends, and then wrap
 the stems back up to the point where the
 short tail emerges from the bundle.

8. Make a couple more tight wraps around
 the stems and then tie the working end
 and the short tail (top, left) in a square
 knot. Tie the tails in a bow and trim the
 ribbon ends. Allow the wand to finish dry-
 ing for several more days.

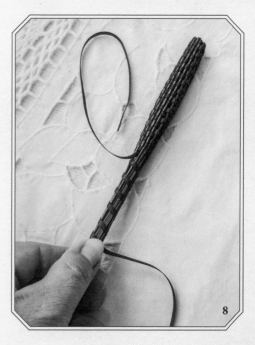

VIOLET AND LICORICE FERN SUGAR

—THE WONDERSMITH

IN THIS MAGIC SUGAR, THE IONONE-SWEET FRAGRANCE OF violets is harmonized with the earthy taste of licorice fern rhizomes. The resulting sugar is a beautiful purple and can be used in drinks, baked goods, and other treats. Try it sprinkled over dark chocolate ice cream or a lemon tart.

TOOLS AND MATERIALS

+ **Food processor or mortar and pestle**
+ **Parchment paper**
+ **Plate**

INGREDIENTS

+ **1-inch section of licorice fern (*Polypodium glycyrrhiza*) rhizome, cleaned**
+ **1 cup granulated sugar**
+ **1 cup fresh violet (*Viola odorata*) blossoms**

DIRECTIONS

1. Using a food processor or mortar and pestle, grind the rhizome with ⅓ cup of the sugar until it's finely ground. Add the violets and process again until smooth. Add the remaining sugar and pulse to combine.

2. Spread the purple paste on a parchment-lined plate to dry fully (several hours or overnight), then break up into small chunks. Store in a sealed glass jar for up to two months.

ABOVE: Artist unknown, *Gathering Violets*, from a Latin translation of the eleventh-century Arab medical treatise *Tacuinum Sanitatis*, Italian School, c. 1400. + *OPPOSITE:* Violet and licorice fern sugar will add a unicorn-friendly sweetness to your desserts—and life generally.
PAGES 28–29: Ellen Borggreve, *Luster*, 2017.

It was always spring in her forest, because she lived there, and she wandered all day among the great beech trees, keeping watch over the animals that lived in the ground and under bushes, in nests and caves, earths and treetops. Generation after generation, wolves and rabbits alike, they hunted and loved and had children and died, and as the unicorn did none of these things, she never grew tired of watching them.

—PETER S. BEAGLE, *The Last Unicorn*, 1968

BESTIARIES *and* ENCHANTED BEASTS

N EXISTENCE SINCE ANCIENT TIMES, BESTIARIES, or books of beasts, were extremely popular among medieval Christians in Europe, North Africa, and the Middle East. Animals we no longer see, like the griffin, phoenix, and manticore, were well known to Europeans and were typically included along with the more common lion, crane, crocodile, salamander, panther, antelope, and bear. Entries usually included a physical description (sometimes with an illustration), some information about the characteristics or behavior of the animal or object, and an allegory about the moral lessons it can teach.

People believed that God had arranged nature as a kind of instruction manual for humanity, and these gorgeous encyclopedias of animals, plants, and precious stones explained how each of God's creations, no matter how strange or fantastic, illuminated his teachings.

Many of the animals were viewed as benign aspects of the stories of Jesus, the Virgin Mary, or both, while many of the dangerous animals embodied aspects of Satan. Others, by their conduct, served as examples of virtues extolled in the Bible. It was not a good time to be a hyena, for instance, as many bestiaries claimed that the hyena regularly stalked graveyards in order to feast on the dead.

In a more palatable example, the turtledove remains faithful to one mate, and when its mate dies, it will live out its life alone—making it a representation of steadfast loyalty and virtue. The lion is not easily angered, hunts only when hungry, will not attack someone who is lying down,

and will allow a captive man to depart. People, too, should take only what they need, be slow to anger, and show mercy and forgiveness.

The unicorn is one of the many animals that signify Christ. The unicorn's fierce, untamable nature shows the inability of hell to hold Christ. Just as the unicorn can only be tamed by a virgin, Christ was born to the Virgin Mary. The single horn represents the unity of God and Christ.

The first medieval bestiary was *Physiologus* (The natural historian or The naturalist). It was written in Greek in the second or third century CE in Alexandria by one or more unknown Christian authors. It described more than forty animals, most of which were native to northern Africa where the writer lived. *Physiologus* was translated into Latin and became a kind of medieval bestseller.

The authors of *Physiologus* and other bestiaries drew on the work of Aristotle, Justinius, and many other classical Greek and Roman writers

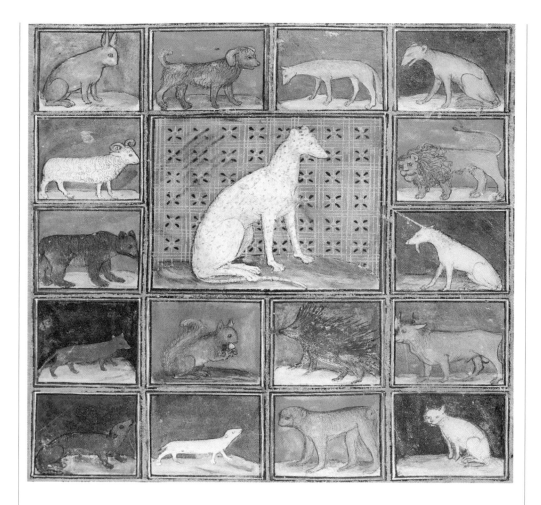

for their information. Prominent among their sources was Pliny the Elder (23–79 CE), a Roman military officer, scholar, and author of *Naturalis Historia* (Natural History). Another source of information was Isidore of Seville, who wrote an encyclopedia called *Etymologiae* (Etymologies), which attempts to explain all things by studying the origins of their names. He believed that the names of things offered insight into their basic nature. Book 12 is about animals and relates the etymology of their names to their natural habitats and physical characteristics.

Many variations on medieval bestiaries appeared over the centuries. Most were lavishly illustrated, and these images were repeated in stone and wood in churches and monasteries, carved into furniture, woven into tapestries, and painted on walls. Medieval animal illustrations are usually not realistic because, for the most part, the artist had never seen an actual elephant or a pelican or a whale. He based his image on the written description and on other artwork he had seen.

For those living in the Middle Ages and the Renaissance, these beasts were as real as the unicorn—and his companions in the animal world. What follows is a sample of the many dazzling creatures in a medieval bestiary.

ABOVE: In the Middle Ages, *De proprietatibus rerum* (*On the Properties of Things*), written by Bartholomaeus Anglicus c. 1240, was the most widely copied, adapted, and translated encyclopedia. This illustration is from the section on mammals in the French edition, translated by Jean Corbechon, c. 1415.

Ant Lion
✴ The spiritual lesson of the ants is that they work together for the good of their community, serving as a fine example for people, who should also work with one another and with God. But there are also ant lions, who take several forms—small, medium, and large—in medieval bestiaries. In the smallest version, the ant lion is the lion of ants—a large ant that hides in the dust and kills its own kind.

In the medium version, ant lions live in Ethiopia or India, are the size of dogs, and dig up gold from the sand. They guard their gold and pursue anyone or anything that tries to steal it. In medieval bestiaries, these ant lions looked more like dogs and were shown fending off greedy humans.

This idea about ant lions may have originated in the *Mahâbhârata* (Great Epic of the Bharata Dynasty) probably composed between 500 BCE and 400 CE. This Hindu epic described ants that excavated gold, or it may have come from the Greek historian Herodotus (about 440 BCE), who wrote of ants that were about the size of foxes and that unearthed gold when digging in the sandy deserts of the Persian Empire.

There's also another kind of ant lion, a larger beast that is the result of a mating between a lion and an ant. *Physiologus* described the ant lion this way: "It had the face (or fore-part) of a lion and the hinder parts of an ant. Its father eats flesh, but its mother grains. If they engender the ant lion, they engender a thing of two natures, such that it cannot eat flesh because of the nature of its mother, nor grains because of the nature of its father. It perishes, therefore, because it has no nutriment. So is every double-minded man; unstable in all his ways."

Basilisk
✴ The basilisk is sometimes shown as a snake with a crest on its head, and sometimes as a rooster with the tail of a snake. Its Greek name, *basiliscus*, means "little king"—a reference to the crown-shaped crest. It's a powerful and deadly beast. Just sniffing a basilisk can kill a snake. Fire coming from the basilisk's mouth kills birds, and its glance will kill a human. It can also kill by hissing. Pliny warned:

> Anyone who sees the eyes of a basilisk serpent (*basilisci serpentis*) dies immediately. It is no more than twelve inches long and has white markings on its head that look like a diadem. Unlike other snakes, which flee its hiss, it moves forward with its middle raised high. Its touch and even its breath scorch grass, kill bushes and burst rocks. Its poison is so deadly that once when a man on a horse speared a basilisk, the venom travelled up the spear and killed not only the man, but also the horse. A weasel can kill a basilisk; the serpent is thrown into a hole where a weasel lives, and the stench of the weasel kills the basilisk at the same time as the basilisk kills the weasel.

The Venerable Bede, an English monk and scholar from the early 700s, recorded that the basilisk was hatched from the egg of a rooster—an extremely rare event. Bartholomaeus Anglicus, a thirteenth-century English monk, wrote that when burned, the basilisk became powerful in a very different way: his ashes could be used by alchemists to turn base metals into gold.

Above: An ant lion and an ant confront each other in *De proprietatibus rerum* (*On the Properties of Things*) in Jean Corbechon's fifteenth-century translation of Bartholomaeus Anglicus's original work (c. 1240).
Opposite: A basilisk with a human victim is inconveniently confronted by a weasel. From a bestiary with theological texts, c. 1200–10, now in the archives of the British Library.

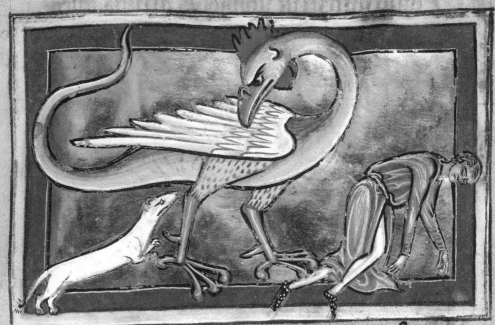

B asiliscus grece latine interptat regis eo qd rex sit
serpentiu. Adeo ut eu uidentes fugiant qr olfac
tu suo eos necat. Ham ↄ hoiem si uel aspiciat interimit
Siquidem ab eius aspectu nulla a—— uis uolans
illesa tsitr s. qin uis sit pcul eu ore ↄ—bta deuorat
Auiet tu uicitur qd ille hoiet i sert caiuis iqbr deine
citr. Itaq; ea uisa fugit. qin illa psequire ⁊ occidit Hi
chil tñ parens ille rerum. sine remedio ↄstituit

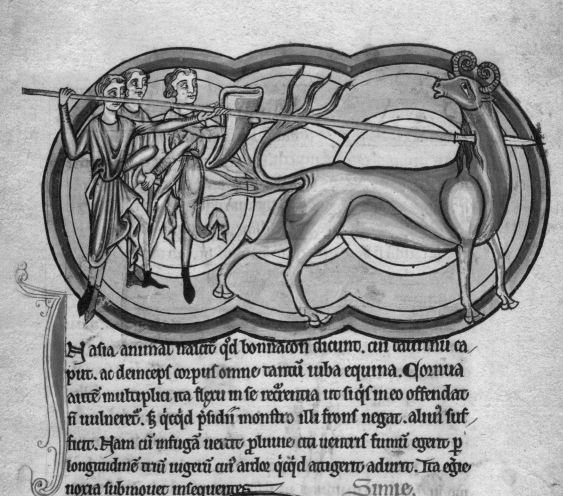

Ṅ aſia animal naſcit qd bonnacon dicunt. cu̅ taurinu̅ ca
put. ac deinceps corpus omne tantu̅ iuba equina. Cornua
aute̅ multiplici ita flexu in ſe recuruntia ut ſi q̅s in eo offendat
ſi uulneret̅. ſʒ q̅cq̅d p̅ſidi̅u monſtro illi frons negat. aliud ſuf
ficit. Nam cu̅ infuga̅ uertit pluuie cu̅ uentr̅is fumu̅ egerit p̅
longitudine̅ triu̅ iugeru̅ cui̅ ardor q̅cq̅d atigerit adurit. Ita egre
noxia ſubmouet inſequentes Simie.

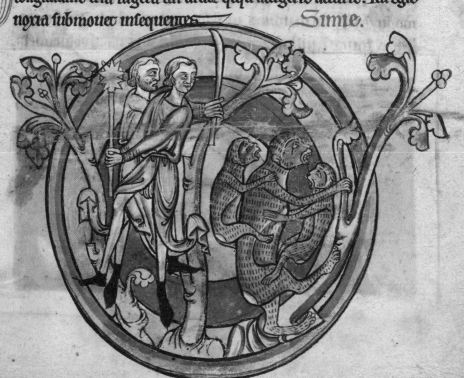

BONNACON ✳ The bonnacon has the body and head of a bull, the mane of a horse, and horns that spiral inward, making them useless for defense. Fortunately, the bonnacon has a more formidable weapon: its dung. It can shoot a powerful dung blast three furlongs (660 feet), burning anything it touches or anyone who touches it. Other accounts say that it shoots a blast of gas.

The book *On Marvellous Things Heard* (an ancient Greek collection of stories about the natural world) claims that the flesh of the bonnacon is sweet and the hide is huge. Most medieval bestiaries show the bonnacon blasting hunters with a stream of fiery excrement or a cloud of noxious gas. The hunters are usually covering their mouths and noses and looking rather overwhelmed by the assault, as well they should.

CALADRIUS ✳ The wonderful powers of this bird are described as early as 80 CE by Greek philosopher Plutarch in his *Symposiacs:*

> We know how often those who suffer from jaundice are healed by looking at the bird caladrius. This small animal seems to be endowed with such a nature and character, that it violently attracts to itself the disease, which slips out of the body of the sick man into its own, and draws off from his eyes as it were a stream of moisture. And this is the reason why the caladrius cannot endure to look at jaundiced persons nor help them at all, but turns itself away with closed eyes; not because it grudges the use of the remedy which is sought from it, as some consider, but because it might be wounded as by a blow.

In *Physiologus,* the caladrius is a white bird resembling a seagull or a dove, which lives in the king's court. If a person is ill, the bird knows if that person will live or die. If it looks into the face of the sick person, she will live, but if it looks away, the person will die. When the caladrius looks at an unhealthy person, it draws the illness into itself. It then flies toward the sun, where the illness is burned away.

In some bestiaries, its dung was said to cure blindness. In others, eating its thigh cured illness.

The caladrius also represents Christ. He turns away from those who do not accept him, who then die to God. He turns toward those who embrace him and takes their illness (sin) upon himself. Christ ascended into heaven, just as the caladrius flies toward the sun.

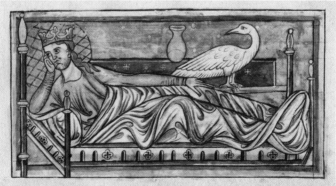

OPPOSITE: In this illumination from a thirteenth-century English bestiary, a bonnacon nobly defends itself by emitting a stream of excrement. Below, a monkey and its babies try to elude hunters as well. *ABOVE:* In the same bestiary, a sick and seemingly ungrateful king lies in bed with a white caladrius whose visual orientation indicates that the king will not die.

DRAGON ✳ Dragons have walked and flown all over the earth in every age. They are present from ancient Greece and Rome to ancient India and China, in Norse myths, Anglo-Saxon poetry, Chinese art, and modern literature.

The dragons of the Far East are water serpents who live in the ocean, breathe clouds, and bring rain. They usually have four legs, long snakelike bodies, and horns or a crest. The dragons of the ancient Western world were legless serpents, sometimes killing elephants by coiling around their necks and strangling them.

By the time of the medieval bestiaries, dragons were still serpents but usually with legs (sometimes two, sometimes four) and wings. They had impenetrable scales, breathed fire, and liked to steal and hoard precious objects. The earliest example in literature of this kind of dragon is in *Beowulf*, an Anglo-Saxon epic poem that described events that took place in the sixth century but was written down between 975 and 1025. The dragon the hero Beowulf must slay is nocturnal, treasure hoarding, airborne, vengeful, and fire breathing.

In medieval Europe, people feared attacks by dragons. Urine from dragons flying overhead would putrefy human skin, and dragons' breath could poison wells and streams (thank goodness for unicorn horns!). Satan was able to take the shape of a dragon, motivating heroes and saints to slay him. Saint George famously did so in Palestine in the third century, but slaying dragons could also be women's work: Saint Margaret of Antioch (289–304) and Saint Elizabeth of Constantinople, who is thought to have lived between the sixth and ninth centuries, slew their fair share.

Because the dragon is associated with Satan, his enemy is the panther, who is a symbol of Christ. Dragons cannot stand the sweet smell of the panther's breath and hide when the big cat roars. Dragons are also repelled by the peridexion tree, which grows in India, and are harmed if they even fall under its shadow. This is likely why doves, symbol of the Holy Spirit and faithful Christians, roost in the peridexion tree.

Another enemy of the dragon is the ichneumon, a mongoose that doesn't care much for social propriety. When it sees a dragon, the ichneumon covers itself with mud, closes its nostrils with its tail, and then attacks and kills the dragon immediately.

ABOVE: A dragon woodcut from *De aquatilibus* (The Marine Creatures), by Pierre Belon, 1553. The book is considered to have laid the groundwork for the contemporary study of fish. ✦
OPPOSITE: A terrifying dragon illumination from Peraldus's *Theological miscellany*, including the *Summa de vitiis* (Summary of the Vices), c. 1236–1250.

Anguis omnium serpentum genus est qo complicari et torqueri potest. et in de anguis qd angulosus sit et numqp rect. Colubru ab eo dictu qd colat u bras ul qd in lubricos tract flexib; sinuosis labat. Nam lubricu dicitu qcqd labitur dum tenentur ut pisces serpens. Serpens aut nomen accipit qa occultis accessib; serpit. n apertis passib; s squamarum minutissimis nisib; reptat. Illa autem que quatuor pedib; nituntur sicut lacerte et stelliones n serpentes s reptilia no minant. Serpentes aut reptilia sunt que ventre et pectore reptant. Quot tot venena tot genera tot pernicies quot species.

Dracone maior tot colores qi tot colores habent quot serpentii siue omnium animantium sup terram. Hunc greci dracontem uocant. Unde et ducuntur in latinum ut draco dicit. Qi sepe ab speluncis abstract fert in aerem concitat qi prop eu aer. Est aut cristat et paruo et ore fistula p qd traht spm et linguam exerat. Vim aute no in dentib; s in cauda ht et uerbere pot qm ictu nocet. In grinu tu est a uenenis. Sed no huic ad morte facien dam uenena n ee necessa ria dicunt qa si quem liga rit occidit. A quo nec ele phans tut est sui corpo p qd elephantes soli catos primt.

...is magnitudine. Nam tota seruitas delicies q triumfant. crura cor noctis mitigat ac suffo Gignitur aut in ethiopia et india ibi in ipo icen ctus. Hunc draconi assimilat diabolus q est imma missu serpens sepe a speluncis in aerem gerat. et aer ipe cum aer qa se erigens rutilat se in anglm luas. et decipit stultos spe false glie leuitate humane. Cristat e dr qa ipe est rex sup te nim no in dentib; s in cauda ht qa suis uirib; plis mendacio decipit.

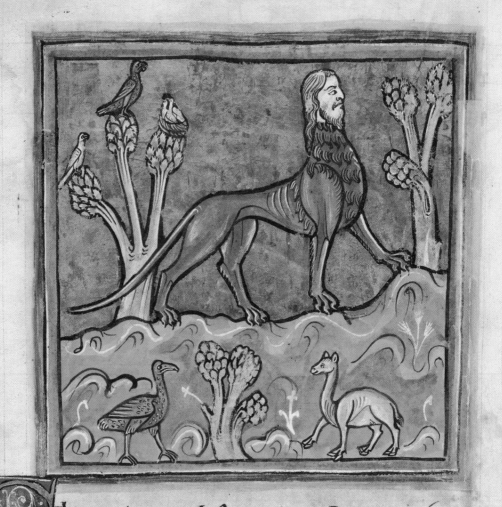

Ethiopia emittit bestiam parandrum nomine · bo-
um magnitudine · ȝbico uestigio · ramosis cornibus ·
capite ceruino · ursi colore · et pariter uillo pfundo ·
Hunc parandrum affirmant habitum metu uertere ·
& cum delitescat fieri ad similitudinem cuicumqʒ rei pxi
mauerit · siue illa saxo alba sit · seu fructetto uirens ·
siue quem alium modum persecat ·

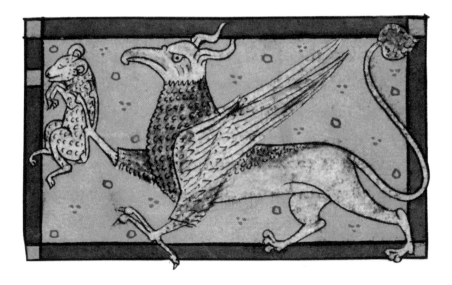

GRIFFIN ✳ The griffin has the body, tail, and back legs of a lion and the head, wings, and front legs of an eagle. Images of griffins can be found in the frescoes in the throne room of the fifteenth-century BCE palace of Knossos on Crete, built by the Minoans. Griffins are also represented in ancient Iranian cylinder seals found in Susa that date from 3000 BCE and on a cosmetic palette from ancient Egypt from 3300 to 3100 BCE.

In Greek and Roman texts, griffins were often associated with gold. Pliny the Elder wrote, "Griffins were said to lay eggs in burrows on the grounds and these nests contained gold nuggets." And according to Bartholomaeus Anglicus, "Griffins keep the mountains in which be gems and precious stones, and suffer them not to be taken from thence."

A griffin is immensely strong, and medieval bestiaries described it as being able to fly away with a man or an entire live ox clutched in its talons. Because the lion was considered the king of the beasts and the eagle the king of birds, the griffin was regarded as an especially powerful and majestic creature—even though it's a less-than-desirable man-eater. For this reason, the griffin became a popular subject for coats of arms, and in medieval heraldry, a symbol for the guardian of the divine.

MANTICORE ✳ A manticore has the head and face of a blue-eyed man, the body of a blood-red lion, and the stinger of a scorpion. (Some descriptions say the tail is covered with venomous spines that the manticore can shoot like arrows.) The word "manticore" is an adaption of the Persian name for the beast—*mardykhor*, "man-eater."

According to the Greek physician Ctesias's writing from the 400s BCE, the manticore lives in India. It can leap great distances and is a very active hunter. Its voice sounds like a trumpet or a reed pipe. Its favorite prey, by far, is humans. To eat them, it has three rows of teeth, stretching from ear to ear. In medieval bestiaries, the manticore is associated with the devil.

Bartholomaeus Anglicus wrote of the manticore, "He runneth full swiftly, and eateth men. And among all beasts of the earth is none found more cruel, nor more wonderly shape."

OPPOSITE: A manticore appears in the *Bestiary and Lapidary* (also known as the Rochester Bestiary), c. 1225–50. ✛ *ABOVE*: This unfriendly griffin and its prey appears in *Bestiaire en Verse* (Bestiary in Verse), Philippe de Thaon, 1285.

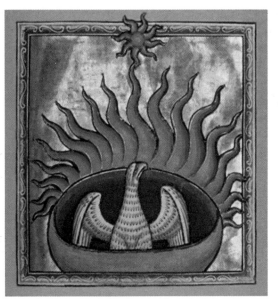

PHOENIX ✳ There is only one phoenix—a magnificent bird that is reborn from its own ashes. Ancient and known to many cultures, it was first described in the West by Greek historian Herodotus in *The Histories* in fifth century BCE:

> [In Egypt they] have also another sacred bird called the phoenix which I myself have never seen, except in pictures. Indeed it is a great rarity, even in Egypt, only coming there (according to the accounts of the people of Heliopolis) once in five hundred years, when the old phoenix dies. Its size and appearance . . . are as follows: The plumage is partly red, partly golden, while the general make and size are almost exactly that of the eagle. They tell a story of what this bird does, which does not seem to me to be credible: that he comes all the way from Arabia, and brings the parent bird, all plastered over with myrrh, to the temple of the Sun, and there buries the body. In order to bring him, they say, he first forms a ball of myrrh as big as he finds that he can carry; then he hollows out the ball, and puts his parent inside, after which he covers over the opening with fresh myrrh, and the ball is then of exactly the same weight as at first; so he brings it to Egypt, plastered over as I have said, and deposits it in the temple of the Sun. Such is the story they tell of the doings of this bird.

The color of the phoenix has been a subject of much debate. Pliny the Elder said it was as large as an eagle and yellow, purple, and rose. In medieval bestiaries, it was shown and described, variously, as blue and purple, crimson, or primarily white and brown.

In the Middle Ages, the phoenix became a symbol for the resurrected Christ. Stories about how the phoenix died and was reborn varied, but they always put the timeline at three days—the same number of days between Christ's death and resurrection. In this way, the phoenix became a symbol of the hope for salvation.

Above: A phoenix as depicted in the *Aberdeen Bestiary*, a mysterious twelfth-century English illuminated manuscript bestiary that was first listed in 1542 in the inventory of the Palace of Westminster's Old Royal Library. + *Opposite:* Two images from an untitled Latin bestiary (c. 1225–1250), with extracts from Giraldus Cambrensis on Irish birds, show the life cycle of the self-immolating phoenix.

collectis aromatum uirgul
tis. rogum sibi instruit.
& conuersa ad radium so
lis alarum plausu uolū
tarium sibi incendium
nutrit seq; urit. pstea
ū die nona auis de cineri
bus suis surgit. Huī figu
ram gerit dns nr ihc xpc
qui dicit potestatē habeo
ponendi animam meā

& iterū sumendi eam. Si ergo fenix mortificandi atq;
uiuificandi se potestatē hz air stulti hōies irascuntur in uer
bo dei qui uerus dei filius est qi dicit potestatē habeo. τ c. Des
cendit naq; saluator nr de celo alas suas suauitatis odoribz
noui & ueteris testamēti repleuit. & mala crucis secm̄ deo
pri pnobis optulit. & tercia die resurrexit. fenix.

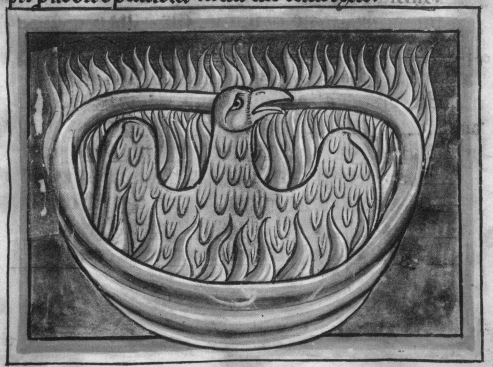

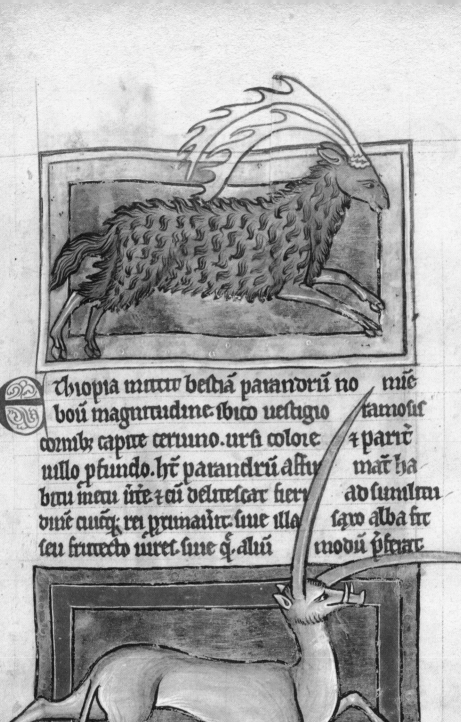

Thiopia mittit bestiam parandrū no
boū magnitudine. sbico uestigio
cornib; capite ceruino. ursi colore
uillo pfundo. ht parandrū astu
bitu metu uite. z cū deluescat hier
ant cuūq; rei pximaut. siue illa
seu brunecto uiret. siue q̄ alui

mūe
ramosi
z parit
mat̄ ha
ad similī
sapē alba sit
modū p̄seiat

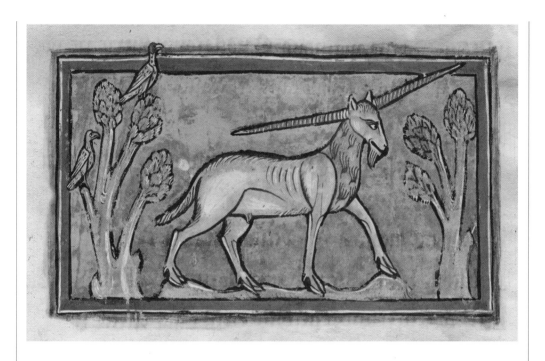

𝒴ALE ✳ The yale (also known as the *centicore*) is a kind of composite beast, with features from many other animals. Pliny the Elder said it was found in Ethiopia and was "the size of a hippopotamus, with an elephant's tail, of a black or tawny color, with the jaws of a boar and movable horns more than a cubit [eighteen inches] in length, which in a fight are erected alternately, and presented to the attack or sloped backward in turn as policy directs."

But other descriptions vary, and depending on which bestiary you read, it might have solid hooves, cloven hooves, or heavy paws, and a tufted tail like a lion or a long and flowing tail like a horse.

Everyone, however, agrees on the horns, which the yale can move independently in any direction. Typically, in battle, it points one forward and one backward, so if the first is damaged, it can keep fighting with the second one. Or, if things get really heated, it can use both horns to fend off multiple attackers coming from different directions.

Because of its special skills in battle, the yale became a popular symbol in medieval heraldry, representing proud defense. It is among the beasts on the crests of the British royal family, including Henry VIII.

The basilisk is the natural enemy of the yale but will not take one on in battle. Instead, if a basilisk encounters a sleeping yale, it will sting it on the forehead, causing the yale's eyes to swell until they burst.

OPPOSITE: **A parandrus and yale from a bestiary with theological texts, c. 1200–10, now in the archives of the British Library.** ✛ *ABOVE:* **A meandering yale immortalized in the *Bestiary and Lapidary* (the Rochester Bestiary), c. 1225–50.**

The SIBERIAN UNICORN

ANY ANIMALS HAVE EVOLVED AND CHANGED over the millennia. The saber-toothed tiger and the woolly mammoth, for example, are ancient animals that have died out and been replaced by similar creatures we know today—the tiger and the elephant. While paleontologists can't be sure due to the tragic scarcity of the fossil evidence, *Elasmotherium sibiricum,* or the Siberian unicorn, may be the ancestor of today's unicorn.

Fossilized remains of the Siberian unicorn were first presented in 1808 by Johann Gotthelf Fischer von Waldheim, a German paleontologist who was director of the Natural History Museum at the Moscow University. He described it as "rhinolike," but *Elasmotherium* possesses the key anatomical difference between rhinos and unicorns: its horn was in the middle of its forehead, similar to that of a unicorn, and not on its snout, like that of a rhinoceros.

This giant mammal probably weighed around four tons, was about fifteen feet long and six and a half feet tall, and grazed the plains of what is now Russia, Ukraine, Kazakhstan, and Uzbekistan. It probably was hairy, like a woolly mammoth.

Paleontologists once thought these possible ancestors of the modern unicorn died out two hundred thousand years ago. But newer radiocarbon dating done in 2016 at Tomsk State University in Russia on the fossils of Siberian unicorns found them to be about twenty-nine thousand years old. That means ancient unicorns and ancient humans knew each other, because humans inhabited the Siberian Arctic as far back as forty-five thousand years ago.

There are legends from the region of giant heavy-bodied unicorns. A bronze vessel from the Warring States period in China (475 to 221 BCE) shows an animal that looks a lot like *Elasmotherium*, with a big heavy body, a very large horn, and its head down grazing. There is also a legend among the Yakut people of Siberia that a hunter killed a giant "black bull" with a horn so huge they had to carry it back to the village on a sled.

Studying fossils tells us when an animal was alive, but it doesn't tell us when the animal went extinct. Because *Elasmotherium* fossils are so rare, scientists keep pushing forward the Siberian unicorn's timeline every time a new fossil is found. In other words, the Siberian unicorn may not have met its end twenty-nine thousand years ago.

The medieval envoy and writer Ahmad ibn Fadlan (877–960) described an animal that sounds very much like the Siberian unicorn in his writings from more than a thousand years ago. Ibn Fadlan was born in Baghdad and in 921 accompanied the caliph's ambassador to Volga Bulgaria, a Muslim state in what is now European part of Russia. He wrote a detailed account of the people and customs there, as well as the natural world.

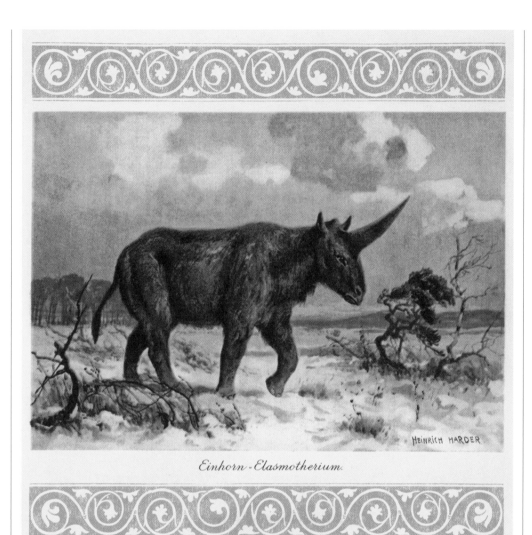

Einhorn-Elasmotherium.

Ibn Fadlan described an animal "smaller than a camel, but taller than a bull. Its head is the head of a ram, and its tail is a bull's tail. Its body is that of a mule and its hooves are like those of a bull. In the middle of its head it has a horn, thick and round, and as the horn goes higher, it narrows until it is like a spearhead. Some of these horns grow to three or five ells [an *ell* is a measure of length from the elbow to the tip of the middle finger] depending on the size of the animal."

The Siberian unicorn had a deep affection for horses, according to Ibn Fadlan. It was said to use its horn to pluck a mounted hunter from his horse and kill him, though it would leave the horse unharmed. The Volga Bulgars resorted to hunting the Siberian unicorn with poisoned arrows, so they could keep their distance.

Today *Elasmotherium* exists only as fossilized remains. Did it evolve into the modern unicorn? The evidence for that is yet be found, but no one can prove otherwise.

ABOVE: Heinrich Harder, illustration of *Einhorn Elasmotherium* for a set of collecting cards called *Tiere der Urwelt* (Animals of the Prehistoric World), 1916.

UNICORNS VERSUS LIONS

HE LION AND THE UNICORN MAY WORK TOGETHER to hold up the crest on the coat of arms of the British royal family, but do not be fooled: that collective effort is an anomaly in the history of these two grudge-holding creatures, which have been enemies for centuries.

As noted by Odell Shepard in *The Lore of Unicorn*, "Among the ruins of the Palace of Forty Pillars at Persepolis, on the left-hand side of the western staircase…there is a bas-relief showing the figure of a lion with teeth and claws fastened upon a one-horned animal of uncertain species resembling at once a bull, a large antelope, and a goat. Three other treatments of the same subject are found in the corresponding positions, the figure of the unicorned animal varying slightly from one to another."

We know that a unicorn cannot be overpowered, even by a lion. But a letter that began circulating in the courts of Europe around 1165 described how the lion sometimes tricks the unicorn. The letter was said to be written by Prester John, a Christian king in Ethiopia who claimed to be a descendant of the Three Magi. "There are in our land also unicorns who have in front a single horn," he said. "Sometimes they kill lions. But a lion kills them in a very subtle way. When a unicorn is tired it lies down by a tree. The lion goes then behind it and when the unicorn wants to strike him with his horn, it dashes into the tree with such force that it cannot free itself. Then the lion kills it."

While modern historians generally agree that Prester John's letter was a fake, the rivalry of the lion and the unicorn, and the lion's method of catching one, found its way into medieval European culture. Shakespeare made several references to the lion's ruse. In *Julius Caesar* (1599), Decius, one of the conspirators against Caesar, says of the emperor, "For he loves to hear that unicorns may be betrayed with trees." It was meant to suggest that the emperor, like the lion, didn't play fair.

In the Brothers Grimm tale "The Brave Little Tailor," the hero captures a unicorn the same way the lion did—by luring him to run into a tree. The Brothers Grimm recorded the story in 1812, but it was based on a much older German folktale.

A group of Flemish tapestries woven around 1500, collectively known as *The Lady and the Unicorn* tapestries, shows a medieval noblewoman flanked by the lion and the unicorn, the beautiful woman having tamed the rivalry between the two. (Read more about these tapestries in "The Lady and the Unicorn," page 144.)

The enmity between the two animals became especially important in Britain, where the lion represented England and the unicorn represented Scotland. Its Scottish roots come from Celtic mythology, which depicts the unicorn as a proud beast that will fight to remain unconquered—like the Scots.

The two animals eventually came together on the coat of arms in 1603 but not before their great rivalry had played out many times on the battlefield and in court intrigues and plots. That rivalry

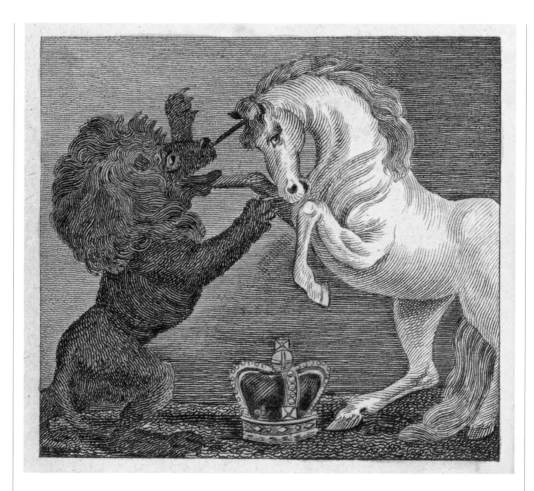

was described in an old Mother Goose nursery rhyme, "The Lion and the Unicorn."

> **The Lion and the Unicorn**
> **Were fighting for the crown:**
>
> **The Lion beat the Unicorn**
> **All round the town.**
>
> **Some gave them white bread,**
> **And some gave them brown;**
>
> **Some gave them plum-cake**
> **And drummed them out of town.**

Lewis Carroll included the lion and unicorn fighting for the crown in *Through the Looking Glass* (1871). As she's watching the two animals battle, Alice repeats the nursery rhyme. The king is also watching, noting that "and the best of the joke is, that it's *my* crown all the while!" After the unicorn wins by running through the lion with his horn, Alice tells him, "Do you know, I always thought Unicorns were fabulous monsters, too? I never saw one alive before!"

"Well, now that we *have* seen each other," said the Unicorn, "if you'll believe in me, I'll believe in you. Is that a bargain?"

"Yes, if you like," said Alice.

The Unicorn then demands plum cake, as unicorns are wont to do. Find a recipe for this magical dessert on page 210.

ABOVE: This image of a fighting lion and unicorn is one of twenty-four engraved and hand-colored plates from the 1818 anthology *Songs for the Nursery, Collected from the Works of the Most Renowned Poets, and Adapted to Favourite National Melodies*, published by William H. Darton and His Sons, London.

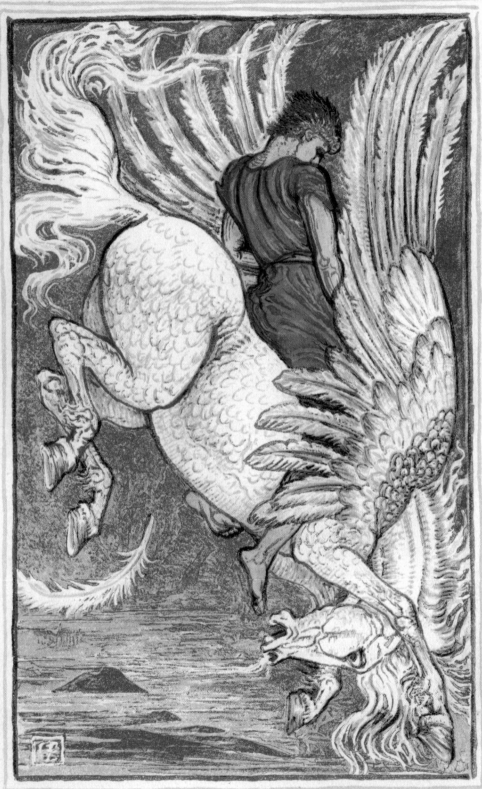

BELLEROPHON·ON·PEGASVS

PEGASUS,
COUSIN *to the* UNICORN

EGASUS, THE IMMORTAL WINGED HORSE, IS NO doubt a cousin of the unicorn. But while unicorns are found the world over, Pegasus confined himself to the world of ancient Greece—both the earth, where mortals lived, and Mount Olympus, home of the gods.

Pegasus's birth was rather unconventional: His mother, Medusa, was raped by Poseidon (god of the sea, water, and horses) on the floor of Athena's temple. Athena was enraged that her temple had been desecrated and blamed the victim rather than her fellow immortal. She turned the once beautiful Medusa into a vicious monster with snakes for hair. When Medusa was later beheaded by the Greek hero Perseus, Pegasus arose from her blood.

Pegasus roamed the earth, wild and free. Wherever his hoof struck rock, a spring sprang up—including the sacred spring Hippocrene on Mount Helicon, the home of the Muses; when poets drank its waters, they were filled with inspiration. The Greek poet Hesiod (750–650 BCE) tells us the great horse's name comes from the Greek word *pegae*, which means "springs."

Pegasus could not be tamed without the help of the gods. Eventually Athena gave the hero Bellerophon a golden bridle that he used to capture the noble stallion when he was drinking at Pirene spring, another water source that was sacred to the Muses.

Bellerophon and Pegasus had a number of heroic adventures, including slaying the unsavory chimera, a monster that Homer described as having a lion's head, a goat's body, a serpent's tail, and breath like blasts of fire. Mounted on Pegasus, Bellerophon was also able to defeat the Amazons and other enemies.

But eventually, the very tragic Greek trait of hubris got the best of Bellerophon. After all his victories, he decided he deserved to live among the gods on Mount Olympus. As he approached Mount Olympus on Pegasus's back, the offended Zeus sent a gadfly to sting the stallion, who then threw Bellerophon to his death.

Pegasus did reach Olympus, though, where Zeus kept him in the royal stables. The king of the gods soon gave him the task of drawing his chariot, which carried thunderbolts. After years of faithful service, Zeus honored him by transforming Pegasus into a constellation, which can still be seen in the northern sky. On the day of his transformation, Hesiod said, a single feather fell to the earth near the city of Tarsus.

OPPOSITE: Bellerophon rides Pegasus, perhaps a bit recklessly, in this Walter Crane illustration that appeared in Nathaniel Hawthorne's *Retelling of Greek Myths*, 1845.

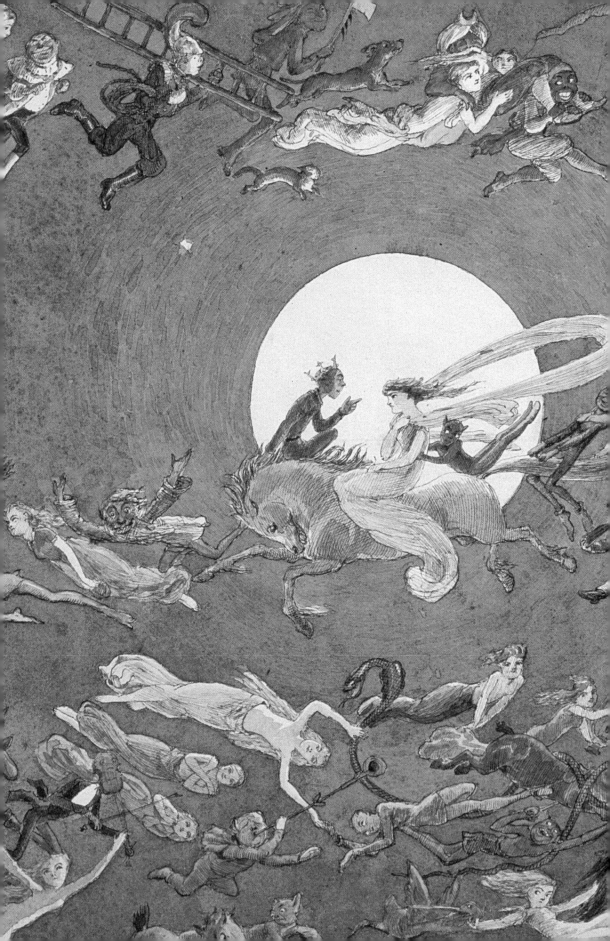

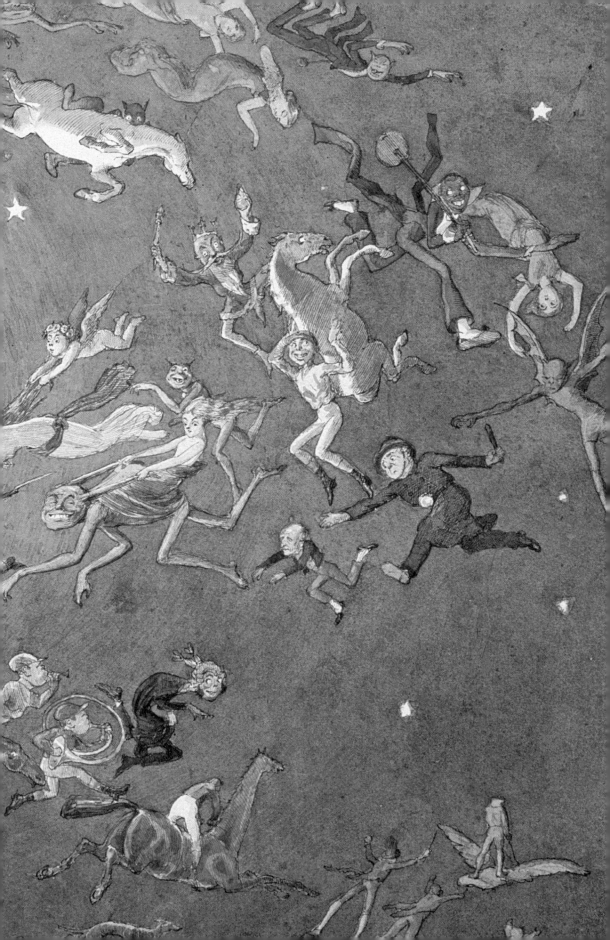

Pegasus and the unicorn have so much in common that various creative artists have been inspired to meld them into one creature: a winged unicorn. Today, that animal is known as an alicorn, the English translation of the Italian word *alicorno*. However, in the 1600s, "alicorn" had a different meaning—it simply meant "unicorn's horn." When Odell Shepard published his classic tome *The Lore of the Unicorn* (1930), he commented in a footnote, "I shall use the word 'alicorn' to mean 'unicorn's horn' wherever it seems convenient to do so in the following chapters. This is not quite a neologism; it is an adoption of the Italian word *alicorno*."

Flying red nonunicorn horses were popularized in the world at large by an unexpected magic-promoting ally: oil companies. In 1911, South Africa's Vacuum Oil adopted the red Pegasus as its logo, and when Vacuum merged with Socony in 1931, the flying horse became its U.S. trademark. A thirty-five- by forty-five-foot rotating red neon Pegasus was placed on top of Dallas's Magnolia Petroleum Building in 1934 to greet attendees of the first annual meeting held there by the American Petroleum Institute; it became part of the city's skyline for decades. In 1968, Mobil began using the red Pegasus at its service stations—and it "remains among the most recognized corporate symbols in American petroleum history," according to the Exxon website.

The idea of a flying unicorn returned in the 1970s, when it appeared in fantasy and science fiction, including Gaudior in Madeleine L'Engle's *A Swiftly Tilting Planet* (1978), and Swift Wind, the winged unicorn of the character She-Ra on the 1980s animated television series *She-Ra: Princess of Power* and the 2018 revival, *She-Ra and the Princesses of Power*. Piers Anthony used the word "alicorn" to refer to a horse with wings and a horn in his 1984 novel *Bearing an Hourglass*. The specific meaning of winged unicorn was crystallized in 2012, though, when the word was introduced in an episode of the television series *My Little Pony: Friendship Is Magic,* which featured an alicorn amulet. The word "alicorn" now refers to any magical pony princess with both a horn and wings.

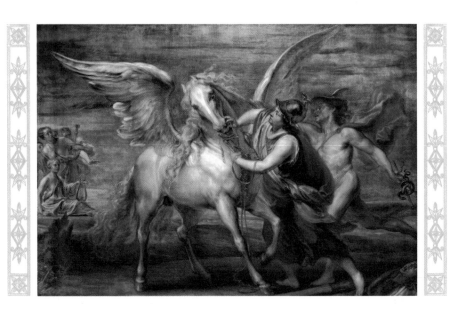

NARWHALS: NOT REALLY UNICORNS *of the* SEA

N 1577, ENGLISH PRIVATEER MARTIN FROBISHER sailed up the northeastern coast of Canada on the second of his three unsuccessful attempts to find a Northwest Passage from the Atlantic to the Pacific Ocean. An officially sanctioned pirate, Frobisher had an enviable license from Queen Elizabeth I to harass French ships whenever he wanted and take whatever he could. But this pirate was mainly looking to plunder natural riches from the New World—and plunder he did.

On that voyage he brought home a cargo of sparkly ore that he thought was gold but turned out to be worthless iron pyrite. But he also found something else on the icy coastline that was worth more than its weight in gold—a unicorn horn.

A contemporary account of that voyage written by Dionyse Settle, one of the sailors on the trip, describes how, on the western shore of America, the men of the Frobisher expedition "found a dead fishe floating, whiche in his nose a horne streight & torquet, of lengthe two yeardes lacking two ynches, being broken in the top where we might perceiue it hollowe, into which some of our Saylers putting Spiders, they presently dyed. I saw not the tryall hereof, but it was reported vnto me of a trueth: by the vertue whereof, we supposed it to be the Sea Unicorne." To test whether the horn came from a unicorn, Settle wrote, the sailors put spiders inside it—a common test for true unicorn horn, which, for centuries, was believed to magically

neutralize poison as well as poisonous creatures like arachnids. The spiders inside the horn soon died, proving the men had indeed had the luck to come upon a unicorn horn.

The hollow white spiral horn was about six feet long. Frobisher gave it to the queen as a gift, and it became part of the Crown Jewels. It is known today as the Horn of Windsor.

In truth, Frobisher had come home with the tusk of a narwhal, a small whale that swims in Arctic waters. The horn was deposited in the Royal Wardrobe and Treasury for safekeeping, where it narrowly escaped being destroyed during the Civil Wars and the Cromwellian period in the 1640s and 1650s. In Herman Melville's 1851 novel *Moby-Dick*, he mentioned that a narwhal tusk hung in Windsor Castle.

Queen Elizabeth wasn't the only rich and famous person to have a narwhal tusk believed to be a unicorn horn. Danish rulers were once crowned on a white-and-gold throne decorated

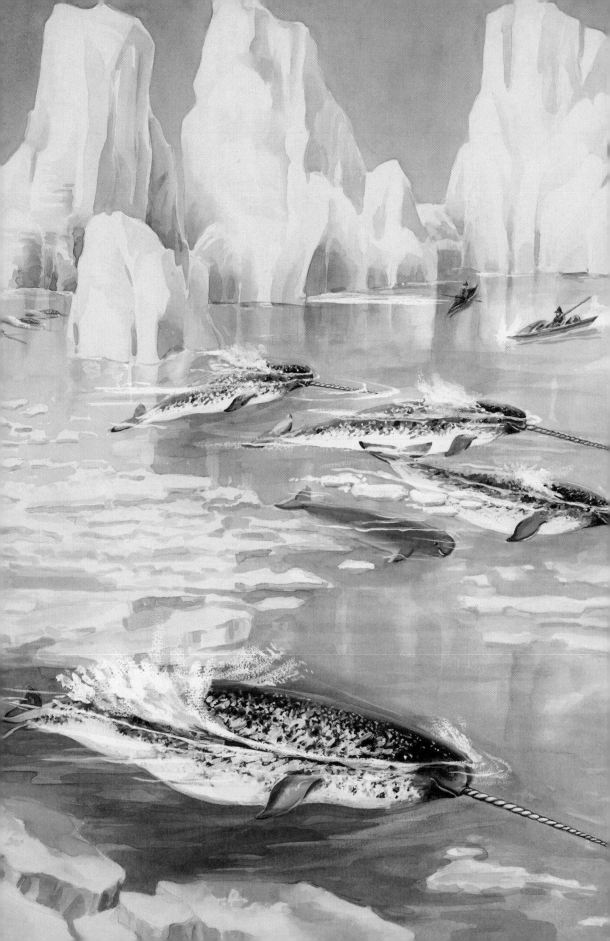

with "unicorn" horns. You can still see one at Rosenborg Castle in Copenhagen. In 1660, the German scholar J. F. Hubrigk wrote, "Is there any Prince, Duke, or King in the world who has not either seen or possessed, and regarded as among the most precious of his possessions, a unicorn's horn?"

Passing off a narwhal tusk as a unicorn horn proved quite lucrative. Princes, dukes, kings, and even popes paid enormous sums for these treasures, and they became, pound for pound, the most precious thing one could buy.

John Dekker, a seventeenth-century English dramatist, wrote that a unicorn's horn "is worth halfe a City." Historians estimate that by the time of the Renaissance, it was the single most precious commodity in the Western world. Dekker said the Horn of Windsor was "valued at pounds 10,000," which, according to art historians at Christie's, comes to about £10 million today.

Narwhals sometimes have been called sea unicorns, but that's a misnomer. The narwhal's long spiral horn is not a horn at all but rather a tusk, an elongated front tooth that grows from the mouth. Narwhal adults have only two teeth; the females typically keep both inside their mouth, but on the males, the left tooth forms a spiral tusk that can grow to more than nine feet long.

Scientists are not entirely sure what the narwhal does with its tusk. They've speculated that it might be a display for female narwhals (a big tusk signals robust genes), a weapon for sparring with other narwhals, or a hunting tool. But recent research has revealed that the tusk is rather soft inside. It also has about ten million nerve endings that can detect changes in temperature, water pressure, and salinity. So rather than sea unicorns, narwhals might be exemplary sea scientists.

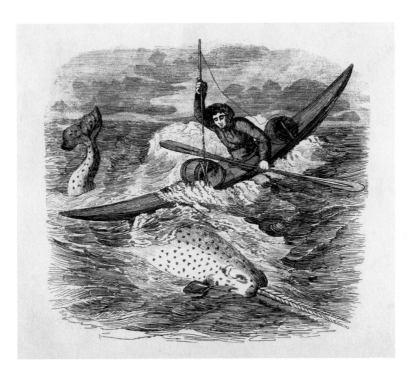

OPPOSITE: Narwhals are hunted by Eskimos in this piece by Else Winkler von Röder Bostelmann, a German-born American artist who joined the New York Zoological Society in 1929 to paint marine life.
ABOVE: Narwhal hunting, from *L'album, giornale letterario e di belle arti*
(The album, literary and fine arts journal), January 23, 1841.

A HORN BY
ANY OTHER NAME

—*Lord Whimsy*

VER THE COURSE OF MY TRAVELS, I'VE SEEN many strange things. I've seen the bright gold eyes of bush babies bounce through treetops in the dark African night. I've stood in rock cavities hundreds of feet above the Australian Outback that fill with a rare species of shrimp during the rainy season. I've mistakenly offended a cuttlefish with the wrong hand gesture. I could go on (and I often do), but suffice it to say, I've seen my share of oddities.

I'm far from unique in my appetites: people in previous ages also harbored an interest in the rare, unusual, and unexplained. One gentleman in particular—a seventeenth-century Danish physician and natural historian named Ole Worm—collected so many natural curiosities that his collection became quite famous, thus becoming an important precursor to the museums of our time. Among his hoard of natural treasures was a long spiral horn. Ole Worm was the first natural historian to conclude that such artifacts were in fact taken from an arctic species of whale known as a narwhal and so concluded that *unicorns did not actually exist.*

Can you imagine?

Ole Worm's folly may be laughable, but it's understandable when you consider the times he lived in. In his day, narwhals were hunted, and their tusks were sold as "unicorn horns" to those wealthy few who could afford them. Following Worm's example, scientists and historians referred to this practice as a relic of a more superstitious time and, like Ole Worm, claimed it disproved once and for all the existence of unicorns.

Of course, as someone who has befriended many enchanted creatures—including unicorns—I have to say this is complete nonsense. Not only do unicorns exist, it is also my contention that narwhals are evidence of the existence of unicorns.

Allow me to explain: I recently had a long conversation with a mermaid friend of mine who happens to be an expert on arctic sea life. According to her, there has been much research among mermaids on the origins of narwhals. The prevailing theory is as follows: unicorns are famous for needing plenty of room to roam; indeed, of all species on Earth, they require the most space. They need so much space that only one of their kind can exist

on Earth at any given time. But according to my mermaid friend, narwhals may be an adaptation by which unicorns—exclusively a land animal—may have accommodated more of their kind by taking to the vast seas of our world. The theory is that two unicorns once appeared on the earth at the same time, compelling one to take to the seas. Centuries later, we have the progeny of that seafaring unicorn: the narwhals.

So, in a manner of speaking, Ole Worm did indeed have a unicorn's horn in his cabinet of wonders. What a silly, silly man! (I suppose one shouldn't expect too much of a man named after an elderly invertebrate.)

This line of reasoning opens up all sorts of other possibilities to consider, doesn't it? For example, if narwhals are the unicorns of the sea, then is it possible that humans are the mermaids of the land? Is it possible that mermaids may have been the marine progenitors of humankind? If so, then what did they breed with to make their adaptation to land possible? Apes? Monkeys? Naked mole rats? It would certainly have been an adventurous and not very discerning mermaid, wouldn't it?

Perhaps it's best not to pry into the earth's past too much: being a busybody is always bad form.

For shame, science!

Above: Lord Whimsy contemplating science and its foibles.

UNICORN *of the* STARS

EAPING GLAMOROUSLY THROUGH THE MILKY WAY is Monoceros, the unicorn constellation. In this star picture, his head and horn are held high as he defies nearby Orion, the hunter—who can never catch this elusive unicorn because Virgo is so far away. The unicorn constellation is best seen in the Northern Hemisphere in January, when the icy night makes a rich backdrop for this magical spattering of faint stars.

That the oldest group of constellations are still known today was the work of Ptolemy, the Egyptian astronomer who lived in Alexandria during the second century. He published a cosmology that included forty-eight constellations, all of which we still seek out in the night sky.

But the ancient Egyptians and the Romans (who ruled Egypt at the time) knew nothing about unicorns, so they named no constellations after them. It wasn't until 1612 that a Dutch cartographer named Petrus Plancius published a celestial globe that included several new constellations, with animals that were favorites of his. These included Monoceros (Latin for "one horn"), which he recognized between Orion and Hydra, the water snake. They also included Camelopardalis (the giraffe) and Apes (the bee).

Then, in 1624, German astronomer Jacob Bartsch, the brother-in-law of the great astronomer Johannes Kepler, published a volume called *Usus astronomicus planisphaerii stellati* (Astronomical use of the stellar planisphere), which introduced six of Plancius's new constellations to a wider audience. The Polish astronomer Johannes Hevelius also included Monoceros in his influential star atlas and catalog published in

1690. Although several of Plancius's constellations are no longer recognized by the International Astronomical Union, Monoceros is still accepted.

Monoceros is not easy to see without a telescope. But, like the unicorn it represents, it is made up of stellar objects that are rich with mystery, power, and beauty. Within its equine outline are sixteen stars with known planets. The closest black hole we know of is V616 Monocerotis, about three thousand light-years away in the unicorn constellation.

The brightest star in the constellation, Alpha Monocerotis, is an orange giant twice the size of the sun. Beta Monocerotis is a triple-star system, with the three stars forming a small triangle. S Monocerotis is a binary-star system, with two stars that orbit each other. Another binary system, Plaskett's Star, is one hundred times larger than our sun and is one of the biggest binary systems known.

In January 2002, V838 Monocerotis suddenly burst into view, becoming six hundred thousand times brighter than our sun and temporarily making it the brightest star in our Milky Way galaxy. NASA's Hubble Space Telescope discovered that an explosion on the red supergiant was lighting

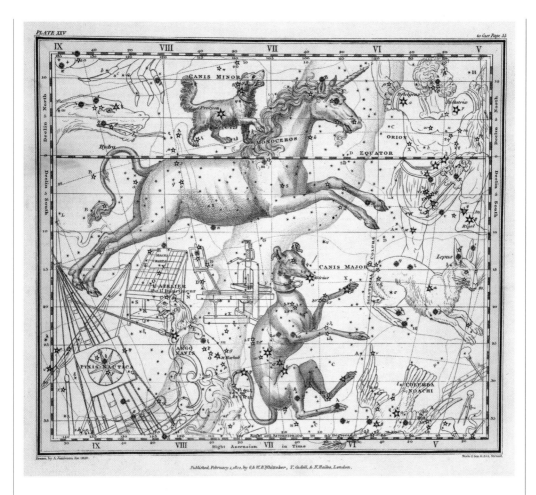

PLATE XXV

to face Page 55

up the dust surrounding the star, causing it to glow in a phenomenon called a "light echo."

Fittingly, within the body of the unicorn constellation are also several gorgeous clouds of stardust known as nebulae. The Rosette Nebula glows red and pink. A stellar wind (flows of radiation and charged gas particles) from a cluster of stars at its core helps shape it into the likeness of a rose.

The Butterfly Nebula, with its two diaphanous wings, formed when its central star exploded. The wings of the Seagull Nebula, a cosmic soaring bird, glow deep red among the bright stars. Just below S Monocerotis is the Fox Fur Nebula, lushly glowing ruddy red. And the Christmas Tree Cluster, a triangular cluster of sparkling blue stars, is topped by a red cloud known as the Cone Nebula.

Aʙᴏᴠᴇ: A colored engraving from the lovingly titled *A Celestial Atlas: Comprising A Systematic Display of the Heavens in a Series of Thirty Maps Illustrated by Scientific Description of their Contents, And accompanied by Catalogues of the Stars and Astronomical Exercises* by Alexander Jamieson, 1822.

The UNICORN
QUESTING LICENSE

IF THE SCENES OF UNICORN HUNTS IN MEDIEVAL ART have inspired you to take up unicorn questing, you might want to get an official Unicorn Questing License from Lake Superior State University (LSSU) in Sault Ste. Marie, Michigan, to avoid potential legal issues. The license allows questers to seek unicorns on Earth, the moon (unexplored areas only), the Milky Way (although the southeast rim is closed on odd years), and everywhere else. Unicorns may be taken during daylight and dark, except when the Tooth Fairy is about. The limit is one male unicorn a month.

LSSU publishes a set of strict regulations for unicorn questing, starting with what is acceptable as unicorn bait: "The only recognized legal unicorn bait is a virgin." Should procuring a virgin prove impossible, the regulations also say unicorns may be taken with serious intent, iambic pentameter, general levity, or sweet talk. Using artificial light to lure unicorns, however, is strictly prohibited.

The first Unicorn Questing Licenses were issued by Bill Rabe, who became LSSU's director of public relations in 1971. He and several professors from the English Department founded the Unicorn Hunters, a society that sponsored events such as burning a snowman on the first day of spring, World Sauntering Day, the International Stone-Skipping Tournament, and Unicorn Questing Season.

In 1976, the Unicorn Hunters also inaugurated the "List of Words Banished from the Queen's English for Mis-Use, Over-Use and General Uselessness," published annually on the last day of the year. Although the society disbanded in 1987 when Rabe retired, the list continues and is currently under the editorship of John Shibley, from the Marketing and Communication Office at LSSU, who heads a team of word sifters. Anyone may submit a word or phrase to banish; the submission must be accompanied by compelling reasons for banishment (irritation and inaccuracy weigh heavily here). Shibley says they receive hundreds of suggestions every year. Among the words and phrases banished in 2019 were "wheelhouse," "legally drunk," "ghosting," "optics," "platform," "collusion," "thought leader," and, Shibley says, "'wrap my head around,' which I was surprised hadn't been banned before."

Unicorn Questing Licenses can be obtained by writing to the university. A license can also be downloaded directly from the LSSU website.

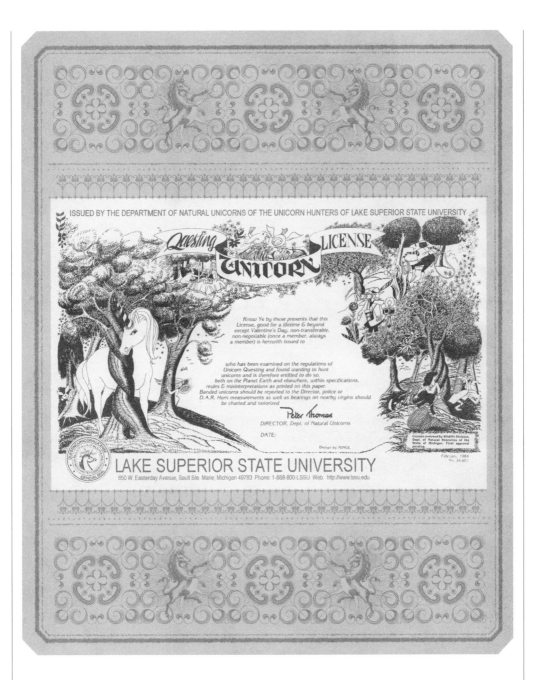

According to Shibley, "We still grant licenses because the unicorn is the original metaphor for unobtainium: elusive, possibly mythical, and ever-bracketed through a journey of self-discovery and reflection that never ends." Requests are processed strictly by the honor system. The applications are reviewed by Michigan's Wildlife Division of the Department of Natural Resources, and the licenses must be worn over the heart, pinned with a sprig of rosemary.

ABOVE: A copy of the coveted Unicorn Questing License, which can be obtained only by the most dedicated unicorn hunters and lovers.

The Controversial
Unicorn Lure

AMONG THE HUNTING REGULATIONS DOCUMENTED on the Lake Superior State University website is a list of items recommended for serious pursuit of the unicorn. These include a small flask of cognac, a one-ounce bottle of Unicorn Lure, a pair of pinking shears, a large envelope, an airmail stamp, a nail clipper (with file), a curry comb, a small bottle of hoof-and-horn polish, and a pair of hoof trimmers. In 2017, an aspiring unicorn hunter wrote in to ask what exactly qualifies as Unicorn Lure—a question that sparked a great deal of controversy and confusion.

Professor Mary McMyne responded: "As far as I know, the Unicorn Hunters retired with Bill Rabe in 1987, and the mystery of what was contained in the 'one-ounce bottle of Unicorn Lure' retired with him. Nevertheless, speculations abound. My own favorite theory involves liquid forms of some of the more elusive questing devices, such as 'Serious Intent' and 'Iambic Pentameter.' I find it inspiring to imagine the historical Unicorn Hunters before a hunt, furiously whispering a bottle full of Dark Lady sonnet-concentrate."

For confirmation, Bill Rabe's children were consulted, in the hope that the secret lived on with them. His son, Karl Rabe, responded, "Typically preorbital gland sweat from a fairy," while his daughter, Kate Forgach, suggested, "I remember the bottle of Unicorn Lure as being filled with clear water. To no doubt humor my unicorn-believing tween self, [Bill] had me perform an incantation over the open bottle. I remember it sitting with his Sherlock paraphernalia in the study." Unfortunately, the substance of the lure remains a mystery, but the entire episode does suggest that at least some unicorns enjoy a fine cocktail—or two.

Opposite: John William Waterhouse, *The Love Philtre*, c. 1913–14.

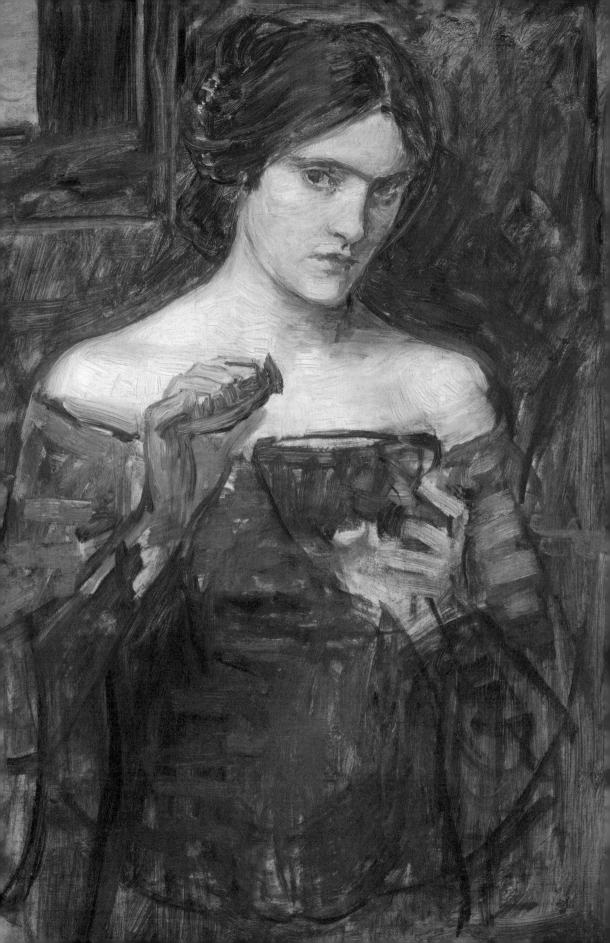

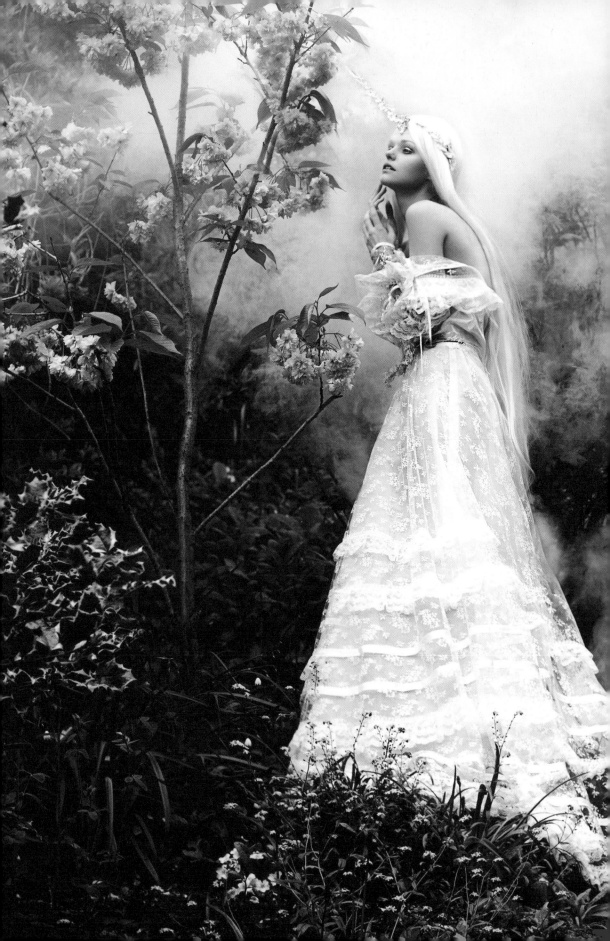

II. Fashion & Beauty

UNICORN COUTURE

THE RESPLENDENT UNICORN HAS LONG INFLU-enced the worlds of fashion and beauty, from couture to designer handbags, to hair tinted in cool pastels, whether a single tone or many, iridescent eye shadow in a rainbow palette, and silver glitter nail polish that glimmers in the moonlight.

Some of the most extraordinary unicorn-inspired designs have come from the house of Alexander McQueen, helmed by creative director Sarah Burton since McQueen's death in 2010. Burton, a colleague of McQueen's for fourteen years before taking over, has maintained the rebellious designer's iconoclastic approach to fashion, including his penchant for incorporating otherworldly creatures into his designs. For the presentation of her masterful and ultraromantic autumn/winter 2016 collection, Burton sent garments featuring unicorns and unicorn-inspired pieces down the runway during London Fashion Week. The collection was heralded by numerous critics as one of the designer's finest. "[Burton delivered] the most beautiful, sensitive, and breathtakingly crafted Alexander McQueen collection," British

journalist Sarah Mower wrote for *Vogue*. "Almost literally it was spun out of dreams." For her part, Burton said she envisioned the woman who would wear clothing from the collection "almost sleepwalking, in a state where reality and dreams become blurred."

Standouts included two black lace evening gowns appliquéd with sequined embroidered unicorns; one dress was decorated with a multicolored unicorn along with butterflies, birds, flowers, and stars, while the other featured a giant shimmering gold unicorn standing on its hind legs and covering half the body. Actress Margot Robbie donned a more modest version of the latter (one that covered her breasts and underwear) for the premiere of the film *Suicide Squad* later that year. "It's a Lisa Frank dream come true!" Kristina Rodulfo exclaimed in *Elle*.

PAGES 64–65: Model Jodi Lakin wears a horn from Fairytas in this image by photographer Bella Kotak.
OPPOSITE: A dazzling unicorn gown from the Alexander McQueen runway in fall 2016. Nicole Kidman wore a lined version of this dress at the 2016 Academy of Country Music Awards. + *ABOVE:* Margot Robbie adapted this Alexander McQueen gown for the New York premiere of the film *Suicide Squad* in 2016.

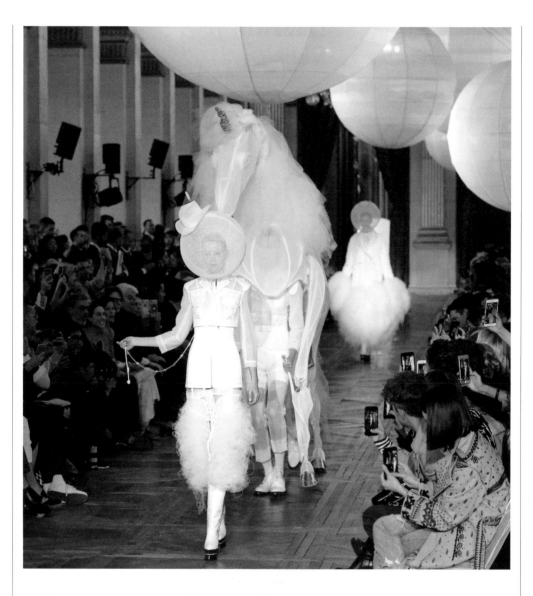

Thom Browne's presentation for his spring 2018 womenswear collection featured a full-blown giant white lace unicorn operated by two model puppeteers and led down the runway by a model wearing a sheer helmet and a white feather-and-lace number. Trailing the unicorn puppet was another sheer-helmeted model wearing a white wedding dress with a gold-outlined unicorn embroidered across the front. Created from a mix of materials, including white tulle, gold bullion, pearls, crystals, and white mink, the dress "hover[ed] like a strange cloud," Laura Jacobs wrote for the *Wall Street Journal*. Along the back are two streaks of red, echoing the unicorn's stab wounds. Fittingly, this confection reappeared alongside the Unicorn Tapestries themselves at the Costume Institute at the Metropolitan Museum of Art's spring 2018 *Heavenly Bodies* exhibit, which was held at both the museum and at the Met Cloisters. For the exhibit, the dress was

Above: At Thom Browne's October 2017 show, models led a live unicorn down the runway and became the envy of girls everywhere.

displayed on a mannequin styled with a bright red wig from wigmaker Shay Ashual to conjure beauty and suffering altogether and, as Catherine Addington wrote for *The Weekly Standard*, turned "an otherwise enigmatic ensemble into the heavenly wedding garment of a martyr."

Vivienne Westwood created a stunning custom bustle gown with a pink unicorn hand-painted on the train for actress Elle Fanning to wear to the opening ceremony of the Cannes Film Festival in May 2017. Fanning, who described herself as "a unicorn flower child at heart, mixed with a schoolboy, and the occasional Cali surfer dude" on *Vogue*'s website, came up with the unicorn idea. Westwood's confection—which included other illustrations such as a shooting star named Elle, hearts, and the planet Gaia—took three hundred hours to finish by hand, with ten people working on the dress for more than ten days. The dress prompted Fanning to tweet: "I had the honor of walking the 70th annual red carpet . . . dressed in a mystical galactic creation of a gown!!! Thank you from the bottom of my soul @viviennewestwoodofficial for making me the most incredible magical dress! AND FOR PAINTING ON THE BACK OF IT!!!!!! Customized with a special unicorn and my name . . . twice!"

Other designers inspired by the unicorn include Pierpaolo Piccioli and his design partner at the time, Maria Grazia Chiuri, at Valentino. For their autumn/winter 2016 haute couture collection—their last collaboration prior to Chiuri's departure for Christian Dior—the two created an elaborate, long-sleeved, floor-length gown replete with a unicorn, bird, and flowers that took 110 hours to hand-paint. In a campier nod to

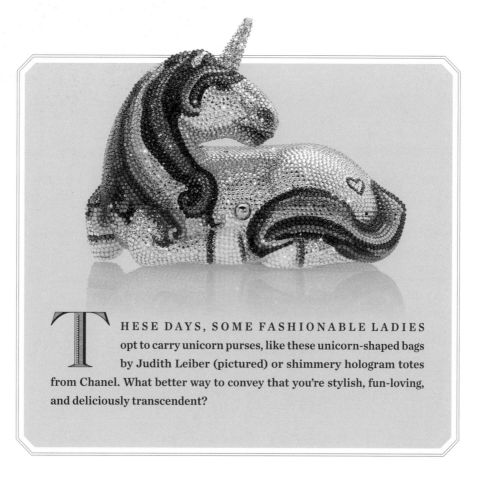

THESE DAYS, SOME FASHIONABLE LADIES opt to carry unicorn purses, like these unicorn-shaped bags by Judith Leiber (pictured) or shimmery hologram totes from Chanel. What better way to convey that you're stylish, fun-loving, and deliciously transcendent?

enchanted equines, Moschino's spring/summer 2018 collection included several candy-colored pieces emblazoned with pastel My Little Ponies and was produced in collaboration with Hasbro, which owns the nostalgic, rainbow-loving brand. As writer Kitty Lindsay put it for website Hello Giggles, "It's like our glitter sticker collection from middle school and our high school fashion go-tos had a baby, and it is magical."

And in numerous 2017 autumn/winter collections, all manner of glitter boots strutted down the runway, most notably by Christian Louboutin, whose sequined creations were dubbed "unicorn skin" by stylist Samantha McMillen, who said, "They look metallic at first then turn green, red, pink, and gold. It's pretty mesmerizing to watch." Yves Saint Laurent came out with a pair of $10,000 thigh-high boots emblazoned with Swarovski crystals, while Chanel offered a boot coated in glitter and fabulousness. Cara Delevingne wore Jimmy Choo's glitter booties and was quoted in *Harper's Bazaar* giving this holiday fashion advice that may or may not betray a deep love of unicorns: "I really love to dress up—and I'm not just talking about looking nice.... I do like to put on a crazy outfit and be an elf or a reindeer. Or even if I just wear a nice sparkly dress with a red nose, it's something different and quirky—it's not just a normal party outfit. I like to have some sort of accessory, even if it's just horns."

Horns, of course, will never go out of style.

OPPOSITE: Elle Fanning poses in her unicorn best on the red carpet at the Cannes Film Festival, 2017.

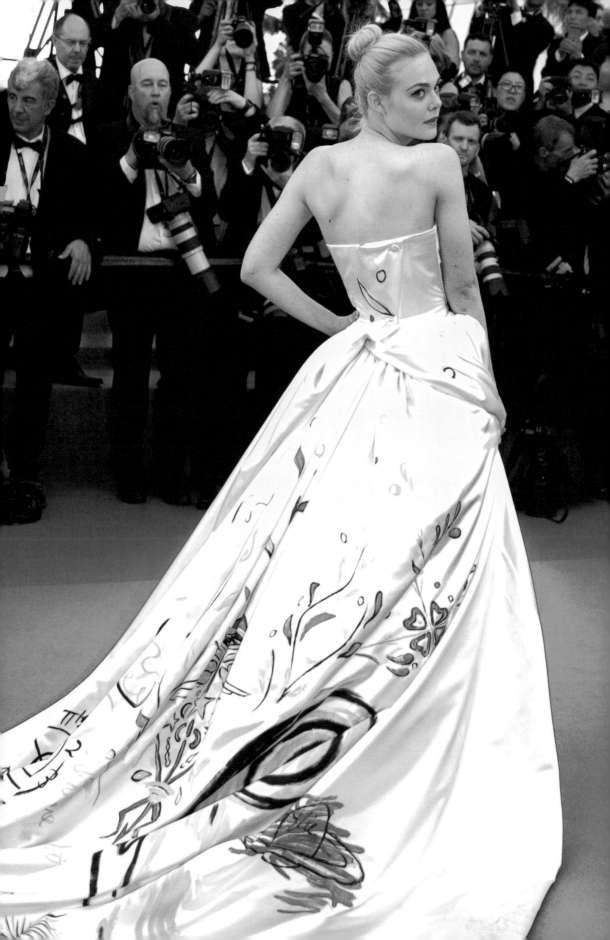

Unicorn Gaga

LADY GAGA, AN OUTSPOKEN CHAMPION OF THE INDIvidual and one whose personal style is at a minimum colorful and attention catching and for whom there is no maximum as far as sartorial outrageousness is concerned, is a unicorn fan. She wears her heart on her sleeve (she has a heart tattoo with the word "Dad" in it on her left shoulder) and a unicorn tattoo on her leg. The unicorn tattoo also has a banner reading "Born This Way," the name of her second album and its single, which reached number one in twenty-five countries. An anthem of individuality, the song was compared in sound and theme to "Express Yourself," a song by another vocal supporter of personal freedom and self-expression, Madonna.

Gaga tweeted that the song "Unicorn Highway" is about her, "flying down the road, with nothing but a dream." Apparently, fans were so enamored with the song and her endorsement of the individual (and deep, abiding love of unicorns) that they not only sent her unicorns but also brought them to her media events and even Photoshopped Gaga into a unicorn, to the star's approval.

Like many women of her generation (born this way in 1986, to be precise), Lady Gaga grew up loving the My Little Pony brand of unicorn. On the *Big Top 40* radio show in the United Kingdom in 2011, she said: "I had My Little Ponys. I was obsessed with the idea of a creature that was born with something magical that sort of made them the misfit in the world of the stallion. I'm actually quite obsessed with unicorns. They are in essence a mythical creature. The unicorn is born magical and it's not the unicorn's fault, and it doesn't make it any more or less special or any less unique, but it can't help that it was born with that magic." "Gagacorn" key rings and stickers were sold during her Born This Way Ball tour, which opened with Gaga riding a large unicorn on stage. In "Gagavision 44," she holds up a little unicorn toy and making its horn light up, says, "Whenever I get sad, I think of all the Little Monsters . . . and say, 'Fight on, little pony, fight on.'"

Around the same time, in May 2011, Gaga appeared on *Good Morning America* playing a unicorn piano. Designer Marla Weinhoff of Atta created a custom life-size fiberglass unicorn in four days, which featured a transparent resin spire, a tufted main and tail, and an inset shelf for a keyboard.

In Gaga's personal style, too, her love of and identification with the unicorn is evident—high ponytails, rainbow- and/or pastel-dyed hair, white glimmering ensembles, and copious amounts of glitter and shine, just to start. On March 25, 2014, the *Cut* reported that "Lady Gaga was spotted walking around New York dressed in a sparkly pink pantsuit, bow tie, and sunhat. Wearing sky-high platforms and impenetrable shades, Gaga shimmered in the sunlight; and, holding her new knee-length white ponytail in hand, she looked uncannily like a unicorn."

OPPOSITE: Lady Gaga arrives at the Ritz-Carlton in Berlin's famous square Potsdamer Platz in October 2013.

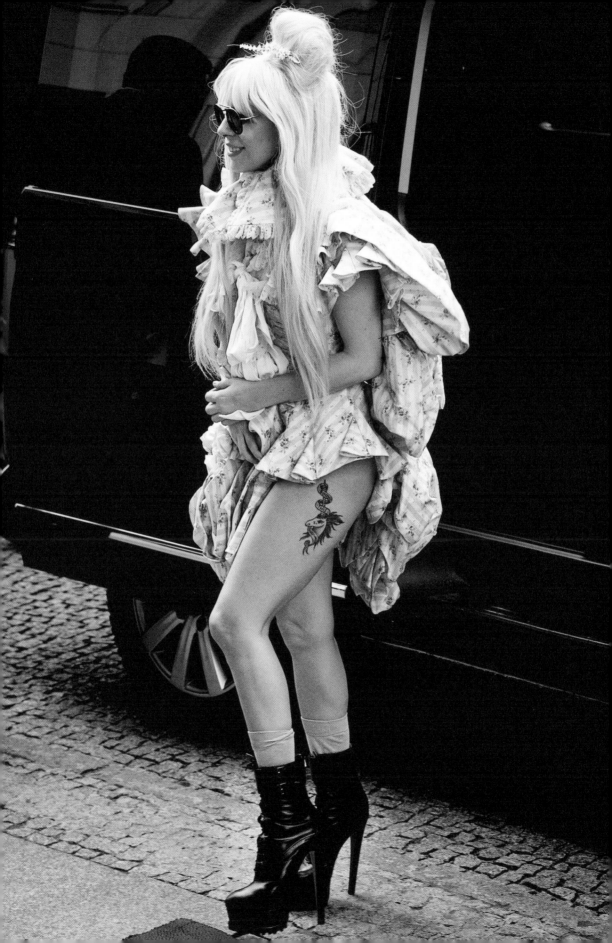

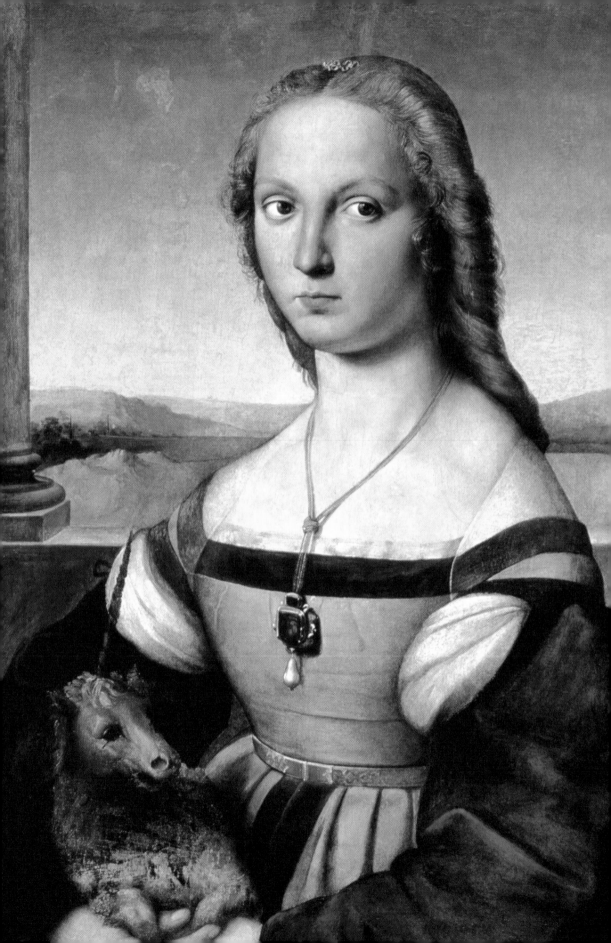

PORTRAIT *of a* LADY *with a* UNICORN

ADY GAGA IS NOT THE FIRST FASHION ICON TO be inspired by the unicorn and its glimmering elegance. In the iconic painting by Raphael, *Portrait of a Lady with a Unicorn*, another fashionable woman poses with the one-horned creature, though in this case it is more a sign of virginal luminousness than rebellious individuality. As Clayton Schuster wrote in a piece for the website Sartle, it's "a painting [that's] trying to bring all the boys to a young girl's yard, because no one's played in it yet if you catch my drift."

The painting is, fittingly, shrouded in mystery. No one knows exactly why it was created, when and where it was painted, or who is pictured in it, though it seems to have been created in 1505 or 1506 and was inspired or at least influenced by Leonardo da Vinci's *Mona Lisa*. The portrait is not mentioned at all in early surveys of Raphael's work and in fact was not identified as his work until the early twentieth century. In a 1682 inventory, when it was in the possession of the Borghese family, Raphael's painting was described as "on panel with a woman seated with a unicorn in her

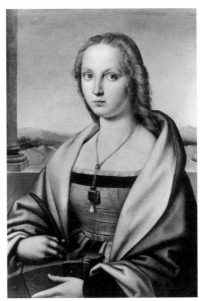

arms…in a black frame, artist uncertain." Because, presumably, no one knew the real value of the painting, in the late 1600s the unicorn was overpainted with a broken wheel and a cape and martyr's palm were added to transform the subject from an anonymous unicorn-holding fashionista to the revered Saint Catherine of Alexandria. (In the early fourth century, pagan emperor Maxentius ordered Catherine to be executed on a breaking wheel after she'd converted hundreds to Christianity, but when she touched the wheel it shattered into pieces, so he had her beheaded instead.)

Opposite: Raphael, *Portrait of a Lady with a Unicorn*, c. 1505–06. + *Above:* The altered painting before the twentieth-century restoration.

A first attempt at identification was made in 1854, when a description at the Borghese palace listed the painting as *Portrait of Maddalena Doni Fiorentina*. Late nineteenth-century Italian art critic Giovanni Morelli uncharitably asserted in his book *Italian Painters: Critical Studies of Their Works* (1892–93) that the "young woman with plump cheeks and a rather vacant expression is none other than Maddalena Strozzi, wife of the Florentine Agnolo Doni, transformed into a saint." In the 2015 tome *Sublime Beauty: Raphael's Portrait of a Lady with a Unicorn*, which examines the painting's mystery in some detail, Linda Wolk-Simon posits that the woman in the painting is instead Laura Orsini della Rovere (born in 1492), daughter of the renowned beauty Giulia Farnese (1474–1524), who was mistress of the Borgia pope Alexander VI, who was quite possibly Laura's father. The Farnese family, as it happens, adopted the unicorn as a heraldic emblem in the mid-fifteenth century, and unicorns abound in the family's tombs and art as well as in some of Giulia's personal apartments. "If the young woman in Raphael's portrait is Laura Orsini della Rovere," Wolk-Simon writes, "the unicorn she holds assumes a dual meaning: a conventional attribute of female virtue, it is also a heraldic reference to the particular sitter's lineage." And given Laura's "dubious lineage," it would have been important for her lineage to be "unimpeachable" when she was hastily and advantageously married to a nephew of Pope Julius II in 1505.

In another essay in *Sublime Beauty*, Anna Colvina argues that the subject was Maddalena Strozzi and that the portrait was made on the occasion of her marriage in 1504. Strozzi's family, she points out, lived in the Gonfalone dell'Unicorno section of the district of Santa Maria Novella in Florence. It was customary to commemorate a wedding in that time with a work of art, though dogs, as symbols of fidelity, were more common than unicorns in such portraits at the time, making the unicorn here a bit more ostentatious (along with the supersize jewels in the portrait). "Thus ... the symbology of virginity might have needed to be bolstered with a further, more direct indication, such as the heraldic reference to the subject's family. This could only have been the Strozzi family at the time of Raphael's stint in Florence," Colvina writes.

It was not until 1927 that scholar Ridolfo Longhi posited that Raphael was the artist of the portrait and recognized that a significant amount of overpainting had occurred; before then, scholars credited anyone from Pietro Perugino, Ridolfo del Ghirlandaio, Francesco Granacci, and Andrea del Sarto to the Florentine school. In 1936, conservators removed the underpainting and transferred the art from wood panel to canvas. In 1959–60, when conservators attempted to treat the painting, which by then was in a fragile state, radiography revealed that the lady originally held a dog rather than a unicorn. No one knows why the dog was replaced by a unicorn and/or if Raphael was the one to do it. The likely reason, according to Colvina, stems from a desire "to better denote the fact that the bride was a member of a family living in that particular area, and to confer on her name and surname something of a heraldic celebration of civic power." No doubt the unicorn's inherent fabulousness had something to do with the modification, too.

OPPOSITE: Model Sarah Bentman, in a dress from Jill Andrews, poses with her pet unicorn Mario from Emma's Daisyhill Farm in Maryland. Photograph by Steve Parke; hair and makeup by Nikki Verdecchia.

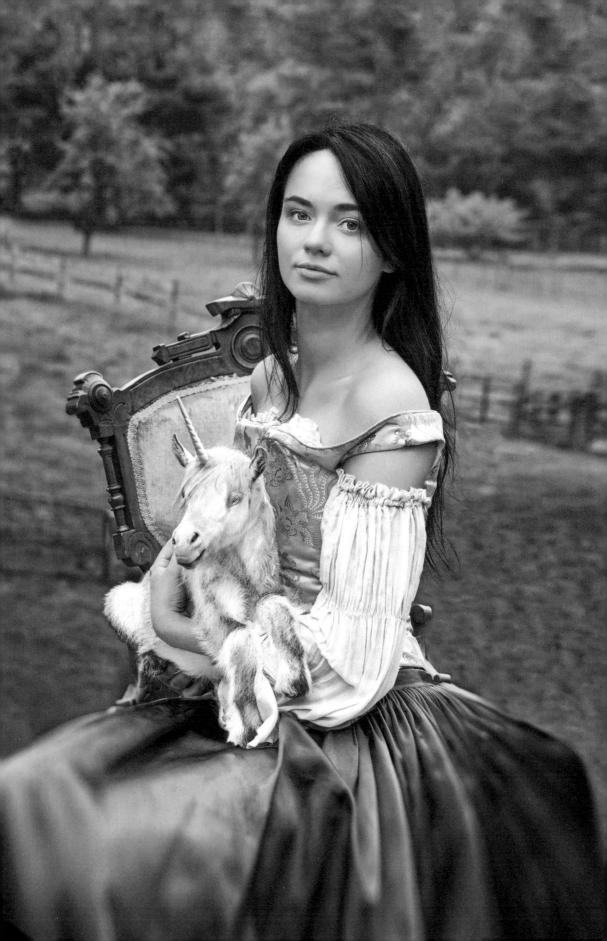

SCENT *of the* UNICORN

"My great-grandmother said only that the unicorn
had a good smell. She never could abide the smell
of any beast, even a cat or cow, let alone a wild thing.
But she loved the smell of the unicorn. She began
to cry once, telling me about it. Of course, she was
a very old woman then, and cried at anything that
reminded her of her youth."

—PETER S. BEAGLE
The Last Unicorn, 1968

What does a unicorn smell like? No one knows exactly, though in *Faerie Magazine*'s medieval issue (2017) Laren Stover conjectured that the unicorn emits the scent of "a ferny, mossy, forest-edged meadow of wild-flowers melded with the very botanicals and fruits that appear in *The Unicorn Is Found* tapestry from the Unicorn Tapestries—sage, pot marigolds, sweet orange (medieval antidotes to poison), holly, and wood strawberries—mixed in with a slightly feral perfume of wild stallion and downy tuft of a bunny's ear."

In 2017, fashion designer Anna Sui launched the unicorn-inspired perfume Fantasia. The flower- and leaf-adorned bottle has a bona fide gold unicorn at top, which was inspired by the idea of a unicorn "standing at the edge of an enchanted forest, with its white mane sparkling majestically, softly being kissed by the light of the moon," according to Sui's creative team. Rather than capture the scent of a unicorn, which, frankly, might be better left to the imagination, Sui tried to capture the essence of what the unicorn stands for—its "strength, energy, purity and grace," "playful femininity," and "sparkling mysticism"—and wanted the scent to immediately transport the wearer to "a fantasy land where unicorns enchant with their magic." To achieve this, she used a hint of luminous pink pepper balanced with sweet raspberry

OPPOSITE: **Photographer Danniella Jaine and florist Georgina Rose wove model Olivia Harriet into this flowery, unicorn-luring scene in Bristol, England, by blending the strands of her hair with the surrounding flowers as she pressed a colorful bouquet to her chest. +** *ABOVE*: **A bottle of Anna Sui's Fantasia perfume. +** *PAGES 80–81*: **This photograph by Steven Meisel was part of the 2017 Fantasia campaign.**

praline, along with a brushstroke of Himalayan cedarwood mixed with golden cypress base, to give, as the creative team said, "a touch of effortless sensuality to the joyful radiant charm of the overall fragrance."

In July 2017, DOIY, a Barcelona-based design firm that creates houseware and lifestyle accessories, launched a unicorn room spray at the National Theatre Bookshop in London. Inspired by cotton candy, the scent is described on the aerosol can as "pink, sweet, gorgeous, dream, fantasy, kids forever, purity, grace, mystery, legend, wild, imagination, purple, wings." In October of that same year, Paris Hilton came out with Paris Hilton Unicorn Mist Rejuvenating Rosewater Facial Spray. Hilton's "magical" skin refresher came packaged in a shimmering holographic bottle (seemingly, its only unicorn connection) and sold out quickly. But on April 9, 2019, National Unicorn Day, Hilton celebrated by rereleasing the limited-edition spray. Pictures of Hilton, clad in head to toe glitter and cradling a live unicorn's face in her palms or floating on a bright pink-winged unicorn inner tube in a swimming pool, can be found on the Paris Hilton Skincare Instagram feed, along with a variety of memes with notes like "Don't Be Basic" and "Bitch. I'm Fabulous."

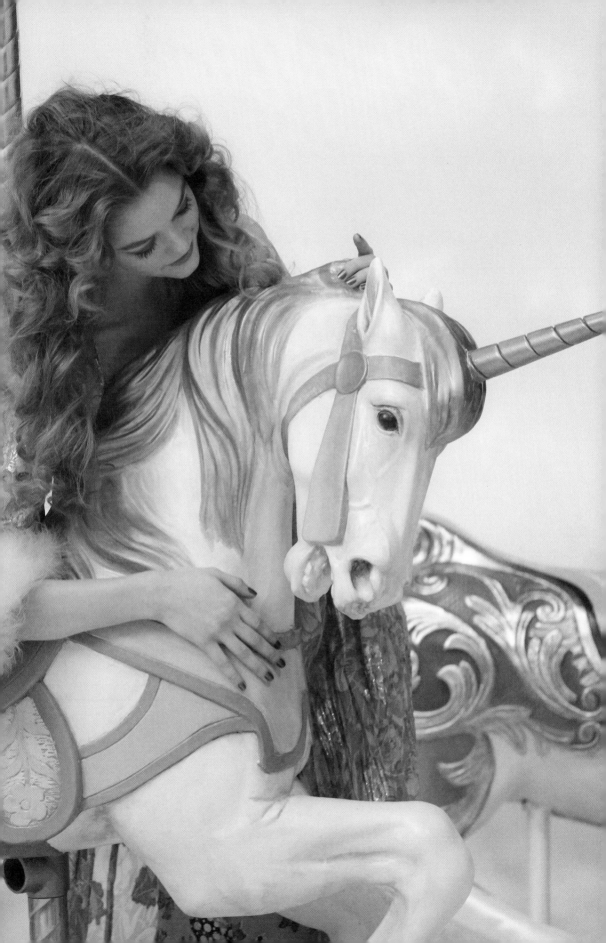

UNICORN HAIR

UNICORN HAIR TYPICALLY REFERS TO TRESSES dyed in bright rainbow colors—a prevalent and enduring trend around the world, from the streets of New York City to Tokyo. The interpretation and application of color combinations is seemingly endless, ranging from understated champagne pink, pale blue, and other pastels to vibrant lilac and neon yellow so intense it could conceivably blind the casual observer.

According to an April 2017 *Elle* timeline tracing the origins of the trend, unicorn hair emerged in 2010 when Bleach London opened its first salon—the world's first establishment to focus on color rather than cut—and offered multicolored unicorn hair that was quickly adopted by celebrities like Alexa Chung and Georgia May Jagger. Bleach would go on to offer its own vegan dyes, which it sells nationwide and ships all over the world.

For her fall 2013 show, fashion designer Sophia Webster featured models with pastel hair, braided and piled up on their heads, to create the perfect unicorn look. In June 2014, the *New York Times* wrote about the platinum-blond trend and quoted colorist Aura Friedman, who is sought after for her "platinum expertise." "It's about making yourself unusual," she said in the story. "It's always fun to have that unicorn in a group of people." Friedman called

Korean American model Soo Joo Park and singer-songwriter-actress Sky Ferreira "unicorns" when they went platinum blond—both became Saint Laurent muses for the season. But to be fair, platinum has long been popular with distinctive, unicornian musicians, such as Lady Gaga.

For the presentation of Marc Jacobs's autumn 2015 collection, models wore unicorn buns (top-knots near their foreheads), which writer Megan Cahn described as "more Morticia Addams than My Little Pony" in *Elle*'s February 2015 issue. For the presentation of his spring/summer 2019 collection, Jacobs debuted "anti-unicorn hair," developed by Redken's International Colour artistic director Josh Wooden. Each model's hair was dyed with a metallic base in purple, titanium, or platinum to create a multi-dimensional shade. "It's not overt or bold," Wooden said. "It's refined."

OPPOSITE: **Rainbow hair by colorist Candace Kerper.** + *PAGE 84*: **Jessica Dru wearing a light-up horn by HelloJaska. Photograph by Elizabeth Elder.** + *PAGE 85*: **Corsetier Joni Steinmann. Photograph and headdress by Maria Mirage.**

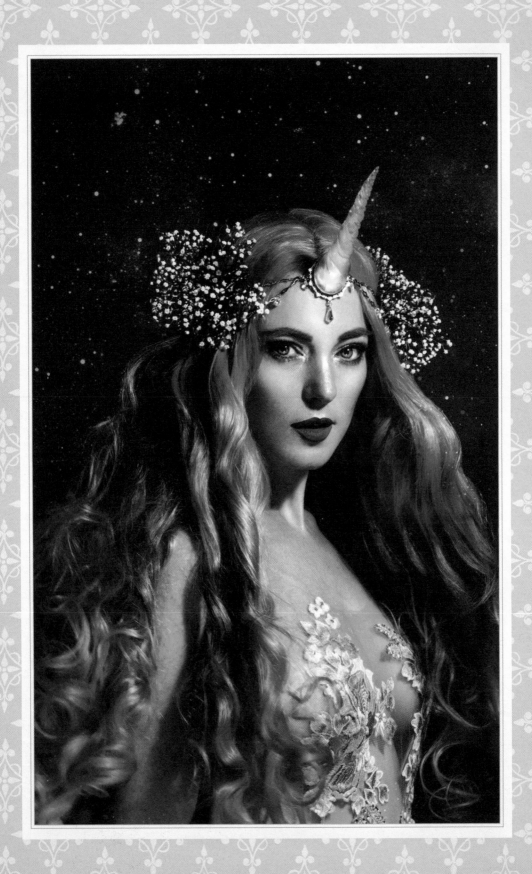

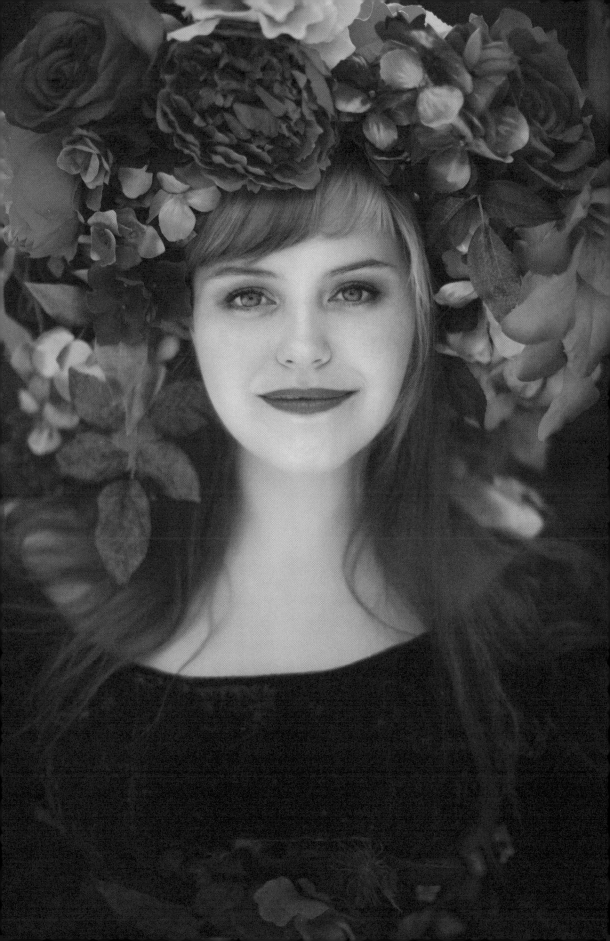

Unicorn Tail Loop Braid

—NIKKI VERDECCHIA

ANY BRAIDING OR PLAITING TECHNIQUE THAT PULLS hair from the sides of the head to the center produces a mane-like effect. This one creates cascading loops, which give added dimension and can be worn either neat and tidy or messed up for more of a wild-horse look. And long-haired ladies have the advantage here: the longer and thicker your hair, the better! For this to work, hair must be at least below-shoulder length. The final look is shown on page 88.

TOOLS AND MATERIALS

+ **Rattail comb**
+ **Clear hair elastics**
+ **Duckbill hair clips**
+ **Hair spray** (optional)

DIRECTIONS

1. Comb hair away from the face and back toward the crown. Using a clear elastic, create a ponytail with hair from the crown section, or top of the head, as shown.

2. Create another ponytail just below that one, using some hair from the crown and pulling some from the sides of the head, as shown.

3. Split the top ponytail into two sections and pull the lower ponytail up between the two sections.

4. Sweep the lower ponytail up toward the face and clip it to temporarily move it out of the way.

5. Add some hair from the back of the head, pulling it from both sides, to the two sections from the top ponytail, and using an elastic, secure a third ponytail below the second.

6. Unclip the second ponytail and split it in the same manner as the first.

7. Temporarily secure the third ponytail out of the way with a clip.

8. Add hair from the back of the head to the two sections from the second ponytail and, using an elastic, secure a fourth ponytail below the third.

9. Repeat step 8, braiding hair down the back of the head to the nape of the neck.

10. Once you run out of hair to add from the back of the head, use the same technique to add hair from the last ponytail.

Finish with an elastic when there is no more hair to add. Using your fingers, fan out the hair from each loop to help hide the elastics and to give the braid a fuller look. If desired, finish with hair spray.

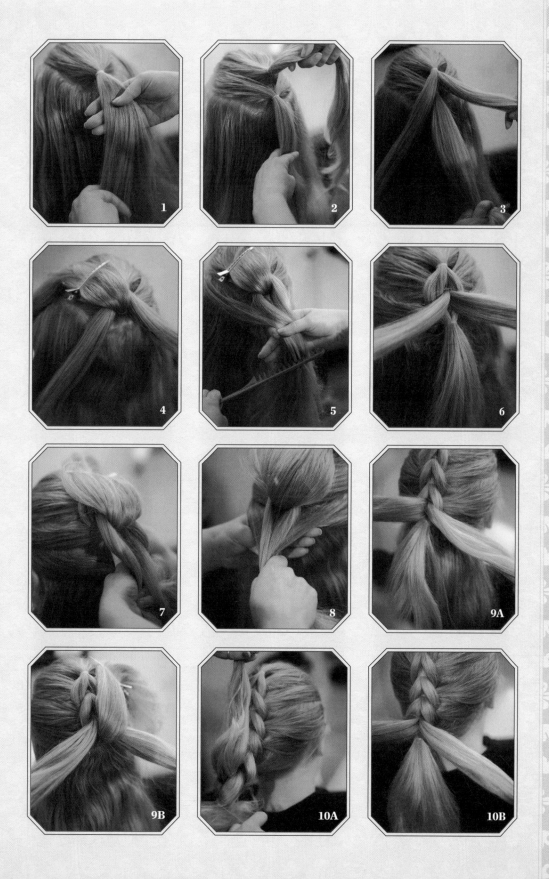

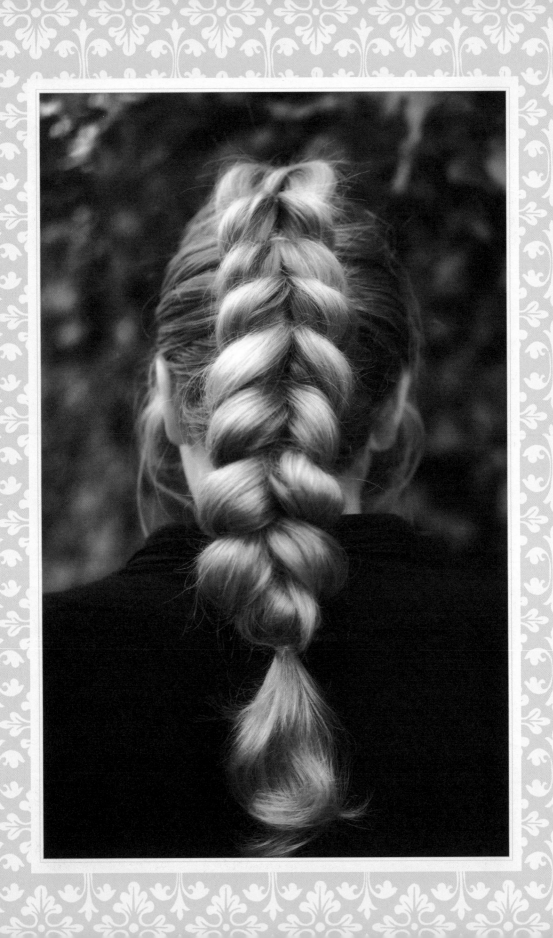

The Mane Thing: Hairstyling Ideas with Unicorn Spirit

—Nikki Verdecchia

THE ICONIC UNICORN—WITH ITS LONG, FLOWING MANE and single spiral horn—is the manifestation of elegance and grace, the stuff that legends are made of. Here are some styling tips for getting the unicorn look yourself.

* To keep hair looking shiny and healthy, use a moisturizing shampoo and a conditioner rich with natural oils. Oil-based products add extra shine to dull or dry hair, and hair masks are moisturizing, too.

* Helpful tools to have in your hairstyling kit include a comb, a rattail comb, a boar-bristle hairbrush, duckbill hair clips, hair elastics, hair bungees, bobby pins, and glittery barrettes. You'll also want to have pomade (or gel) and hair spray on hand.

* If soft drama is your thing, pull all your hair to one side and use bobby pins to secure it, hiding them with wisps of hair. This creates the look of a falling mane. You can add more dazzle by using sparkly barrettes or clips to keep your hair in place.

* Braids are a terrific way to show off your styling skills and create the appearance of a mane. Pick up a book about hair braids at your favorite bookshop or library, or check out Pinterest and online tutorials for looks to try at home or to show your stylist. See page 86 for how to create the glamorous Unicorn Tail Loop Braid shown on the opposite page.

* Adding fashion shades of hair color is a tried-and-true way to show off your unicorn spirit. Whether you want to go silver, gold, or any shade of the rainbow, the trick to getting the truest color is to decolorize your natural hair color first—something that should be done by a professional stylist. There are two methods: a decolorizing process that is immediate but harsh on the hair or a highlighting process that is gentler but requires lightening the hair over a series of appointments. Once your base color has been lightened, you can change the color yourself at home every couple of weeks with a temporary tint.

* For a high unicorn tail, pull all your hair into one ponytail at the crown of your head using a boar-bristle brush to keep the base hair smooth. Use a hair bungee instead of a hair elastic to help keep the tail tight. Apply pomade for a lustrous shine.

* Wear a unicorn headpiece to mimic the unicorn's signature horn. See page 108 for how to fashion a glamorous Jeweled Unicorn Circlet of your own.

OPPOSITE: This gorgeous Unicorn Tail Loop Braid will make you feel positively equine.

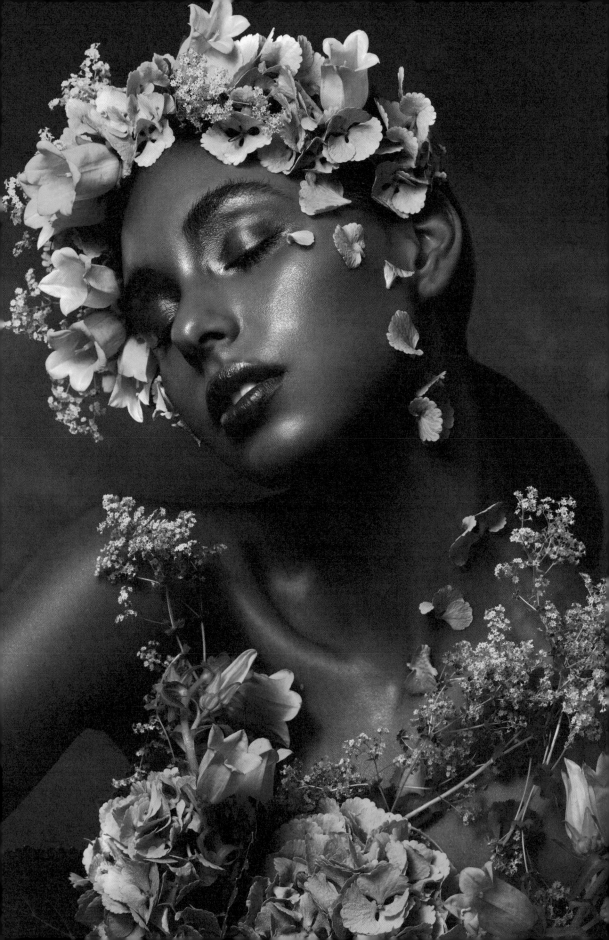

UNICORN-INSPIRED MAKEUP IDEAS

— *Nikki Verdecchia*

ANY WELL-KNOWN BEAUTY BRANDS—TARTE, Too Faced, and Lush among them—have debuted unicorn products over the last few years and quickly sold out. Nonetheless, products are readily available for those who want to get their unicorn on. Even Chanel's autumn/winter 2017 couture collection presentation at Paris Fashion Week elevated that season's look with makeup artist Tom Pecheux's unicorn eye. Pecheux opted to "paint [models'] lids with a kaleidoscope of azure, rust, gold, olive and even a bright spot of crimson right near the tear duct," as Andrea Miller described on the website Flare in July 2017.

When venturing out for unicorn accountrements, be on the lookout for unicorn shimmer body scrubs, glitter eye shadow palettes, rainbow highlighters, and products like Unicorn Tears lipstick, Tarte's unicorn-inspired Magic Wands brush set, and Unicorn Horn holographic nail polish.

For tips on technique, there are literally thousands of YouTube tutorials for glittery and colorful unicorn makeup and even more images on Instagram with helpful hashtags such as #unicornmakeup and #unicornbrushes.

No self-respecting unicorn leaves home without makeup on! Clever application of eye shadow, especially, can set you apart from the other unicorns in the crowd, whatever unicorn trend you are chasing or inventing.

THE COLORFUL UNICORN ✳

If you're a color-conscious unicorn, dramatic eye shadow is essential, either in one intense shade, like pink or purple, or within a complementary palette of different tones of the same color. For serious color impact, try applying a few different colors of eye shadow next to each other. They could have a mini-rainbow effect, an ombre look, or a subtler tone-on-tone gradient impression. Experiment by playing with eye shadow color combos on a paper towel, before applying to your eyes. The sky's the limit!

OPPOSITE: **Model Paris in shimmering, colorful makeup by Branka Vorkapic. Photograph by Bella Kotak.**

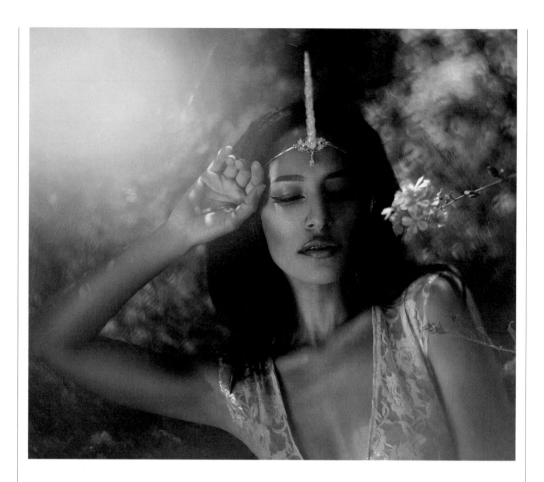

For instructions on creating a Rainbow Unicorn Eye, see page 96.

THE TRADITIONAL UNICORN ✳

As most unicorns of lore are pure white, a more traditional unicorn lover may prefer white, silver, and pale shimmery tones of shadow. Experiment with layering products to get the look you want, since these tones are light. Apply the color once and then reapply as many times as necessary until you achieve the effect you're going for.

THE DARK UNICORN ✳

For a moodier, sultrier unicorn look, working in shades of black and gray will create drama and intrigue. Try playing around with dark shimmery and opalescent tones, too.

THE OTHERWORLDLY UNICORN ✳

If an ethereal mien is your jam, choose a monochromatic color palette and use it for each area of your face: a shimmery pale blue on your cheeks, a medium blue on your lids, and a deeper blue on your lips. Add blue glitter as you see fit to make the look pop! This approach works with any other color, too.

ABOVE: Vanessa Walton of Creature of Habit in a gown of her own design and a circlet by Firefly Path. Photograph by Elizabeth Elder. + *OPPOSITE:* Model Madilynn G in a dress and the same circlet by Firefly Path. Photograph by Bella Kotak; makeup by Kristina Grohs. + *PAGES 94–95:* Models Jane Sin and Chloe Doan. Lace designs, flowers, and styling by Vanessa Walton; photograph by Elizabeth Elder.

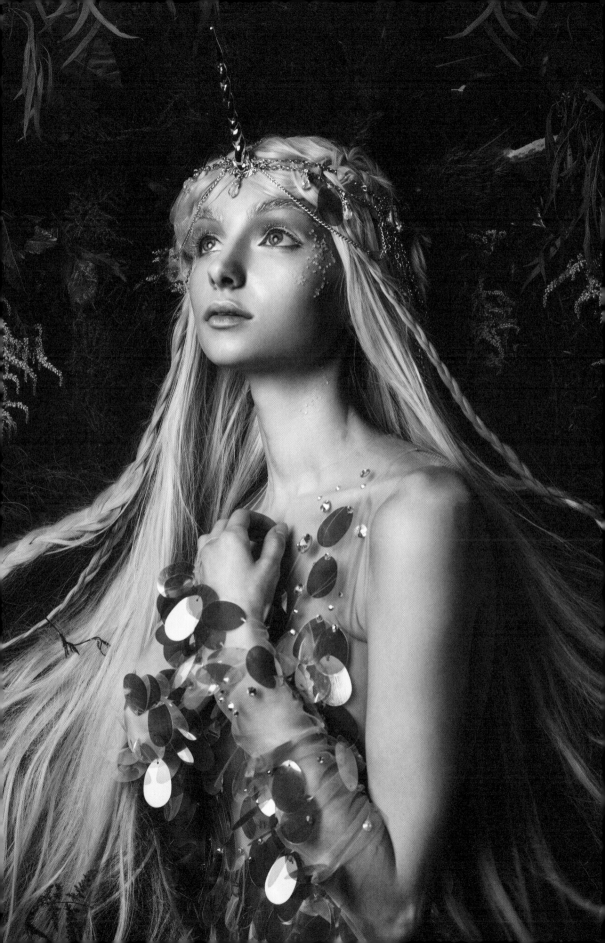

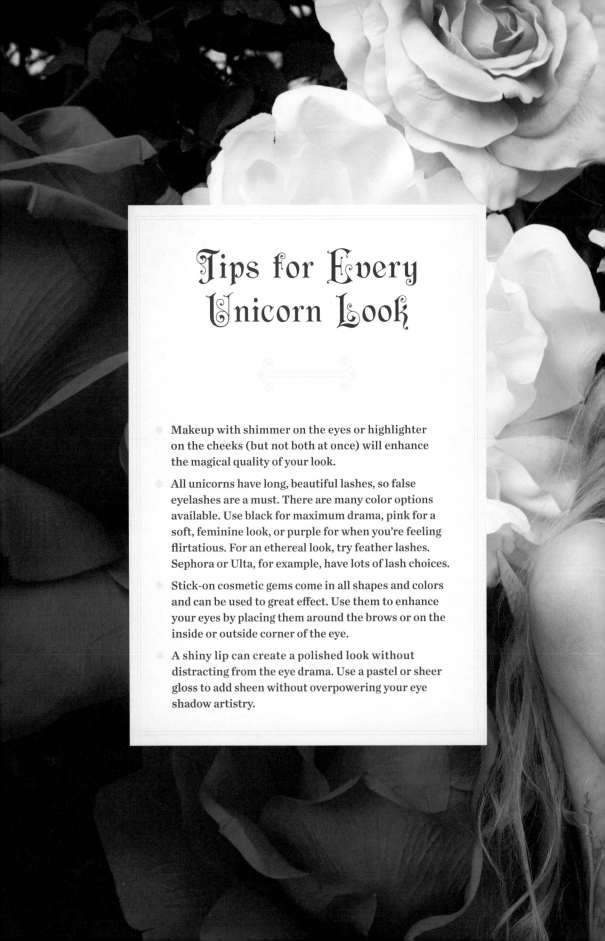

Tips for Every Unicorn Look

* Makeup with shimmer on the eyes or highlighter on the cheeks (but not both at once) will enhance the magical quality of your look.

* All unicorns have long, beautiful lashes, so false eyelashes are a must. There are many color options available. Use black for maximum drama, pink for a soft, feminine look, or purple for when you're feeling flirtatious. For an ethereal look, try feather lashes. Sephora or Ulta, for example, have lots of lash choices.

* Stick-on cosmetic gems come in all shapes and colors and can be used to great effect. Use them to enhance your eyes by placing them around the brows or on the inside or outside corner of the eye.

* A shiny lip can create a polished look without distracting from the eye drama. Use a pastel or sheer gloss to add sheen without overpowering your eye shadow artistry.

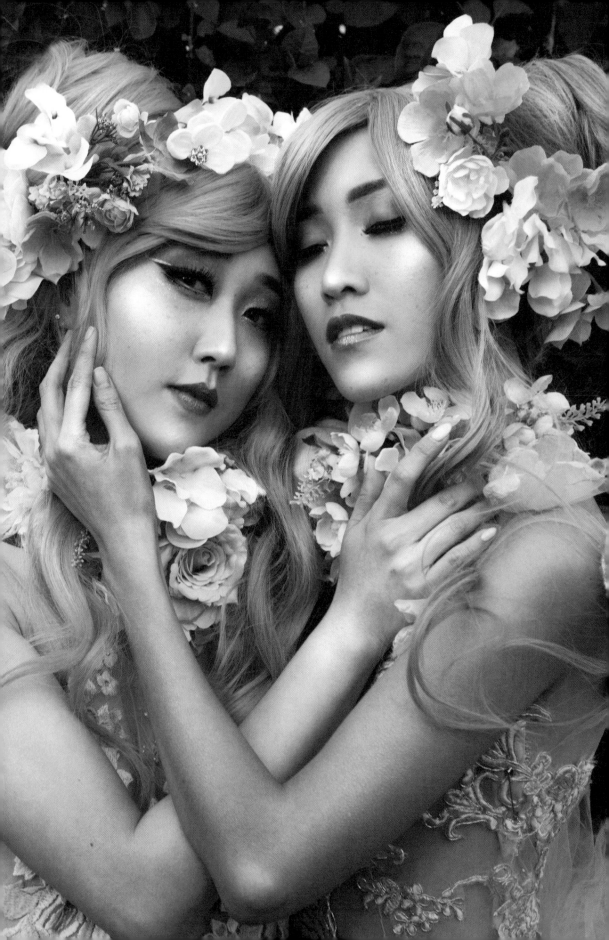

Create Two Unicorn Eye Looks

—NIKKI VERDECCHIA

YOU DON'T HAVE TO BE A MAKEUP ARTIST TO CREATE a vivid, show-stopping eye, but every unicorn huntress can learn some tips from the pros. The silvery eye takes its inspiration from the elusive white unicorn of legend, while rainbows and unicorns have long been linked.

RAINBOW UNICORN EYE

Creating a colorful rainbow eye may appear complicated, but it's easier than you think!

TOOLS AND MATERIALS

- **Medium eye shadow brush**
- **Cream-colored eye shadow**
- **Three small-tipped eye shadow brushes**
- **Bold pink eye shadow**
- **Bold blue eye shadow**
- **Taupe eye shadow**
- **Black liquid eyeliner**
- **Shimmery white eye shadow**
- **Black mascara**
- **False eyelashes**

DIRECTIONS

1. Using a medium eye shadow brush, apply cream-colored eye shadow over the entire lid and up to the brow to create an even base for the other eye shadows.

2. Using a small-tipped eye shadow brush, apply pink shadow across the entire lid.

3. Starting at the outer corner, use another small-tipped shadow brush to apply blue eye shadow up to the crease and just beyond the center of the eyelid.

4. Using another small-tipped shadow brush, apply taupe shadow in the crease of the eye to help blend the bold colors on the eyelid into the cream shadow on the brow bone.

5. Apply a thick line of liquid eyeliner on the top lash line. Create a wing in the outer corner with the same eyeliner.

6. Apply shimmery white eye shadow to the brow bone and inner and outer corners of the eye.

7. Apply black mascara to top and bottom lashes.

8. Apply black false eyelashes to the top lash lines to complete the look.

OPPOSITE: The Rainbow Unicorn Eye (left), and the Jeweled Unicorn Eye (right).

Jeweled Unicorn Eye

Sparkling looks are easy to create using metallic shadows and cosmetic glitter.

TOOLS AND MATERIALS

- **Medium eye shadow brush**
- **Shimmery white eye shadow**
- **Small-tipped eye shadow brush**
- **Metallic silver eye shadow**
- **Black liquid eyeliner**
- **Black pencil eyeliner**
- **Black mascara**
- **Black false eyelashes**
- **Water-based pomade or cosmetic glitter glue**
- **Multicolor cosmetic glitter**

DIRECTIONS

1. Beginning at the upper lash line, use a medium eye shadow brush to apply shimmery white eye shadow upward across the lid, into the crease, onto the brow bone, and on and above the brow itself.

2. Using a small-tipped eye shadow brush, apply silver shadow onto the eyelid, starting at the inner corner of the eye and extending beyond the crease to the brow bone.

3. Using black liquid eyeliner, apply a thick line across the top lash line, creating a wing that extends beyond the corner of the eye.

4. With black pencil eyeliner, create a thin line along the bottom lash line, starting at the inner corner of the eye and extending outward to meet the wing at its end point at the outer corner of the eye.

5. Repeat step 4, using the black pencil eyeliner, to line the upper water line of the eye.

6. Apply black mascara to the bottom and top lashes.

7. Apply false lashes to the top lash line.

8. With your finger, apply a small amount of a water-based pomade or glitter glue to the center of the lid. Then drag the pomade or glue diagonally across the eye to the outer corner of the brow bone and across and above the brow. Add cosmetic glitter on and above the brow for a more dramatic finished look.

Make Unicorn Dust

—Helen Nevett

THE UNICORN LOOK IS ALL ABOUT GLITTER AND SHIMMER, so take the expression of your unicorn individuality a step further: Make your own custom cosmetic glitter blend. It's quick and easy to do, and you can store your special mix in a uniquely decorated container.

TOOLS AND MATERIALS

- **Selection of cosmetic glitters**
- **Small ceramic bowl and spoon, for mixing the glitter together**
- **Small glass jar with lid, for storing glitter**
- **Small piece of white paper rolled into a simple paper funnel** (optional)
- **Vintage brooches, rhinestones, or gems** (optional)

DIRECTIONS

1. Pour the glitters into the ceramic bowl and blend together with a spoon.

2. Transfer the mixture to the jar. If the neck of the jar is narrow, make a paper cone to use as a funnel.

3. Place the lid on the container and give the glitter a shake, whispering a wish to yourself as you do.

4. If you like, you can decorate the jar with vintage brooches, rhinestones, or gems to add extra sparkle, or just keep it plain to showcase your magic dust. Make sure to keep the mixture sealed—and far away from unicorns, who will use it all!

"What do stars do? They shine."

—NEIL GAIMAN, *Stardust*, 1999

BEAUTIFYING POTIONS
to ENCHANT *a* UNICORN

—*Alise Marie*

ERTAIN MAIDENS ARE ENDOWED WITH BOTH THE wisdom of the eons and the beauty of the heavens. These ladies, blessed by starlight, have been granted the ethereal gift of communicating with mystical beasts—never in an attempt to capture them or to lure them to their demise but rather to receive the rare magic they offer. As the guardians of this magic, these lucky maidens may choose to share it with others and, if they do, will permit its use for only the purest intentions.

Three of these enchanted potions are presented on the following pages. Each of these potent concoctions contains an exceptional blend of beautifiers to impart moisture, shine, and magnetism to every inch of one's body, all of which revolve around two key ingredients: rose and avocado—a most auspicious pair, both ruled by Venus, the goddess of love. The rose has long been revered not only for its powers of love and beauty but also for its strength. It promotes happiness and heightens psychic ability while imparting superior levels of moisture and age-defying properties. The avocado is rich with vitamin E, which fights visible signs of aging by healing damaged skin tissue. It soothes inflammation, calms breakouts, and contains fats that form a protective barrier to skin and hair, locking in moisture. A final note: organic is always preferred and highly recommended, in everything!

Mineral mica powders are pure and natural, but there are sustainability issues, and cosmetic glitter is traditionally made from plastic. Eco-friendly plant-based options are now available for both.

Stars-in-Her-Mane Hair Mist

THIS HEAVENLY BLEND ADDS MOISTURE, TAMES FRIZZIES, gives a bit of texture, and imparts a subtle shine that catches the moonlight. Light, hydrating, and softly scented, rosewater is a fantastic base for potions. The vegetable glycerin acts as a humectant, drawing moisture into your tresses, while the avocado oil keeps it there. This makes an excellent light setting mist, too, for loose waves or pin curls. Adding to the allure is the gilded underlying sheen of mica, topped by glittering flecks of sparkle for an understated, bewitching glamour. Should you want more sparkle, and who doesn't, you can increase the wattage by choosing a medium cosmetic glitter instead of fine. Just be sure to store it in a bottle with a wide-enough spray nozzle to avoid clogging.

Makes about 4 ounces

TOOLS AND MATERIALS

+ 3 ounces pure organic rosewater
+ 4-ounce colored-glass spray bottle
+ ½ teaspoon vegetable glycerin
+ ½ teaspoon avocado oil
+ Small funnel
+ ½ teaspoon pearl mica powder
+ 1 teaspoon each pale rose and lilac fine cosmetic glitter

DIRECTIONS

1. Pour the rosewater into the spray bottle. Add the glycerin and avocado oil, swirling clockwise to combine.

2. Using the funnel, pour in the mica. Swirl the bottle clockwise to mix it in. Add both glitters and swirl again to fully blend.

3. Cap the bottle, swirl the potion clockwise thirteen times, and mist onto dry hair.

4. Swirl clockwise before each use to remix any contents that have settled. Store in a cool, dry place and use within thirty days.

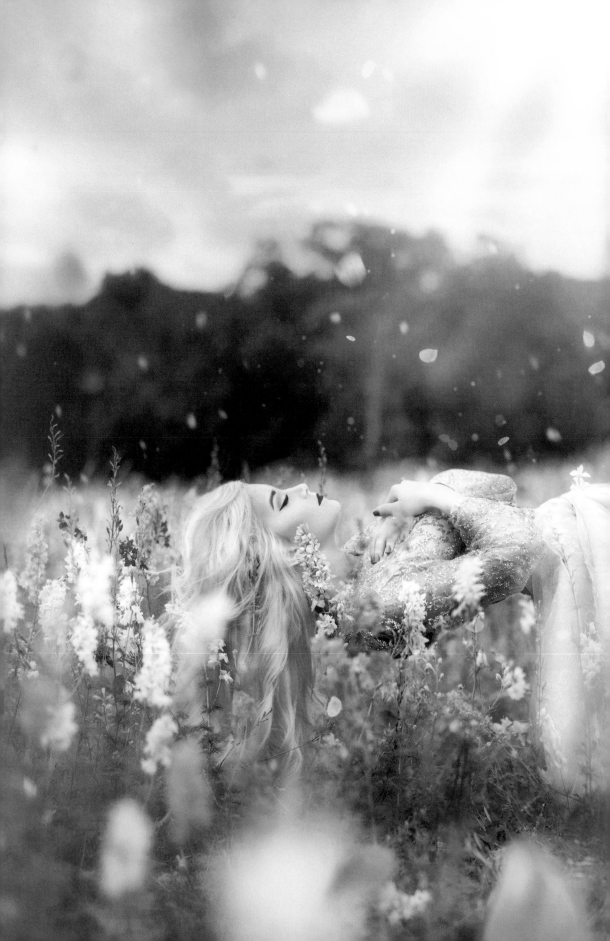

Holographic Lip Balm

THIS DELIGHTFUL LIP BALM SOFTENS, HYDRATES, AND plumps lips with rich moisture. It includes candelilla wax, a plant-based alternative to beeswax that creates a buttery, easily blended balm, and rose hip oil, which contains high levels of antioxidants from vitamins A and C.

Makes about 3 ½ ounces

TOOLS AND MATERIALS

+ **1 ounce avocado oil**
+ **1 ounce rose hip oil**
+ **Large heat-safe glass measuring cup**
+ **6-quart pot or double boiler**
+ **1 ounce candelilla wax**
+ **Wooden spoon**
+ **Pot holders**
+ **½ teaspoon each iridescent pearl and rose mica powder**
+ **Pinch of lilac mica powder** (optional)
+ **16 drops rose absolute essential oil**
+ **Small funnel** (optional)
+ **Small storage containers with lids** (glass is preferable but not necessary)

DIRECTIONS

1. Combine the avocado and rose hip oils in the measuring cup.

2. Place the measuring cup inside the pot or double boiler. Fill the pot with water until it reaches the level of the oils, no higher. This should leave the top of the cup exposed.

3. Turn on the heat to the lowest setting and then add the wax to the measuring cup. Slowly heat until the wax melts completely, stirring frequently with a wooden spoon to incorporate the wax and oils. Do not allow the mixture to come to a boil, as this can cause rancidity and diminish the balm's efficacy.

4. When the wax has fully melted and the liquid is clear, remove the pot from the heat. Using pot holders, carefully remove the measuring cup from the pot. Add the iridescent pearl and rose mica powders and, if using, the lilac mica powder. Stir until well blended.

5. Add the rose absolute oil, and stir. Using a funnel, if desired, slowly and carefully pour the hot balm into the storage containers. Allow the mix to cool fully and then cap tightly. Store in a cool, dry place and use within sixty days.

The Enchantress Body Nectar

QUENCH YOUR SKIN WITH THIS SHIMMERING POTION that moisturizes, protects, and glows with a woodsy, lightly floral fragrance. This mixture can be used on the face as a natural highlighter, and an extra dose of vitamin E gives the skin a dewy, youthful glow. Cedarwood and spruce bring in a sense of the fairy-tale forest and the magic of healing and protection. Jasmine and rose have long been associated with enhancing allure, beauty, and femininity.

Makes about 3½ ounces

TOOLS AND MATERIALS

- **2 ounces avocado oil**
- **1½ ounces sweet almond oil**
- **4-ounce glass spray bottle**
- **¼ teaspoon vitamin E**
- **Essential oils:**
 8 drops cedarwood
 20 drops jasmine
 5 drops rose absolute
 3 drops spruce
- **Small funnel**
- **1 teaspoon pearl mica powder**

DIRECTIONS

1. Pour avocado and sweet almond oils into the spray bottle. Add the vitamin E, swirling clockwise to blend.

2. Add the drops of each essential oil, swirling clockwise one oil at a time.

3. Using the funnel, add in the mica powder, and swirl clockwise to mix in.

4. Cap the bottle tightly. Spray onto the skin, massaging lightly to spread the glow all over.

5. Make sure to swirl the bottle clockwise three times before each use to mix the ingredients thoroughly. Store in a cool, dry place and use within thirty days.

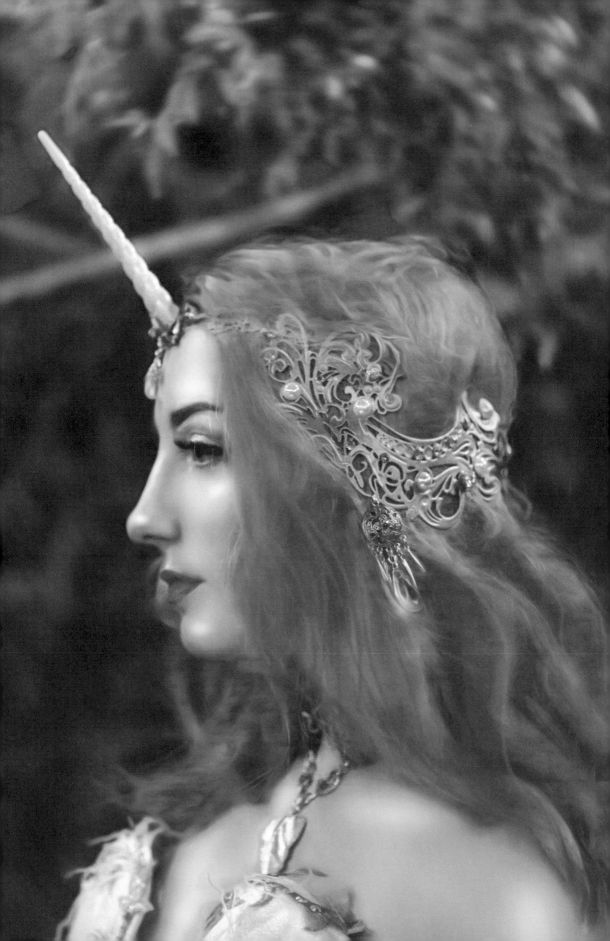

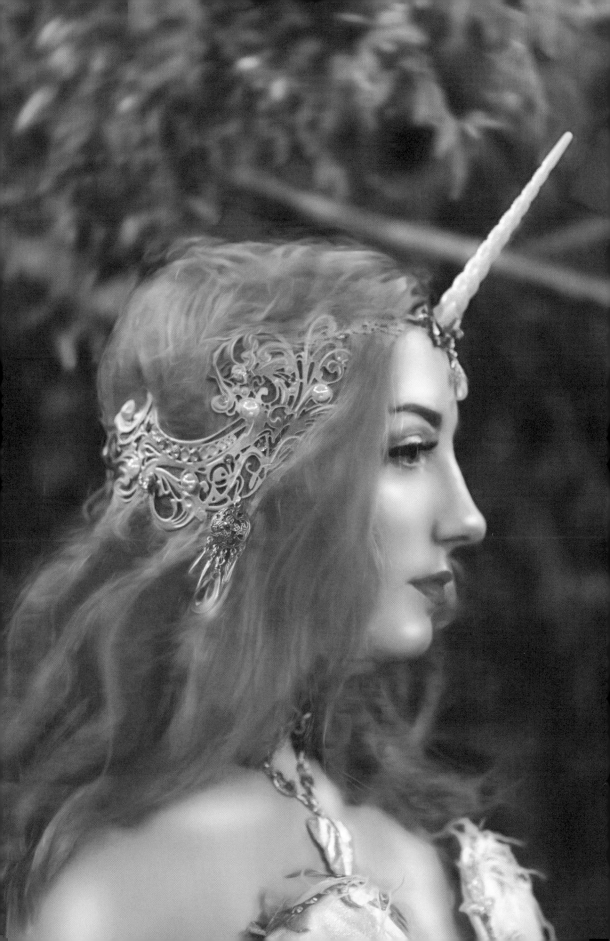

Jeweled Unicorn Circlet

—FIREFLY PATH

T HE FINISHING TOUCH TO ANY UNICORN HUNTRESS'S tattire is an enchanted headpiece, worn for both decoration and protection. Head-pieces, which can take the form of a headband, tiara, or crown, often act as a symbol of religious or political significance. Made of precious or difficult-to-find materials, an enviable and horned circlet takes on even more value.

A circlet is a circular head ornament traditionally made of precious metals and jewels or of flowers and vines. In sorcery, a circlet can be imbued by a spell or worn by one who is casting a spell. Created over two days using assorted jewelers' supplies, tools, and techniques, this unicorn headpiece can be worn either to attract the mythical creatures or to channel them in ceremony.

TOOLS AND MATERIALS

- Wire snips
- One 4- to 5-inch opalescent white plastic icicle Christmas ornament
- Jewelers' saw or power saw
- Permanent craft adhesive glue, such as E6000 clear glue

- 1 large metal filigree jewelry finding
- Hammer
- 2 small filigree bead caps
- 2 flat-back crystals
- One 10-inch flat chain
- Needle-nose pliers

- 5 jump rings
- 1 crystal droplet bead
- 1 smaller bead cap (for the crystal droplet bead)
- 1 bead rod
- One 8-inch strip of 0.7mm sewing elastic

PAGES 102–103: Photographer Savannah Kate Bridges took this magical self-portrait as she levitated among wildflowers in a bid to attract a unicorn. Results are unknown. + *PAGES 106–107:* JoEllen Elam Conway of Firefly Path models her own unicorn circlet. Photograph by Simply Savannah Art. + *OPPOSITE:* In this photograph by Brian Ziff, artist and singer Kerli wears Firefly Path's unicorn circlet.

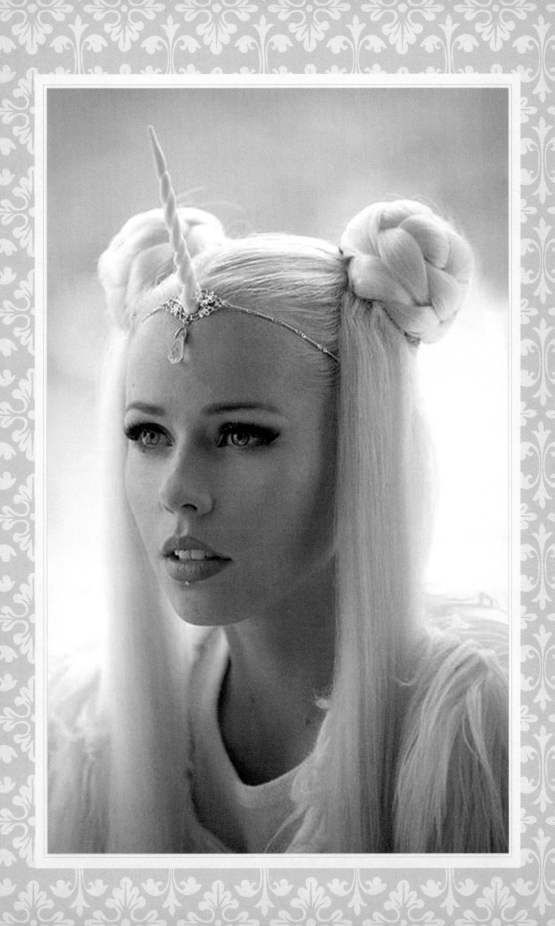

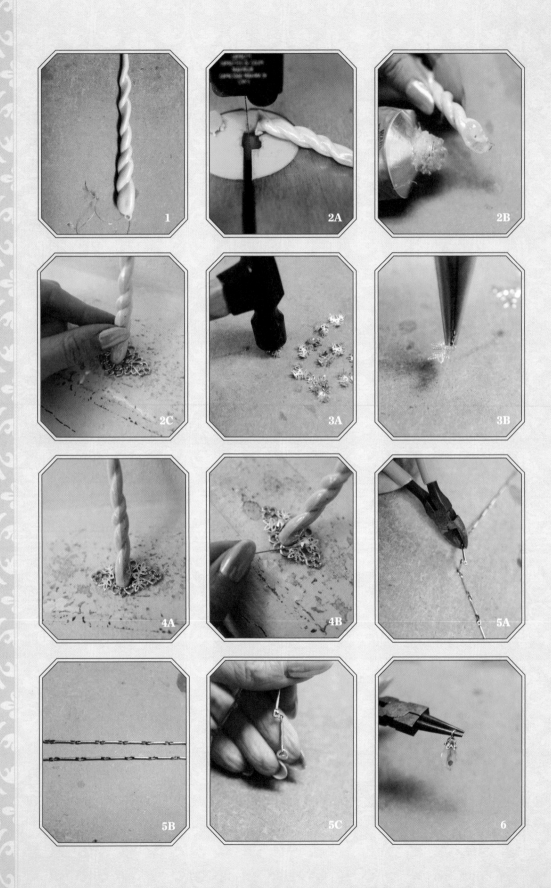

DIRECTIONS

Day 1

Prepare the ornament and set it aside, allowing it to dry overnight.

1. Snip any attachments, such as hanging cord, off the icicle.

2. Using a jewelers' saw, cut the end of the icicle at an angle to create the horn base (2A). Place a small dollop of glue on the bottom of the horn (the cut side) (2B) and glue the horn to the center of the large filigree finding (2C).

3. Use a hammer to flatten the small filigree bead caps (3A). Fold one side of both the bead caps to a 90-degree angle (3B). Glue the bead caps to each side of the horn.

4. Glue the flat-back crystals to the center of the bead caps on each side (4A and 4B). Allow the glue to set for twenty-four hours at room temperature in a dry spot.

Day 2

Finish your masterpiece.

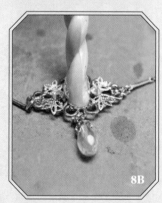

5. Cut the chain into two 5-inch pieces (5A and 5B). Using needle-nose pliers, attach one jump ring to the end of each chain (5C).

6. Thread the crystal droplet bead and the smaller bead cap through the bead rod, creating a loop at the top.

7. Attach the chains to each side of the jewelry finding with jump rings.

8. Attach the droplet bead with a jump ring to the bottom of the large filigree (8A and 8B).

9. Tie the elastic to one end of the chain.

10. Thread the end of the elastic through the end of the other chain. Place the headpiece at the center of your forehead and tighten the elastic to comfortably but securely fit your head size. Tie a knot and trim any extra elastic.

Unicorn Collar and Cuffs

—VANESSA WALTON OF CREATURE OF HABIT

THESE LACY WHITE CUFFS AND COLLAR EMBODY THE whimsy and diaphanous nature of the unicorn. Fluttering feathers, like a unicorn mane, cascade from a structured ornate lace. If you look closely, you can see a subtle swirling of colors, soft and gentle. Use your imagination and intuition to guide you in creating these lovely pieces and don them whenever you wish to feel the wise and ethereal magic that unicorns embody.

TOOLS AND MATERIALS

- 1 yard 4-inch-wide soft white lace trim

- Scissors

- Straight pins

- Sewing needle and thread, either in coordinating colors or clear

- 4 yards ⅜-inch-wide white silk or satin ribbon

- Liquid seam sealant, such as Fray Check

- Fabric dye, such as Rit, in colors of your choice (optional)

- ½ yard white feather trim

- Hot-glue gun and glue sticks

- Permanent jewelry adhesive, such as Gem-Tac glue (optional)

- 3 to 4 dozen rhinestones in various sizes, from 8mm to 11mm

- One small bag of 6mm iridescent bugle beads

NOTE: Choose lace that has some body to it and a scalloped edge, such as Venetian lace.

DIRECTIONS

1. Measure the lace trim by wrapping it around your wrist and neck to see what length of trim you will need for the circumference of the cuffs and collar. Add an extra ½ inch at both ends for seam allowance. This extra overall inch allows for greater adjustability and results in a more substantial piece at the back for sewing on the ribbon. Cut lace for two cuffs and one collar. (**Note:** The flat side of the lace edging will be on the top, toward the arm, and the scalloped side will lay on the hands.)

2. Fold the raw edges of the lace ¼ inch toward the inner side of the lace and repeat a second time so that the raw sides are completely encased. Pin with straight pins, as shown. Wrap the lace around your wrists and neck to test the placement and seam allowance—make sure it leaves a small gap at the back of your wrist where the pinned ends meet.

3. Sew the folded lace edges firmly in place.

4. Cut lengths of ribbon for the cuffs and collar. For the cuffs, cut four 21-inch lengths of ribbon—two for each cuff. For the collar, cut two 18-inch lengths of ribbon.

5. Pin the ribbons to the ends of the cuffs and collar, checking their placement: the ribbon and cuff (and collar) edges should line up when they meet in the back (5A and 5B). Sew them in place and remove the pins.

6. Finish the ends of the ribbon by cutting them to a point. Use liquid seam sealant to seal the ends.

OPPOSITE: Vanessa Walton models her own design in this photograph by Elizabeth Elder.

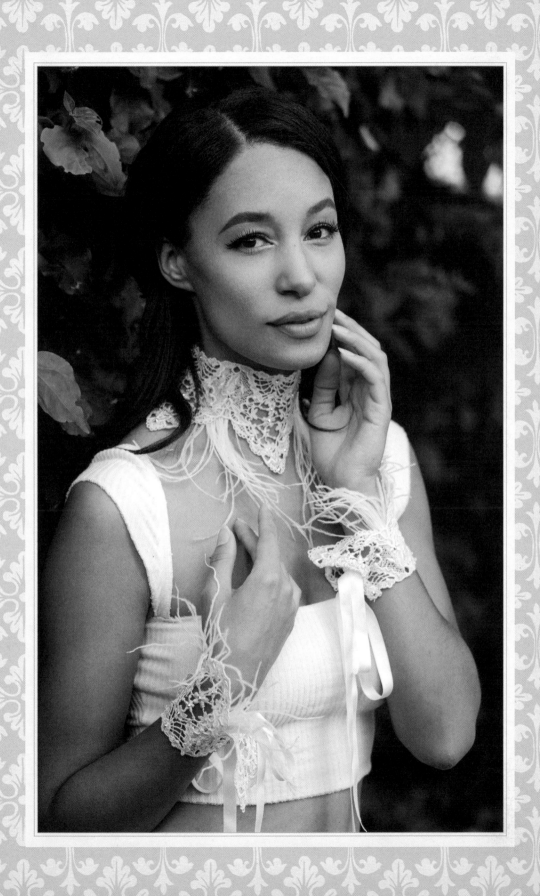

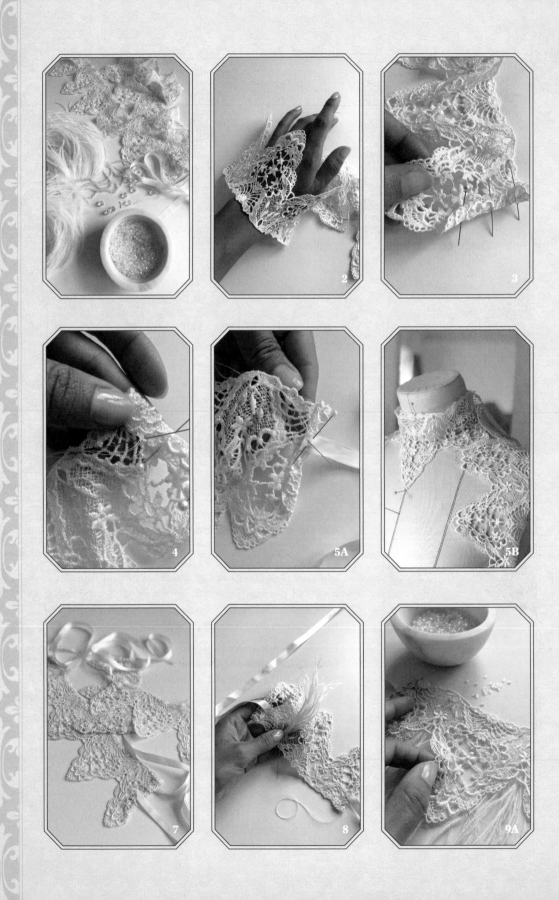

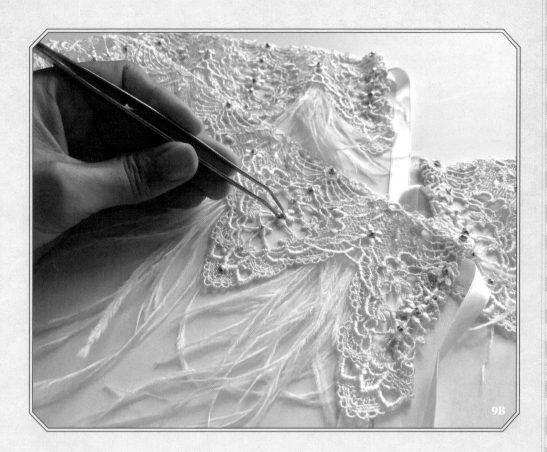

9B

7. If you want to add a little bit of color to the lace to give it a dreamy pastel rainbow glow, you can create three small dye baths, adding a little splash of dye to a full jar of hot water (any size vessel is fine). First, wet the lace and dip small portions of it into the dye for a few moments to pick up very faint color. Because the lace will be wet before you dip it into the dye, the color will spread easily—almost like a watercolor wash. The Rit dye colors used here are petal pink, teal, and purple.

8. For the unicorn mane, sew small portions of the feather trim between the pointed edges of the collar and cuffs on the inner side. Secure the sewing and any loose feathers with small dabs of hot glue.

9. Use jewelry adhesive, as shown, to embellish the cuffs and collar with rhinestones; then sew on bugle beads (9A and 9B).

Lace up your collar and cuffs and head for the nearest magical forest to bask in the sunlight.

FOREST BATHING

— Rona Berg

 NICORNS EMBRACE THE MAGIC OF THE FOREST, living as they do among wild mushrooms and toadstools, on mulchy ground carpeted with spongy moss, near sparkling waterfalls and fresh mountain springs. Their ghostly silhouettes can be seen—albeit rarely—ambling amid patches of lacy ferns or wild orchids (the almost unfathomably deep pink lady's slipper is a favorite) or gently brushing by a thicket of bright, pungent wild ginger.

In recent years, perhaps we humans haven't quite appreciated that magic, or we wouldn't abuse nature the way we do. But that may be starting to change, as "forest bathing," or "bathing in nature"—which has nothing to do with water and everything to do with a cleansing of another sort—has become increasingly popular. Forest bathing is a slow, serene, and thoughtful walk in the woods to connect with nature and refresh the mind and spirit. And now, there are documented physical benefits, too.

Forest bathing officially began in Japan, where the term *shinrin-yoku* translates to "forest bathing" or "taking in the forest atmosphere." It was coined by the Japanese Ministry of Agriculture, Forestry, and Fisheries in 1982 and integrated into the Japanese National Public Health Program to help improve public health by encouraging leisurely strolls through the forest. Doing so was believed to offer great physiological benefits. Since then, Japanese officials have spent millions studying the effects of nature on human health and happiness.

From 2005 to 2006, for example, Japanese researchers conducted field experiments in twenty-four forests across the country. The first day, six subjects were sent to walk in a forest, and the rest walked in the city. On the second day, they switched. The researchers measured cortisol (the "stress" hormone), heart rate, blood pressure, and pulse of each person before and after each walk. Not surprisingly, results showed that compared to the city walk, a walk in the woods lowered pulse rates, blood pressure, parasympathetic nerve activity, and cortisol. The presence of phytoncides (antimicrobial oils emitted by trees and plants) appear to bolster the human immune system. Today, there's a whole field of research dedicated to "forest medicine" as a means of preventive treatment and healing. And it's now catching on in other parts of the world.

Forest bathing is not hiking, it is not a workout, it is not striding purposefully toward a two-, four-, or eight-mile marker. It is about being mindful, in the moment: feeling the roughness

Opposite and page 118: **Bella Kotak captured model Scarlett forest bathing in the Swedish wood.**

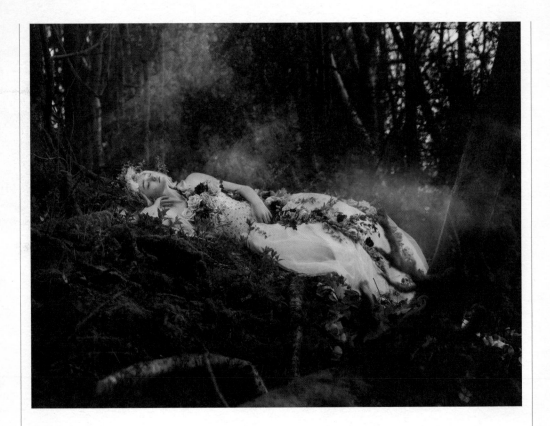

of bark and snapping twigs, inhaling the forest smells, heightening awareness of your surroundings, appreciating nature, and absorbing the peace that can be found there. It is cleansing in a metaphysical way, which offers tangible physical benefits and creates the sense that new beginnings are possible, as every bit of new growth in the forest makes you feel reborn or at least evokes the feeling that you can begin again where you are.

At a recent talk, environmentalist Paul Hawken said: "Ralph Waldo Emerson once asked what we would do if the stars only came out once every thousand years. No one would sleep that night, of course. The world would become religious overnight. We would be ecstatic, delirious, made rapturous by the glory of God. Instead the stars come out every night, and we watch television." Now, perhaps more than ever, we need to slow down and reflect on the interconnectedness between ourselves and others and of the living things in our world. In *The Hidden Life of Trees*,

German forester and ecologist Peter Wohlleben talks about how trees are ecosystems, communities, maybe even families. They can communicate by sending electrical impulses to one another—which can be very slow, especially when the trees are hundreds of years old. Trees can taste the saliva of leaf-eating insects and respond by sending out a self-protective chemical signal that attracts predators to feed on that type of insect. According to Wohlleben, trees even experience something similar to emotions.

"When one tugs at a single thing in nature, one finds it attached to the rest of the world," the great naturalist and Sierra Club founder John Muir said in his 1912 book *The Yosemite*. We are part of the weave of nature, and we forget that sometimes. But a walk in the woods—forest bathing—brings us back. In order to slow ourselves down, be well, and sustain what we have, we need to take care of nature, and she will care for us in return.

Guided Meditation

A GUIDED MEDITATION CAN CALM THE body, relax the mind, and create a sense of stillness and peace, whether you meditate at home or in a soft, mossy, unicorn-approved spot in an outdoor wooded area.

1. Wearing loose-fitting, comfortable clothing, sit cross-legged on a soft patch of earth or a cushion. If you have a *zafu* (meditation cushion), use that. Shake out any tension in your hands, look around, and take in your surroundings.

2. Rest your hands, palms up, on your knees, and take several deep breaths—in through the nose and out through the mouth. Close your eyes and focus on your other senses: feel the sun on your face, listen to the sounds of leaves and wind, smell the fresh and verdant scents of the trees, shrubs, and flowers. As you breathe out, notice the sensations in your body.

3. Loosen your shoulders, gently rolling them back.

4. Become aware of your breath and draw your thoughts inward, focusing on the breath and quieting the mind. Let any intrusive thoughts drift away. Keep returning your focus to your breath. Notice any tension in your body and relax that area and breathe.

5. Slowly open your eyes and become aware of your surroundings again.

6. Start by meditating for five minutes at a time, and work up to twenty minutes or whatever feels good to you. Make this into a daily practice and you will reap many benefits, including increased calm and intuitive powers.

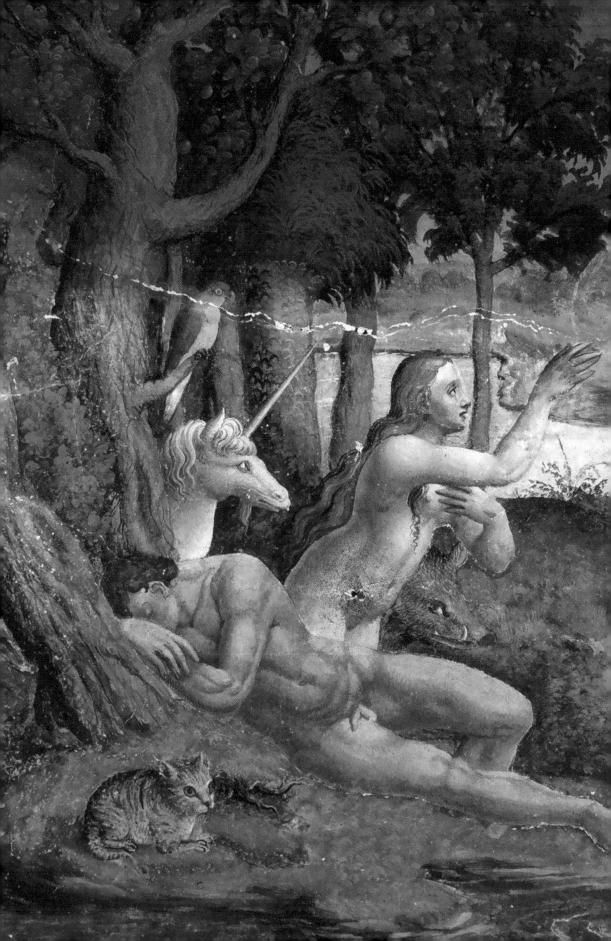

III. Arts & Culture

UNICORNS *in* ANTIQUITY

RISTOTLE (384–322 BCE), KNOWN AS THE FATHER of Western philosophy and still regarded as one of the greatest thinkers in Western history, approached all the subjects on which he was expert—and there were a great many—through systematic scientific examination. In addition to his work in ethics, politics, and metaphysics, Aristotle was considered a master on many other subjects, including biology, botany, and medicine. In 350 BCE, he wrote *Historia animalium* (The History of Animals), a ten-volume treatise, which was his largest work. In book 2, part 1, he categorized animals by their various internal organs and external parts. "Furthermore, of animals some are horned, and some are not so. The great majority of the horned animals are cloven-footed, as the ox, the stag, the goat; and a solid-hooved animal with a pair of horns has never yet been met with. But a few animals are known to be singled-horned and single-hooved, as the Indian ass; and one, to wit the oryx, is single-horned and cloven-hooved."

Aristotle's understanding of the animal came from Ctesias (born in 400 BCE), a Greek doctor, who, after spending seventeen years in the Persian court attending to King Darius II, returned home to Greece. There he compiled everything he had learned about India during those years—from Persians, Indian merchants, and envoys to the Persian court—into a book he called *Indica* (On India). It was an encyclopedia of sorts—a compendium of information about the people, geography, animals, and natural history of India. By "India," historians believe Ctesias meant the Tibetan Plateau, which for centuries has been known to be the homeland of the unicorn (see "Chiru (Tibet)," page 163).

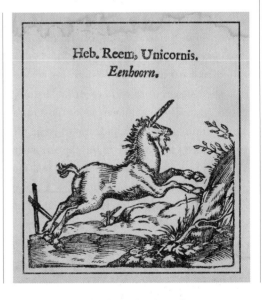

Heb. Reem, Unicornis. Eenhoorn.

In said tome, Ctesias wrote a very detailed account of the unicorn. It began:

> In India there are wild asses as large as horses, or even larger. Their body is white, their head dark red, their eyes bluish, and they have a horn in their forehead about a cubit in length. The lower part of the horn, for about two palms distance from the forehead, is quite white, the middle is black, the upper part, which terminates in a point, is a very flaming red. Those who drink out of cups made from it are proof against convulsions, epilepsy, and even poison, provided that before or after having taken it they drink some wine or water or other liquid out of these cups. . . . These animals are very strong and swift; neither the horse nor any other animal can overtake them.

There is no doubt Aristotle was familiar with the work—he directly quotes *Indica* several times in *Historia animalium*. While he didn't describe the single horn as having any special powers, he did assert that the one-horned animal Ctesias called the "Indian ass" did exist.

There was little information available about the far-flung parts of the world, and whatever there was became quite influential. These accounts by Ctesias and Aristotle were widely read by later scholars. Pliny the Elder (23–79 CE), a Roman naturalist, compiled an encyclopedia called *Naturalis historia* (Natural History), describing everything known about the natural world—animals, plants, and minerals—in his time. Book 8, chapter 31, is about the terrestrial animals of India. In it, he mentioned a beast he called a *monoceros* (Greek for "one horn"), "a very fierce animal . . . which has the head of the stag, the feet of the elephant, and the tail of the boar,

while the rest of the body is like that of the horse; it makes a deep lowing noise, and has a single black horn, which projects from the middle of its forehead, two cubits in length. This animal, it is said, cannot be taken alive." Lest one thinks he was talking about a rhinoceros, Pliny mentions that animal in a different chapter.

Roman scholar Claudius Aelianus (ca. 175–235 CE), in *De natura animalium* (On the Nature of Animals), described an animal quite like the one Ctesias mentioned:

> I have found that wild asses as large as horses are to be found in India. The body of this animal is white, except on the head, which is red, while the eyes are azure. It has a horn on the brow, about one cubit and a half in length, which is white at the base, crimson at the top, and black between. These variegated horns are used as drinking cups by the Indians. . . . It is said that whosoever drinks from this kind of horn is safe from all incurable diseases such as convulsions and the so-called holy disease, and that he cannot be killed by poison.

Travel was so difficult and dangerous in the ancient world that these naturalists learned from one another, and so the descriptions of the one-horned Indian ass were passed down unquestioned from Ctesias to Aristotle to Pliny to Claudius Aelianus and other scholars. Their works were regarded as encyclopedias—collections of true knowledge about the world. As Latin became the common language of scholars throughout the Western world, the Greek name that Pliny gave this animal, *monoceros,* was translated into the Latin *unicornis.* In Middle English, this word became "unicorn." For those who spoke Middle English, it was the name of an animal they knew to be real—they knew because great scholars like Aristotle had described it.

PAGES 120–121: Artist unknown, *Creation of Eve*, sixteenth century. + OPPOSITE: A unicorn from *Handelene van de Natuere*, a 1644 Dutch translation (translator and artist unknown) of Pliny the Elder's *Natural History*, c. 79. + PAGES 124–125: Hieronymus Bosch, *The Garden of Earthly Delights* (detail), 1490–1500.

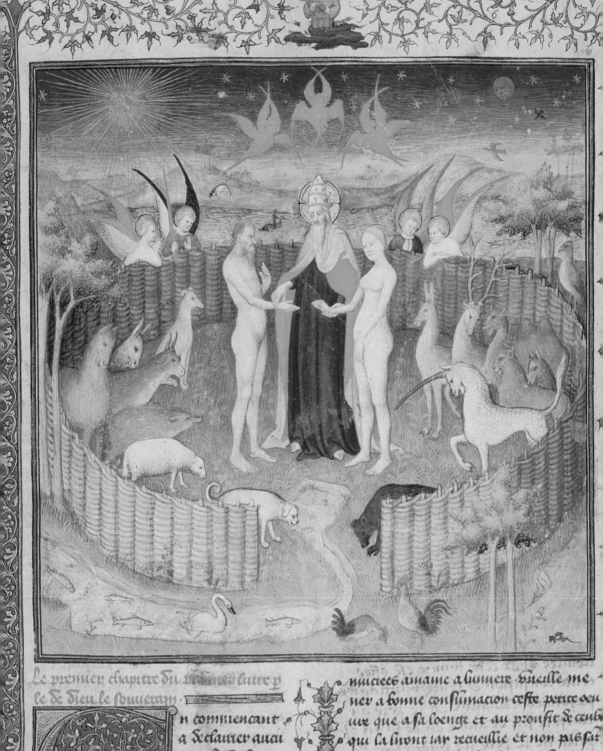

Le premier chapitre du tiers liutre p
le de dieu le souuerain ·

n commencant
a declairer auci
nes choses des pro
prietez et des na
tures des choses
tant espirituelles
comme corporelles
Nous prendons
tre commencement a cestui qui est co

nuteces aiment a lumiere vueille me
ner a bonne consumacion ceste petite oeu
ure que a sa loenge et au prouffit de ceulx
qui la liront par recueillie et non pas sa
labour de diuers dit des sains et des pro
phetes Le ij· chapitre parle de lumiere de
la diuine essence et de la pluralite des

l est donc persones
si comme dit innocent vn seul vray
dieu perdurable sanz mesure no
nuable tout puissant le pere le filz et

UNICORNS *and the* BIBLE

N THE MIDDLE AGES, THERE WAS ONE BOOK THAT was considered to contain the irrefutable truth: the Bible. Unicorns were in the Bible. In fact, unicorns are mentioned nine times in the 1611 King James version—twice in Numbers, once in Deuteronomy, once in Job, three times in Psalms, and once in Isaiah. Unicorns are not mentioned in any of the modern translations of the Bible, which instead refer to the animal as a wild ox or a buffalo.

To understand how the word for unicorn evolved to oxen, we have to go back to the classical Hebrew, where this animal is called *re'em* (רְאֵם), a real animal. In *Asimov's Guide to the Bible* (1968), Isaac Asimov writes:

> The Hebrew word represented in the King James Version by 'unicorn' is re'em, which undoubtedly refers to the wild ox (a urus or an aurochs) which is ancestral to the domesticated cattle of today. Re'em still flourished in early historical times and a few existed into modern times, although it is now extinct. It was a dangerous creature of great strength and was similar in form and temperament to Asian water buffaloes.

The translators of the King James Bible were not sure what a *re'em* was either, so they looked for clues in the Greek and Latin translations. A group of Jewish scholars in Alexandria known as the Seventy made the first Greek translation of the Bible from the Hebrew in the third century BCE. Asimov explains that when this Greek translation of the Bible was prepared, "[the *re'em*] was already rare in the long-settled areas of the Near East and the Greeks, who had had no direct experience with it, had no word for it."

The translators left no record of their discussion on the subject, but we do know that they translated the Hebrew word *re'em* into Greek as *monoceros*, or "one horned." In *The Lore of the Unicorn*, Odell Shepard writes:

> They did not know what animal the Hebrew seers and poets had in mind when speaking of the Re'em, but they found that it was characterized as fleet, fierce, indomitable, and especially distinguished by the armour of its brow. Dim recollections were awakened by these traits, and so the Seventy called the one unknown animal by the name of another. Even from our point of vantage it seems doubtful whether they could have found a closer equivalent for a beast which had been mysterious and awful to the Hebrews than this monoceros or unicorn which was to themselves still strange, remote, and conjectural.

OPPOSITE: *The Marriage of Adam and Eve* from *De proprietatibus rerum* (*On the Properties of Things*) written by Bartholomaeus Anglicus (c. 1240) and translated into French by Jean Corbechon (c. 1415).

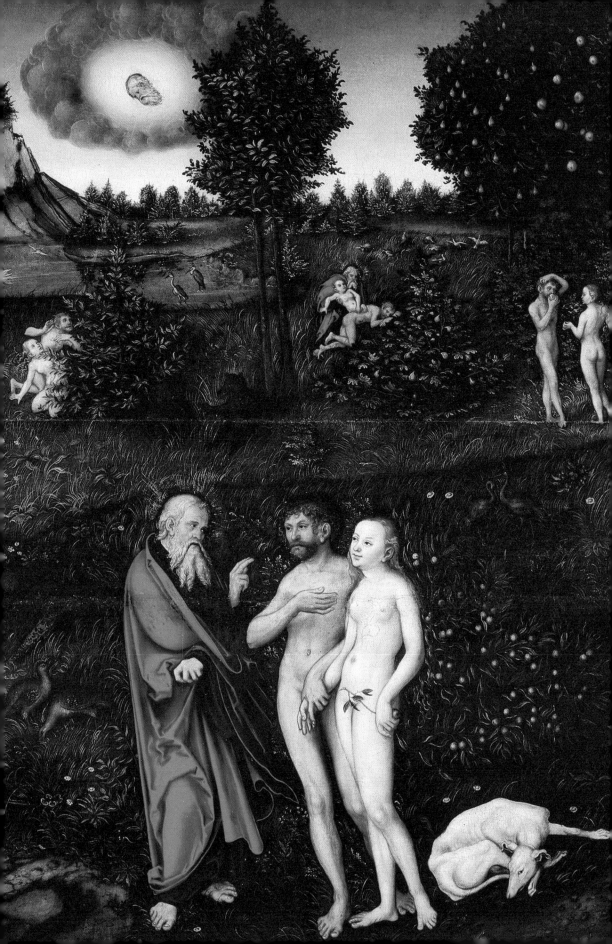

In the fourth century CE, Saint Jerome translated the Greek version of the Bible into Latin; it is this version that became the official Bible of the Catholic Church. In it *monoceros* became the Latin *unicornis*, or "single horn."

When the translators of the King James Bible got stuck on the word *re'em* in the original Hebrew Bible, they checked the Greek, which said *monoceros*, and the Latin, which said *unicornis*. This word was already in the English language (see "Unicorns in Antiquity," page 122), translated as "unicorn."

Unicorns are not mentioned specifically in the New Testament, but they came to be a potent symbol of both Jesus Christ and the Virgin Mary. Many aspects of the unicorn's natural history were regarded as allegories of Christ's life. Just as the unicorn can be tamed only by a virgin, Christ was born to the Virgin Mary. In fact, the story of Christ's life has been told allegorically through a unicorn hunt. In the Annunciation, for example, when the archangel Gabriel tells Mary that she will give birth to the son of God, Gabriel is often painted as a hunter, sounding his horn to point to his prey, while the mythic unicorn lies innocently in Mary's lap. Likewise, the part of the story in which the unicorn dips his horn into a pool of water to purify came to be seen as an image of Christ entering into the world to expunge the sins of humans just as the pursuit and slaughter of the unicorn can be interpreted as humans' rejection of Christ and his violent death. These parallels became so powerful that the fourth-century theologian Bishop Ambrose of Milan famously wrote, "Who then is this unicorn but the only begotten Son of God?" And Saint Basil, one of the great fourth-century fathers of the Eastern Church, said, "[Christ] will be called the Son of unicorns, for as we have learned in Job, the unicorn is irresistible in might and unsubjected to man."

LEFT: Lucas Cranach the Elder, *Paradise* (detail), 1530.

Unicorns on Noah's Ark

NUMEROUS PAINTINGS EXIST OF UNICORNS boarding Noah's ark, including this one—*The Ark*, painted by Lodewijk Tieling in Amsterdam in 1700 and now hanging in the Metropolitan Museum of Art. And more than a few of the biblical references to unicorns occur after the flood, suggesting that the unicorn did indeed survive it (See "Unicorns and the Bible," page 127). How else could they be alive today? Still, the topic is controversial.

Conrad Gesner's *Historia animalium* (History of the Animals) from 1551 described the unicorn but, as Odell Shepard tells us, it "was a mere compendium of what had been previously written on the subject and gave little evidence of original thinking" and further suggested "that the unicorn may have been destroyed in Noah's flood." According to Shepard, the book "exerted an influence quite out of proportion to its merits." He explained that in the sixteenth century Gesner also suggested that some "'bones' recently discovered in Germany were the horns of unicorns washed together there during Noah's Flood." This opinion was often ridiculed, Shepard says, but it gained many adherents and had a lasting effect. Indeed, some modern tales, like the one told in the classic song "The Unicorn," written by Shel Silverstein in 1962 and popularized by the Irish Rovers in 1968, explain that unicorns missed their ride on the ark due to playing "silly games"—and this is why unicorns disappeared from the world.

In *Jewish Fairy Tales and Legends* (1919), Gertrude Landa tells the story of how Noah pondered how to bring unicorns onto the ark and how the giant Og found a giant unicorn, "as big as a mountain"; Noah tied a rope around its horn so the unicorn could swim alongside the ark during the flood.

In 2016, evangelical Christian Ken Ham said he received a revelation that mythical creatures were on board Noah's ark. "God came to me in a dream and showed me a vision of Noah's ark," he said in a radio interview on WEHW in Franklin, Tennessee. "In the vision, I saw Noah tending to unicorns and chupacabras in cages." Ham was instrumental in building the creationist theme park Ark Encounter, which opened in 2016 in Grant County, Kentucky, and contains a life-size replica of Noah's ark complete with models of animals that might have been on the ark. Sadly, there are no unicorns.

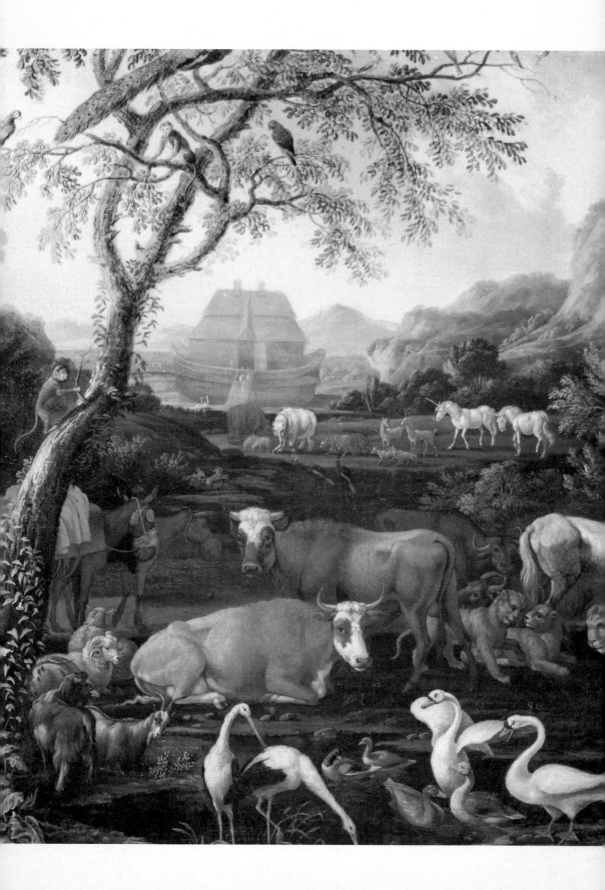

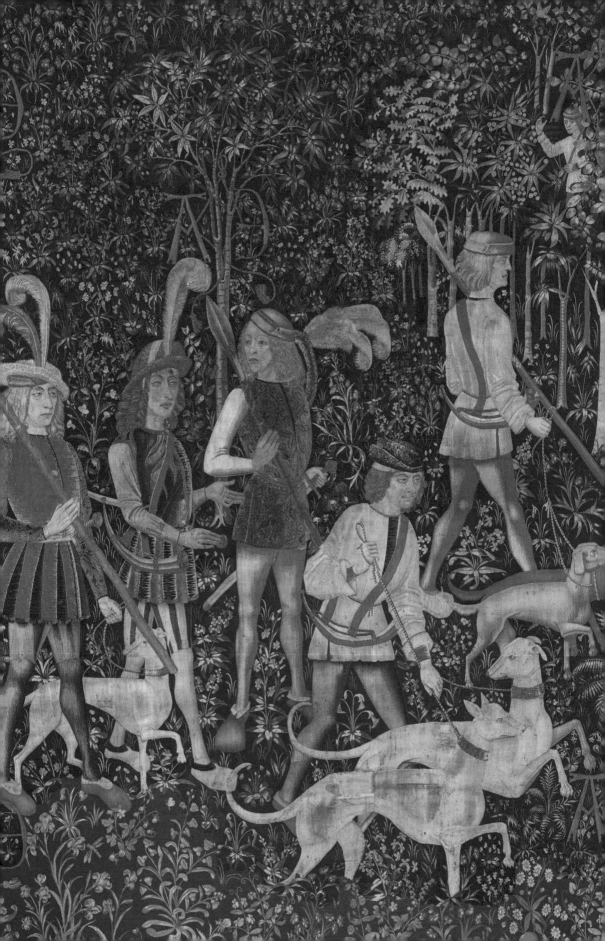

The UNICORN TAPESTRIES

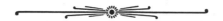

HE DAZZLING UNICORN STARS IN TWO ultrapopular narratives that appear again and again across medieval Europe. In the first, a serpent poisons a well or stream so that none of the animals can drink, but when the unicorn dips his horn into the water, the poison is neutralized and drinking the water is safe again.

In the second, a group of hunters pursue a unicorn but are unable to catch him, so they enlist the help of a beautiful young maiden. The unicorn finds her sitting under a tree in the forest and is so enchanted that he becomes docile and lays his head in her lap. Sadly, it's a trap. The hunters and their dogs seize the unicorn. In some versions of the tale, they kill him; in others, they keep him tied up and tame him, while the maiden wrestles with conflicting feelings about her part in the hunt.

Many have associated the first story with the coming of Christ to absolve humankind from its sins; the second story's significance is more dual in nature. It's often aligned with Christ dying for our sins as well as the domestication of the single man. These two stories were represented in both sacred and secular ways in art and poetry throughout the Middle Ages and into the Renaissance. Both are also part of a sumptuous set of seven tapestries made around 1500. Today, they are collectively known as the Unicorn Tapestries, the most famous work of art in the world featuring our favorite creature.

According to Margaret Freeman, who not only developed the gardens at the Cloisters (see "The Unicorn Garden," page 18), but wrote the definitive book on the tapestries in 1976, aptly titled *The Unicorn Tapestries*, "the seven tapestries at the Cloisters represent the most completely realized hunt of the unicorn that the Middle Ages produced." A thorough understanding of all the layers of meaning in them might forever elude us, but that certainly hasn't stopped endless speculation over the years, from her and others.

READING THE TAPESTRIES *

The overall concept of the unicorn hunt had both religious and secular significance. The hunt was a symbol of Christ's incarnation through the Virgin Mary, his pursuit by nonbelievers, his martyrdom, and his resurrection. But the tapestries are also an allegory of courtship and marriage. Depicting hundreds of plants, animals, and people, they present an elaborate story through symbolic imagery.

The first tapestry, *The Hunters Enter the Woods*, shows a young lord and his two companions resplendently dressed (overdressed, actually, for a hunt), about to begin their search for a unicorn. They are joined by a page as well as hound keepers and their dogs. There is also a signaler with a trumpet hidden in the woods,

OPPOSITE: The Hunters Enter the Woods, c. 1500.

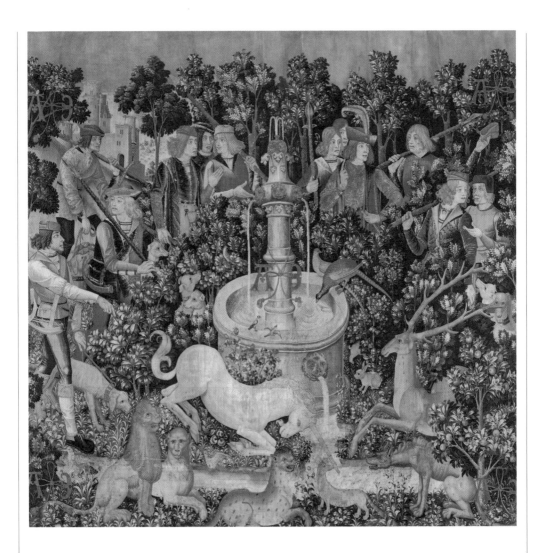

just under the mysterious insignia "AE," which appears five times in the first tapestry and repeatedly in the six others.

Sweet violets can be seen behind the hunters. These flowers were said to grow in the Garden of Eden and are associated with humility and with the Virgin Mary. Near the trumpeter are walnut fronds, symbols of both Christ and fruitfulness. Near the young lord is a cherry tree, sometimes also associated with the Virgin Mary and the baby Jesus. The cherry also has erotic overtones and is often placed in scenes of revelry. The flora let us know that this is a tale that can be read two ways: as an allegory of love or of the life of Jesus Christ.

The second tapestry is *The Unicorn Is Found*. A large group of hunters surround the unicorn in a clearing near a castle, where a fountain flows into a small stream and a group of animals waits patiently. The unicorn dips his horn in the water to purify it, while the leopard, stag, hyena, lion, and other animals look on.

At the base of the fountain on the right is a rabbit, a symbol of fertility, as are the goldfinches—an adult and a fledgling—on the rim of the fountain. They eat thorns and thistles, which

Aʙᴏᴠᴇ: The Unicorn Is Found, c. 1500.

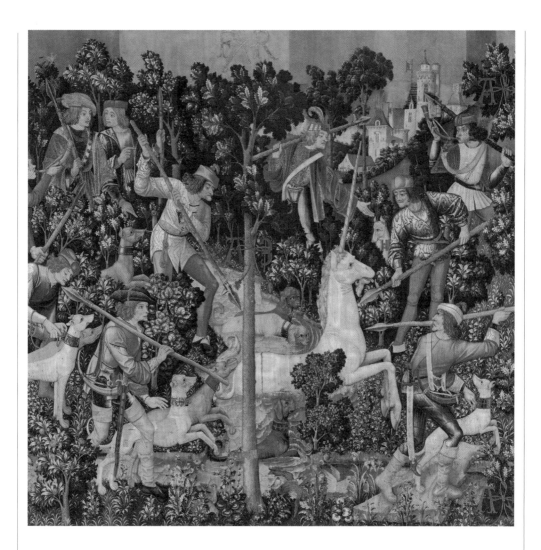

also recall Christ's crown of thorns. The stag, which kills serpents, here represents Christ as the destroyer of evil. The orange tree at the lower right is associated with fertility and is also related to the overall tale, since citrus seeds are part of an antidote to poison, which, presumably, was in the water. The flowering sage and yellow marigolds are antidotes, too.

While the hunters pause to witness the miracle wrought by the unicorn in the second tapestry, in the third tapestry, *The Unicorn Is Attacked*, the hunt is brutally, cruelly on. The hunters are eager, even venal in their pursuit.

With the dogs hot on his trail and the hunters threatening him with spears, the unicorn leaps across the stream in an attempt to escape. Prominently sewn into the sky are the initials "FR," while the ubiquitous "AE" appears on the collar of the white greyhound on the left.

Silhouetted against the unicorn's body is a flowering hawthorn tree. The prickly branches symbolize Christ's crown of thorns, and the hawthorn is also associated with the May Day celebration and the arrival of the spring mating season. On the bank of the stream, near the ducks, are field daisies, sometimes called, in medieval times,

ABOVE: *The Unicorn Is Attacked*, c. 1500.

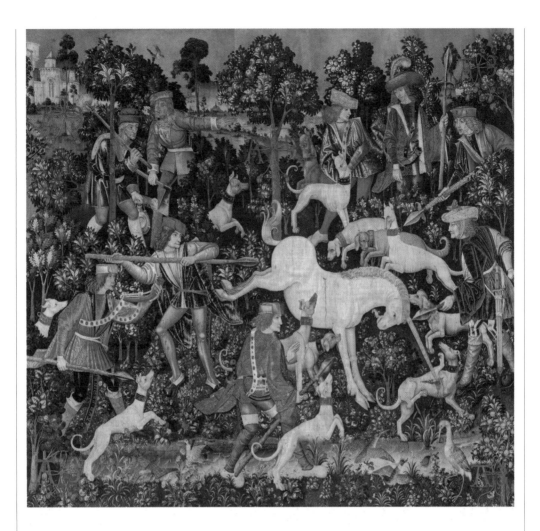

oculus Christi, or eye of Christ. Medieval herbalists prescribed them as a cure for the kind of lustful, unsavory desire that leads to adultery, though it's unclear how many affairs they prevented.

In the fourth tapestry, *The Unicorn Defends Itself,* the hunters try to move in for the kill, clearly forgetting the legend that a unicorn cannot be taken by force. The unicorn kicks out at the men and uses his horn to gore a dog. At lower left, the trumpeter blows his horn. The scabbard of his sword is inscribed *Ave Regina C Totelorem* (Latin for "Hail, Queen of the Heavens"), marking him as the angel Gabriel, who said these same words to Mary when he told her she would give birth to God's son. Among the flowers here are forget-me-nots, symbols of fidelity.

Only two fragments remain of the fifth tapestry, *The Mystic Capture of the Unicorn.* In one, the trumpeter blows his horn to call the hunters. In the other, the sleeve and hand of the complicit maiden caresses the unicorn's mane, while the dogs are already on his back and drawing blood. The maiden's attendant nods and raises her hand, perhaps as a signal to the trumpeter.

In both fragments we see the outline of a wooden fence; the unicorn and the virgin are in an enclosed garden, a symbol of chastity. We see holly, a symbol of Christ's nativity, and a tree with

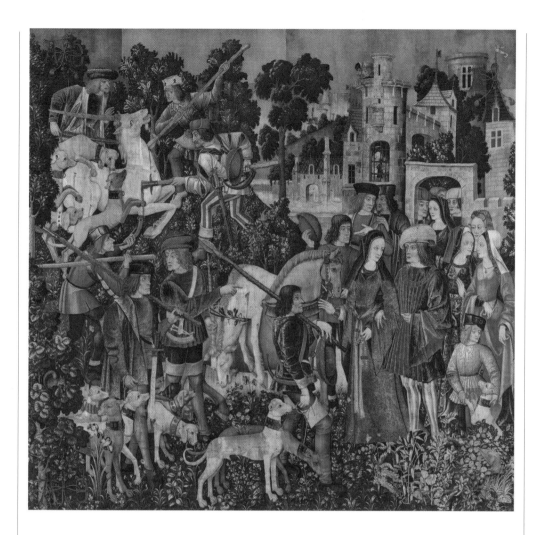

apples rendered in gilt thread, a symbol of forbidden fruit and worldly love. Red and white roses grow all around the fence. The red rose is a symbol of both martyrdom and pleasure, while the white rose is symbolic of the Virgin Mary.

The Unicorn Is Killed and Brought to the Castle, the sixth tapestry, shows two events. The upper left depicts a scene in the forest where the betrayed unicorn is stabbed by the hunters while the dogs also set viciously upon him. The suffering unicorn clearly becomes an allegorical figure of Christ on the cross.

In the lower right, the lord who led the hunt now stands arm in arm with his lady at the entrance to the castle. The dead unicorn is slung over the back of a horse, and a hunter roughly holds his head by the long spiral horn. The unicorn, as a symbol of the martyred Christ, wears a wreath of oak branches, hawthorn, and holly (symbolizing the crown of thorns), while the lady fingers a rosary tied around her waist. A squirrel sits on a hazelnut tree, far above the danger—a symbol for lofty behavior. The hazelnut is associated with union, regeneration, and immortality. A few swans swim in the moat; they are signs of good luck, which seems ironic in this sad scene, but they are a promise of what comes in the next tapestry.

ABOVE: *The Unicorn Is Killed and Brought to the Castle*, c. 1500.

The final tapestry is *The Unicorn in Captivity*. The unicorn has puncture wounds on his breast and back but is alive again. He is resurrected, though he bears the scars of this suffering. He is chained to a pomegranate tree surrounded by a circular fence in a field of flowers. The many types of flowers here collectively signify earthly love and fruitful marriage. While the tree doesn't look like a pomegranate, its fruits clearly are, and some are so ripe they are bursting. This fruit, with its many seeds, is a symbol not only of fertility but also of Christ's resurrection (he bursts alive from the tomb) and the many scattered seeds of the church. Visible against the unicorn's flanks are bluebells, which drive away evil, and wild orchids, which, when eaten, are considered aids to fertility. Carnations around the fence are symbols of betrothal and marriage as well as of Christ and the Virgin Mary. Some of the other flowers in this sumptuous garden are the English daisy—a symbol of the Christian holiday Easter, and a "measure of love" ("he loves me, he loves me not")—as well as the Madonna lily and red wallflowers, which eased the pain of childbirth. The columbine symbolized the Holy Spirit and was thought to prevent impotence.

Here, the unicorn may be interpreted as the risen Christ in paradise. The chain of love is a common symbol in medieval love poetry, and that he is chained to a tree also suggests a bridegroom forever attached to his wife. This is the final scene of an allegorical hunt of love, in which the quarry is captured by his maiden and finally tamed.

About the Tapestries ✳

This series of seven tapestries was woven for an unknown patron around 1500, most likely in Brussels, as this was where the finest weaving of the time was done. The work is so exquisite that the back of each tapestry is almost the same as the front, down to the strands of hair on the men and the fine details of the flowers and birds. The tapestries have different styles—some are static and some are lively, so it's likely there was more than one artist at work. Certainly, weaving them required a large workshop with many skilled artisans.

The joined initials "AE" that appear in every tapestry continue to confound art historians. One theory is that they refer to Anne of Brittany, who was twice queen of France, and that the tapestries were commissioned for her wedding in 1499. However, this has never been proven, and there's not much evidence for it either. Who "AE" is remains a mystery.

Scholars are not entirely sure who commissioned the tapestries, but there are some clues. The initials "FR" sewn into the sky in the third tapestry have been linked with the La Rochefoucauld family of France. According to the family, they were commissioned for François de La Rochefoucauld, possibly as a wedding gift (in 1470, François married Louise de Crussol, whose family crest was a unicorn's head), but there are no records to confirm this. Alternatively, François may have commissioned the tapestries for his son, Antoine, who married Antoinette of Amboise in 1518. Again, there are no records of the original commission, so art historians can only look at the clues in the tapestries themselves and make educated guesses.

What is certain is that a list of the possessions of François VI, duc de La Rochefoucauld (François's great-great-great-grandson), compiled when he died in 1680, included "tapestries presenting a hunt of the unicorn in seven pieces" that hung in the bedroom of his Paris mansion. The tapestries were also listed in a 1728 inventory of the La Rochefoucauld château at Verteuil, France, from which they were stolen by peasants during the French Revolution in 1793. The peasants wrapped potatoes in them to keep the tubers from freezing in their barns.

That might have been the last of them if not for a chance discovery. In the mid-1850s, a peasant's wife happened to make mention to Count Hippolyte de La Rochefoucauld of some "old

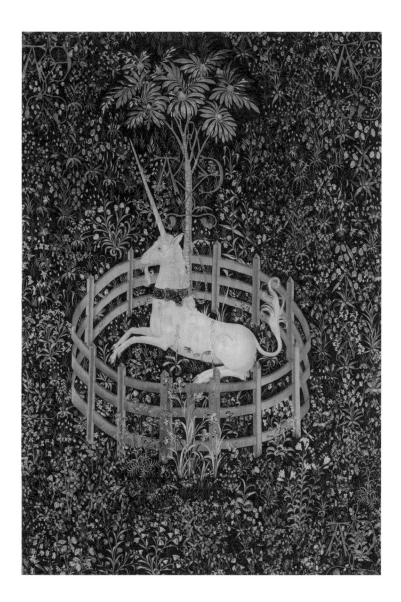

curtains" her husband had in their barn in Verteuil, a commune in southern France, to protect his vegetables. When the count investigated, he discovered they were his family's Unicorn Tapestries. He bought them all—including the severely damaged one that existed only in fragments—and had them reinstalled at his château, where they hung for the next fifty years.

In 1922, the six intact tapestries were exhibited at an art gallery in New York City, where John D. Rockefeller spent more than $1 million to buy them for his New York City mansion. In 1937, he donated them to the Cloisters, which houses the medieval art collection of the Metropolitan Museum of Art. The seventh tapestry, which is in fragments, was recovered in 1936 when a curator from the Met visited Gabriel de La Rochefoucauld in Paris and learned that the family still had this last piece. The museum bought the fragments and included them with the other six tapestries when the Cloisters opened in 1938.

Aʙᴏᴠᴇ: The Unicorn in Captivity, c. 1500.

The LAST UNICORN:
A CONVERSATION *with*
PETER S. BEAGLE

HE UNICORN TAPESTRIES HAVE INFLUENCED countless people who've come in contact with them, possibly even providing evidence to many a modern mind that unicorns exist. Peter S. Beagle, author of *The Last Unicorn*, visited the tapestries at the Cloisters regularly as a child, though the dust in the old monastery triggered his asthma and caused him to lose his voice.

The tapestries were worth it, he says in his collection of poetry and short stories, *We Never Talk About My Brother* (2009): "Woven from silk, gold, and silver sometime around the end of the fifteenth century, brilliantly dyed with weld, madder, and woad, these seven hangings captured my imagination with their silent tale of a brutal unicorn hunt." Beagle would go on to publish possibly the most beloved unicorn novel of all time. *The Last Unicorn*, which came out in 1968 and was adapted into a movie by Beagle himself in 1982, is about a unicorn's quest to find others of her own kind.

To follow is a conversation with Mr. Beagle, who graciously agreed to talk about a subject near and dear to his heart.

Carolyn Turgeon (CT): Can you describe how the tapestries inspired *The Last Unicorn*?

Peter S. Beagle (PB): As a boy, I was fascinated by the Unicorn Tapestries, by the unraveling of the story. Years later, I wrote a series of poems telling the story of the tapestries. There's a small boy in the series early on. He's there with his dog watching the hunt, and I imagined his view of what's going on and his response to it. You can see his immense dislike for the maiden, the virgin, who's supposed to lure the unicorn. When he carries the dead unicorn at the end of the tapestry, he looks away. He doesn't want to see it.

I ended the series with a vision of the unicorn the very next day—alive, lying in a small enclosure he can jump out of any time he wants to. He survives. The unicorn always does.

When I was twenty-three, my best friend and I were sharing a cabin in the Berkshires. He'd go out all day and paint, and I wanted to show him that I was working, too. So I was fussing around with a story, a couple of them, but I didn't like

either one of them. And then somehow the whole image of the unicorn came to me, and I started there.

I can't say that I knew that much about unicorns at the time. I even remember going to the closest library to find more images of the unicorn, more folklore. I couldn't find much, so I made a lot of it up as I went along.

I wrote a draft that is not very similar to the book that was eventually published. I got to maybe fifty or sixty pages, and then I put it away because, very shortly afterward, I married and had children to feed. And for the first time in my life, I had to be a breadwinner. And that was tricky when the only talent you have is for telling stories.

CT: When did you go back to writing the novel?
PB: When I started to make a living as a writer, I got back to the unicorn. I juggled things. I'd make some money writing an interview story, and then I'd go back to the novel, which came out in 1968.

Today, people think of *The Last Unicorn* as having been a bestseller. It never was. Nothing I've done has been a bestseller. The main thing is that *The Last Unicorn* stayed in print. And now it's officially a classic. I've been very lucky in my time.

CT: What about the movie—how did that happen?
PB: The movie came out fourteen years after the novel. The producers were very faithful to the book and to the script I wrote. They filmed it pretty much the way I'd written it. And there were wonderful side benefits, like the fact that an old friend of mine, who's the best actor I know—René Auberjonois—played the skeleton and steals the one scene he's in. I've watched the movie so many times but usually, if it happens, kind of dodge it and just stick my head in for René's scene. I also became good friends with Christopher Lee. I'm

sorry he's gone. He was a strange and lovely and remarkable man.

CT: Have you read other books that focus on unicorns?
PB: A book I should have read at the time and came across before finishing the original draft was Odell Shepard's *The Lore of the Unicorn*. I've still got a copy of it here. Beyond that, there's a gorgeous and terrible scene in T. H. White's *The Once and Future King* when the Orkney boys decide that they will hunt and capture and kill a unicorn and bring its head to their mother Queen Morgause because they adore her, as White did his own mother. They're terrified of her, but they all yearn to have her undivided love. It's an awful scene—a butchery. And I have a hard time reading it. But White was one of the writers who really affected me in a way that Tolkien

ABOVE: A poster for the film *The Last Unicorn*, 1982.

doesn't. I admire Tolkien, but he never makes me cry. White does it every time. He makes me laugh, and he makes me cry, both, sometimes in the same paragraph.

There is also a children's book I read when I was quite young called *The Colt from Moon Mountain* by Dorothy Lathrop about a little girl growing up on a farm, probably in the mid-nineteenth century, maybe somewhere in the Midwest. She sees a wild colt in the woods that she can never get close to but that she knows is different somehow. She keeps trying to get close to it. And her mother gets drawn into the affair with her and eventually they find a picture of a unicorn in the dictionary and begin to understand.

CT: When you learned more about unicorns, did anything surprise you?
PB: That there were enough different takes on the unicorn, so it wasn't simply the beautiful creature of the legends I knew, the Western ones. There were also the Chinese and the Japanese unicorns that were notably different.

There was this creature that I realized must've been based on the rhinoceros in the Mideast, but it's large and aggressive: the karkadann. I can't be sure, but I think I might be the only person who's written a short story about a karkadann, "The Karkadann Triangle." (See "Karkadann" on page 166.)

Marco Polo saw a rhinoceros in his journeys in the Mideast. He was really disappointed and saddened. He wrote in his journal of the experience: "I just never thought unicorns would be so ugly."

CT: Is there anything else about unicorns that you want to share?
PB: I'm stuck with them. In the words of my best friend, whom I've known since we were five years old, who's always been a painter the same way I was always a storyteller: "I've finally come to the conclusion that what is, is."

I once tried to make a deal with Ursula Le Guin, who's the master of us all, because she had said that she loves creating worlds. And she loved the physical aspect of doing that, but dialogue was hard for her. And I said, "What—why don't you create my worlds? You handle the things, and I'll do the dialogue."

When I was sick of being the "unicorn guy" at one point, I tried to make a deal with her to trade up my unicorns for her dragons—though she did dragons so well I don't think they should be allowed to be done by anybody else.

Once she said to me, "You know, you can never get dragons off the curtains. And do you know how long it takes to housebreak them?"

"Unicorns are very easy in that way," I said. "They always ask to go outside."

OPPOSITE: This fashionable unicorn showed off his noble profile for photographer Marketa Novak in Prague.

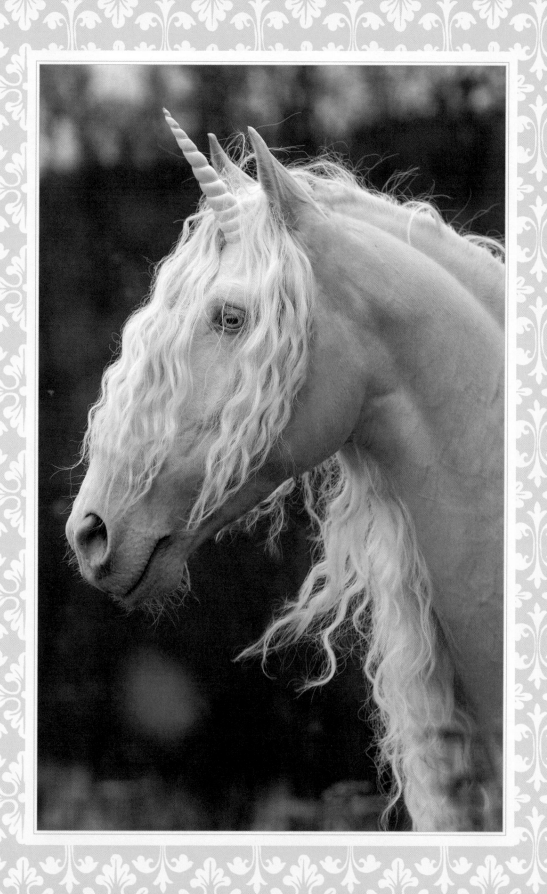

The LADY and the UNICORN

 IN THE MIDDLE AGES, UNICORNS AND MAIDENS kept close company. Either the maiden's taming of the unicorn was a metaphor for courtly love, or the unicorn represented Christ and the maiden, the Virgin Mary. The lion and the unicorn were sworn enemies (see "Unicorns Versus Lions," page 46), yet in the world of heraldry they often appear together, with the lion representing strength and the unicorn representing chivalry. In medieval art, the lion represented a husband; the unicorn, a wife.

All these themes come together in the series of six exquisite tapestries known as *The Lady and the Unicorn*, today housed at the Musée de Cluny in Paris. The tapestries were commissioned by Jean Le Viste, a wealthy lawyer, though not a nobleman, from Lyons, who became an influential adviser to French kings, including Louis XI and Charles VIII. Le Viste died in 1500, at about the time it is thought *The Lady and the Unicorn* tapestries were created by unknown weavers. There are no records of the commission, so art historians do not know the exact dates or even where the tapestries were made, but their style and quality suggest they came from workshops in the southern Netherlands. No one knows why they were commissioned, and that mystery has intrigued art historians for centuries.

As with most allegorical artworks of the day, the tapestries can be read as both sacred and secular. They draw on the maiden-unicorn themes and symbolism mentioned here, and it is thought that they may be an allegory for marriage or depict a woman renouncing the sensual for the spiritual.

Five of the six tapestries depict a physical sense—touch, taste, smell, hearing, and sight. All show an aristocratic woman, sometimes with an attendant but always flanked by a unicorn on her left and a lion on her right, each animal making a fashion statement in the coat of arms of Jean Le Viste. The woman and, at times, some of the animals in the panels are engaged in an activity that illustrates each sense.

All the tapestries show the lady on a crimson background filled with flowering plants in the millefleur style. There is no record of why particular plants and animals were chosen for each tapestry. But art historians do know that each of these plants and animals was symbolic—some symbols were secular, some were sacred, some were both. For example, the daffodils in these tapestries are a secular symbol of death and a sacred symbol of resurrection.

In *Touch*, the lady stands with one hand holding the unicorn's horn, and the other holding up a pennant. The lion sits to the side and smiles creepily. The lady is flanked by fruit trees, which

OPPOSITE: The Lady and the Unicorn: Touch.

144

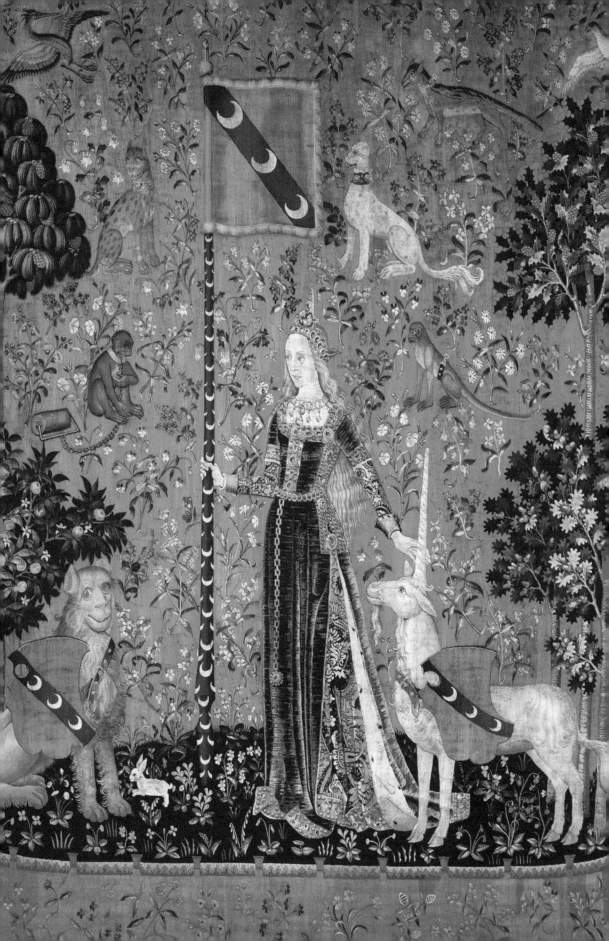

are symbols of fertility, as are the rabbit and the partridge in this scene.

In *Taste*, the lady takes some sweets from her attendant, and the little monkey at her feet nibbles, too. A parakeet—a symbol of wealth—flutters on her left hand.

In *Smell*, the lady makes a wreath from the carnations brought by her attendant, while the monkey smells a rose he's stolen from a basket. Both the carnation and the rose are symbols of sacred as well as profane love.

In *Sight*, the lady holds up a mirror so that the unicorn can see his reflection. The unicorn kneels on the ground, with his front legs in the lady's lap—a classic pose for unicorns being seduced. In the background, animals that symbolize both fertility and trickery cavort.

In *Hearing*, the lady plays a portative organ (a small tabletop instrument) as her attendant pumps the bellows. The table is covered by a sumptuous Oriental rug, another symbol of wealth.

The sixth tapestry is the largest—and the most mysterious. Here, the woman stands in front of a blue tent, its flaps held open by the lion and the unicorn. Her attendant holds a small chest, into which the lady is placing the jewels she wore in the other five tapestries. A small lapdog (symbol of faithfulness and loyalty) sits on a pillow placed on a bench to the lady's right. Emblazoned on the tent are the words *À mon seul désir*, which might mean "to my sole desire" or "by my own free will." It is the only tapestry in which the woman is smiling.

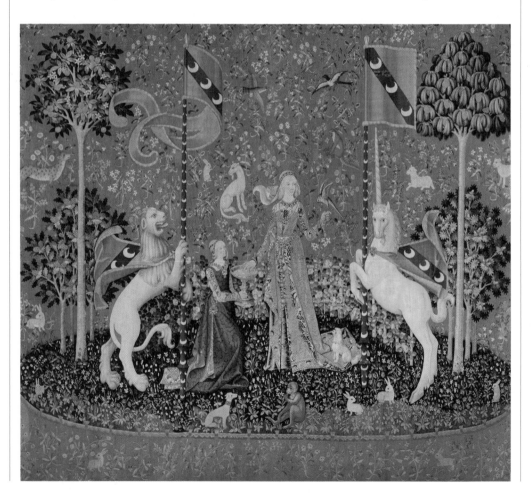

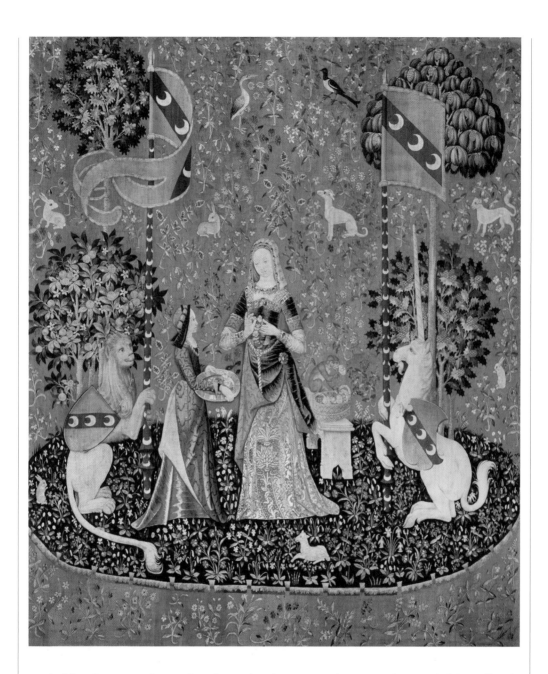

Art historians can only speculate about what this all means. Some say the lady is rejecting the worldly senses or the courtly pleasures for something more spiritual. Perhaps the sixth sense is her sense of moral reasoning or her sense of fidelity to her husband, or maybe the artist was suggesting wisdom or virtue triumphs over passion.

Around 1475, Le Viste married Geneviève de Nanterre, whose family were French nobles. The tapestries may have been an allegory of Geneviève giving up her noble birth to marry the un-noble Jean, who must have been a rather alluring fellow.

The enduring mysteries raised by these exquisite tapestries have only contributed to

Opposite: The Lady and the Unicorn: Taste. + *Above: The Lady and the Unicorn: Smell.*

their fame. "Part of the fascination is that you can have several interpretations," said Musée de Cluny director Elisabeth Taburet-Delahaye in a 2014 interview in the *New York Times*. She added that the mystery over who wove the tapestries and whom they depict has made *The Lady and the Unicorn* a "kind of Mona Lisa" of the Middle Ages.

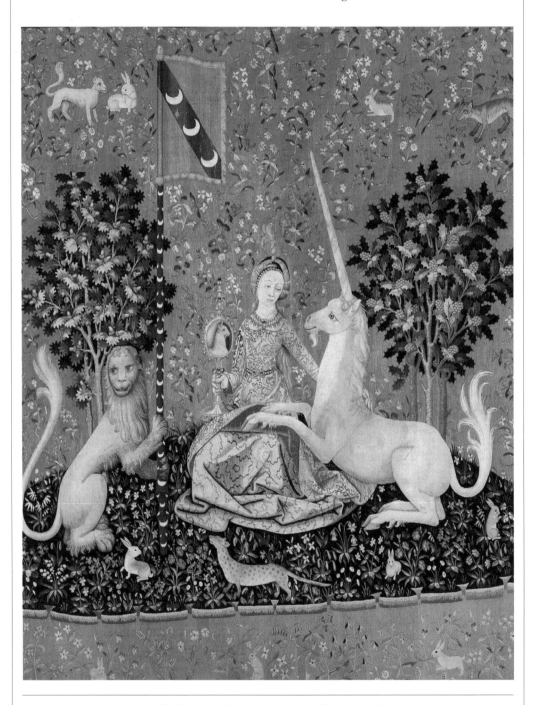

ᴀʙᴏᴠᴇ: The Lady and the Unicorn: Sight. + ᴏᴘᴘᴏꜱɪᴛᴇ: *The Lady and the Unicorn: Hearing.*
ᴘᴀɢᴇꜱ 150–151: *The Lady and the Unicorn: To my sole desire.*

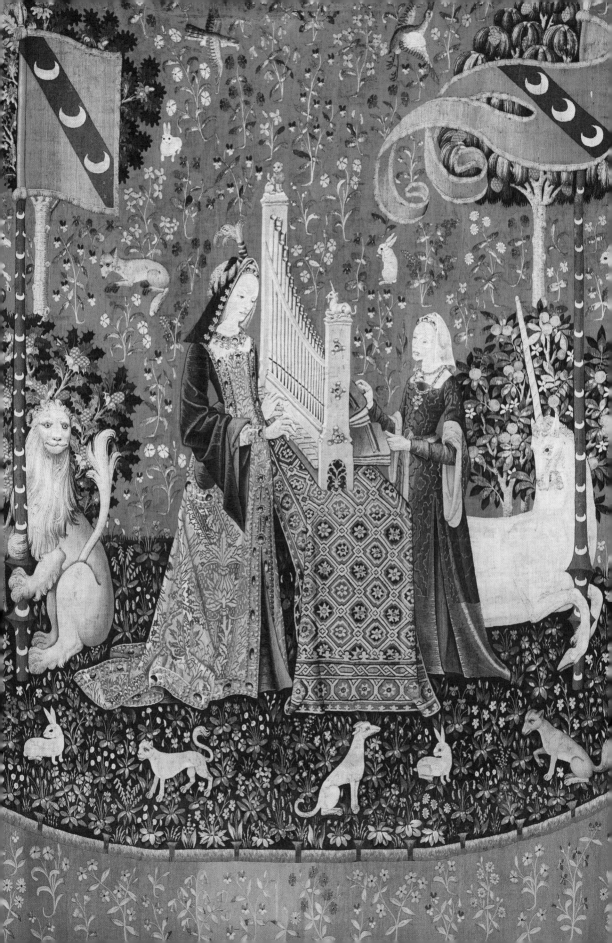

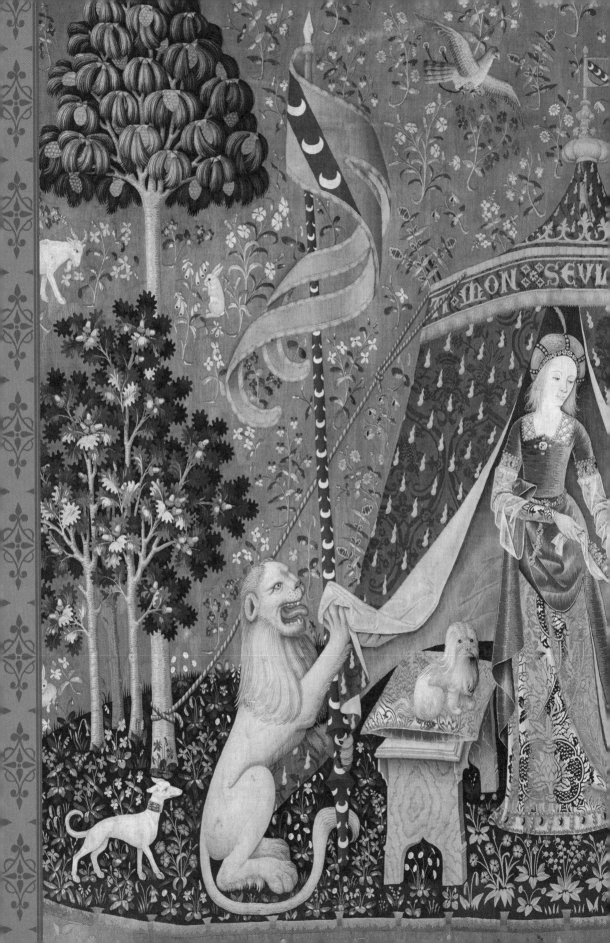

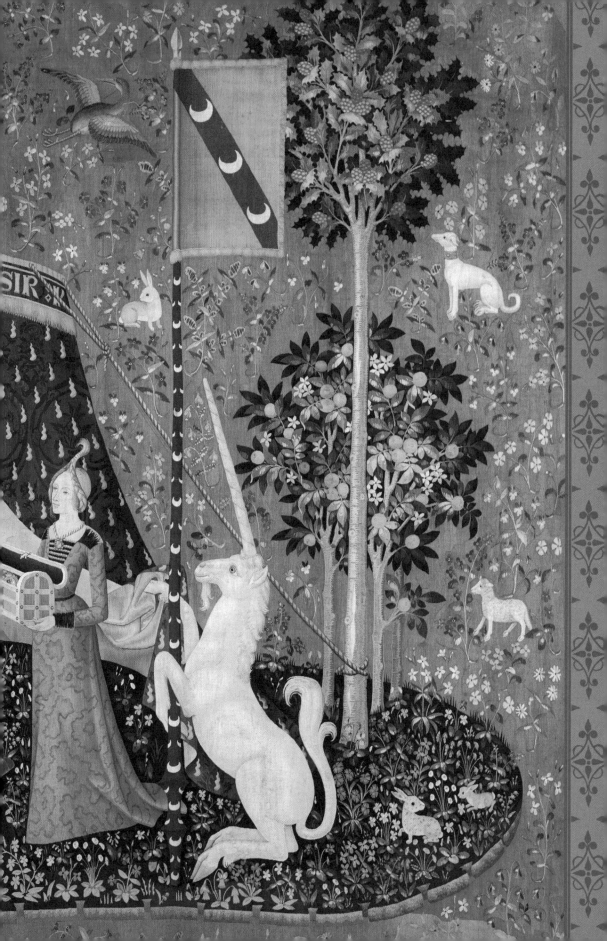

The Lady and the Unicorn as Muse

THE LADY AND THE UNICORN TAPESTRIES HAVE
been an unending source of inspiration to artists the world over, includ-
ing authors of unicorn handbooks. In 1887, five years after the tapestries
had been acquired by the Musée de Cluny, French symbolist painter Gustave Moreau
painted what might be one of the most stunning and enviable unicorn scenes in *The
Unicorn*, a work that shows three clothed and one naked woman hanging out with their
unicorns on an enchanted island. Moreau blended symbols of the medieval era and the
Renaissance, such as: a lily (purity and chastity), a chalice (chivalry and also associated
with the Holy Grail), and a dragon (strength but also treachery). One of the women is
dressed much like the lady in the Musée de Cluny tapestries.

Contemporary tapestry artist Jean Picart Le Doux created and exhibited *Tribute to the
Unicorn* in 1964, which showed a white unicorn on a stylized version of the flower-strewn
red background of the famous French tapestries. And Claude Rutault's *The Lady and the
Unicorn Remembered in Oblivion* (2018) is a woven series in which the figures from the
original work have been blurred to abstraction.

A more subtle take on both sets of tapestries was American artist Kimberley Hart's
2008 installation at the Socrates Sculpture Park in New York, *Gingerbread Blind with
Unicorn Charm*. In the trees she placed a hunting blind reminiscent of a Victorian play-
house. It overlooked a familiar scene: a maiden in a fenced garden, with a trap laid out
for a unicorn. But the woman herself was a mirror—an echo of the *Sight* tapestry, where
the unicorn gazes at himself in a mirror offered by the lovely maiden.

OPPOSITE: Gustave Moreau, *The Unicorns*, c. 1885. After viewing this painting in Moreau's
studio, the French collector Emile Straus wrote, "I just saw one of the most beautiful things
that I have ever seen in my life!"

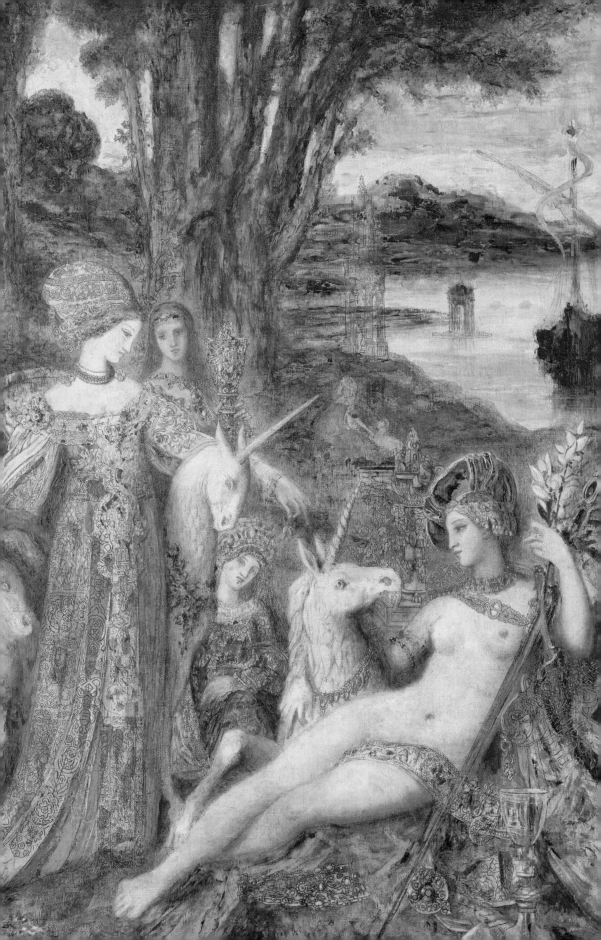

UNICORNS *in* HERALDRY

HE FIRST HERALDIC IMAGES APPEARED IN England during the reign of Henry I (1068–1135). It was a time of instability and upheaval, and as feuding coalitions struggled to take territorial control, they needed some way to identify their alliances on the battlefield, using images everyone could readily understand and relate to.

By the thirteenth century, male members of the nobility throughout Europe started putting symbols that represented their families on their shields, seals, and banners. Towns also developed their own coats of arms—usually based on the heraldry of the noble family that oversaw the town. Eventually, the patterns, colors, objects, and animals of these coats of arms became its own complex language.

The unicorn seen most often in heraldry is a more equine version of the classic medieval unicorn. He has the majestic white body of a horse, the regal tail of a lion, and the powerful legs and hooves of a stag—and, of course, a long spiral horn extending from his forehead, sometimes red and black, sometimes white or gold. Some crests show only the head, and some make the unicorn more horse-like, but there is no mistaking his fierce power and majestic grace.

The unicorn is sometimes shown collared and chained, as in the Unicorn Tapestries (see page 133), the implication being that he has been tamed. But when you look more closely, in most of those images the chain is not attached to anything. The end swings free; the unicorn has broken his bonds and cannot be taken again.

That defiant stance may be why two unicorns appear on Scotland's coat of arms. In Celtic culture, the unicorn is a symbol not only of purity and innocence but also bravery, masculinity, pride, and power. The unicorn was added to the royal coat of arms of the king of the Scots in the twelfth century. Two crowned unicorns rearing up on their hind legs support the royal shield. Both wear gold collars attached to chains that have been yanked free of their tethers, just as the Scots wanted the world to know they would fight to remain unconquered.

In the fifteenth and sixteenth centuries, gold coins in Scotland had the image of a unicorn on them, and two gold coins were known as the unicorn and the half-unicorn. Unicorns often topped the stone pillars placed in the main squares of royal burghs. Certain noblemen, such as the Earl of Kinnoull, and clans such as Clan Cunningham, were given special permission to use the unicorn in their arms, and it was considered a great honor.

Scotland and England were unified in 1603 when King James VI of Scotland became James I of England, Ireland, and Scotland. James replaced the unicorn on the left of the Scottish arms with

Opposite: A watercolor of the Scottish royal coat of arms by an unknown artist from the sixteenth-century *Lambeth Armorial*.

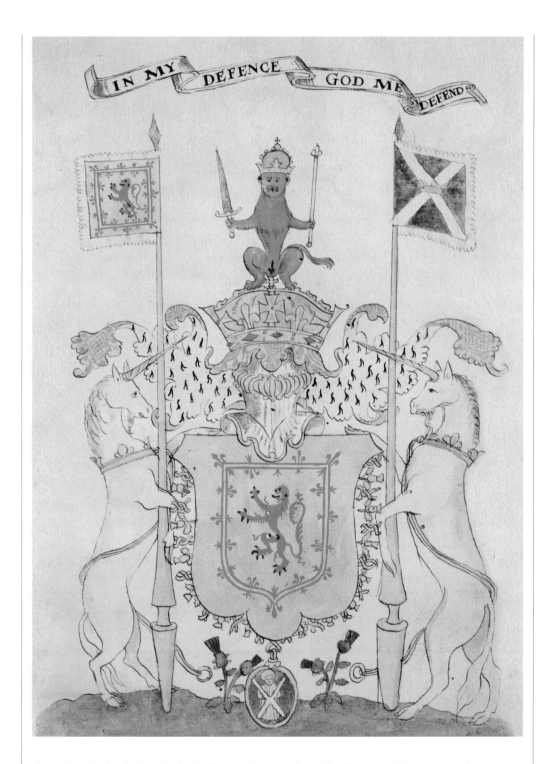

the national animal of England, the lion, to show that the countries were indeed united. At the time, England and Scotland were separate states with different parliaments but shared the same king.

They officially passed the Act of Union in 1707, and the unicorn became a permanent symbol of the royal arms of the United Kingdom. It is on the coat of arms of Queen Elizabeth II today.

The POETIC UNICORN

N MEDIEVAL POETRY, THE HIGH IDEALS OF COURTLY love—love that emphasized noble chivalry rather than the consummation of passion—were inspired by the stories of the unicorn and virgin whose purity and beauty seduces, captures, and tames him.

The first known account of a lady entrapping a unicorn was in *Physiologus*, a second-century Greek text by an unknown author. "Men lead a virgin to the place where he [the unicorn] most resorts and leave her there alone. As soon as he sees this virgin he runs and lays his head in her lap. She fondles him and he falls asleep. The hunters then approach and capture him and lead him to the palace of the king."

Another well-known tale of how to capture a unicorn advises positioning oneself between a unicorn and a tree, waiting for the unicorn to charge and then quickly stepping aside so that the unicorn runs into the tree, his horn embedded in the bark (also see "Unicorns Versus Lions," page 46). This image, too, became iconic in literature.

English poet Edmund Spenser's epic *The Faerie Queene* (published between 1590 and 1596) examines the virtues of the unicorn by following the exploits of several knights. He wrote:

Like as a lion, whose imperial power
A proud rebellious unicorn defies,
T'avoid the rash assault and wrathful
 stowre
Of his fierce foe, him to a tree applies,
And when him running in full course he
 spies,

He slips aside; the whiles that furious beast
His precious horn, sought of his enemies,
Strikes in the stock, ne thence can be releast,
But to the mighty victor yields a
 bounteous feast.

Another image that appears often in very early chivalric poetry is the unicorn's ruby—a precious stone that grows at the base of the horn that, in some tales of the unicorn, is the source of the animal's magical powers. Wolfram von Eschenbach's (1170–1220) epic poem, *Parzival*, about an impoverished Bavarian knight, introduced the theme of the Holy Grail into German literature and uses the figure of the virginal maiden with the ruby:

We caught the beast called Unicorn
That knows and loves a maiden best
And falls asleep upon her breast;
We took from underneath his horn
The splendid male carbuncle-stone
Sparkling against the white skull-bone.

The ruby is also featured in another twelfth-century German epic, *Alexanderlied* (Song of Alexander), written by the German poet and priest Lamprecht der Pfaffen. In it, among the gifts sent by Queen Candace to Alexander the Great, was a unicorn with a ruby.

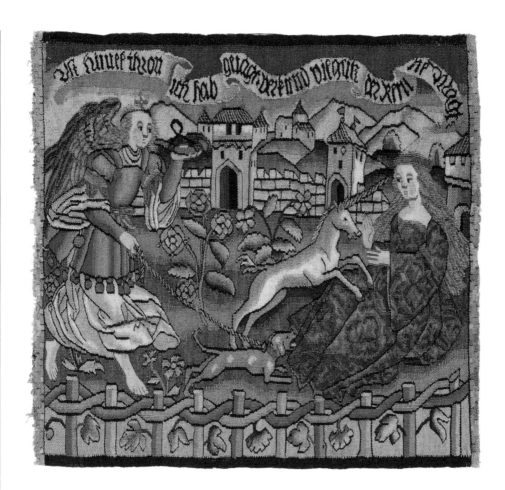

I had from this rich queen
A beast of proud and noble mien
That bears in his brow the ruby-stone
And yields himself to maids alone.

The story from *The Faerie Queene* and that of the unicorn with a ruby in his brow came together in a play by George Chapman, a late contemporary of Shakespeare, called *Bussy D'Ambois, a Tragedie* (1607). In describing D'Ambois's fight with an enemy, the narrator tells us:

> . . . I once did see
> In my young travels through Armenia,
> An angrie Unicorne in his full cariere
> Charge with too swift a foot a Jeweller,

That watcht him for the Treasure of his browe;
And ere he could get shelter of a tree,
Naile him with his rich Antler to the Earth.

The tale of the unicorn and virgin became inextricably synonymous with seduction and emotional surrender. In the mid-1200s, French scholar Richard de Fournival wrote *Le bestiaire d'amour* (The bestiary of love), a work addressed to an anonymous woman who became a model of the literature of courtly love. He wrote:

> For when the unicorn senses a virgin
> by her smell, it kneels in front of her
> and gently humbles itself as if to be of
> service. Therefore wise huntsmen who
> know his nature set a virgin in his way;

ABOVE: A tapestry panel depicting the hunt of the unicorn, 1550–99, Swiss School.

he falls asleep in her lap; and while he sleeps the hunters, who would not dare approach him while awake, come up and kill him. Even so has love dealt surely with me.... Love, the skillful huntsman, has set in my path a maiden in the odor of whose sweetness I have fallen asleep, and I die the death to which I was doomed.

Thibaut de Champagne (1201–53), an epic poet in northern France and the great-grandson of Eleanor of Aquitaine, wrote in a similar vein:

The unicorn and I are one:
He also pauses in amaze
Before some maiden's magic gaze,
And, while he wonders, is undone.
On some dear breast he slumbers deep,
And Treason slays him in that sleep.

Just so have ended my life's days;
So Love and my Lady lay me low.
My heart will not survive this blow.

The more sacred vision of the unicorn also had its place in courtly poetry. *Le roman de la dame à la Licorne et du beau chevalier au lion* (The novel of the woman with the unicorn and the beautiful knight with the lion), an anonymous French mid-fourteenth-century romantic epic, describes another aspect of courtly love: the knight who must perform many daring deeds to win his lady's affections. In this poem, the fair knight is represented by a lion, and the chaste lady by a unicorn. The poet-knight compares his beloved to a "mirror...clear, shining, unsullied," in which he sees both himself and her pure love. It's a kinder, gentler version of the unicorn as a symbol of love.

ABOVE: An illustration for *The Sunday Picture Book, No. 2, Scripture Manners and Customs,* c.1873.
OPPOSITE: Guinevere von Sneeden, *Letting Light In,* 2017. + *PAGES 160–161:* Domenico Zampieri (Domenichino), *The Virgin and the Unicorn,* 1604–05.

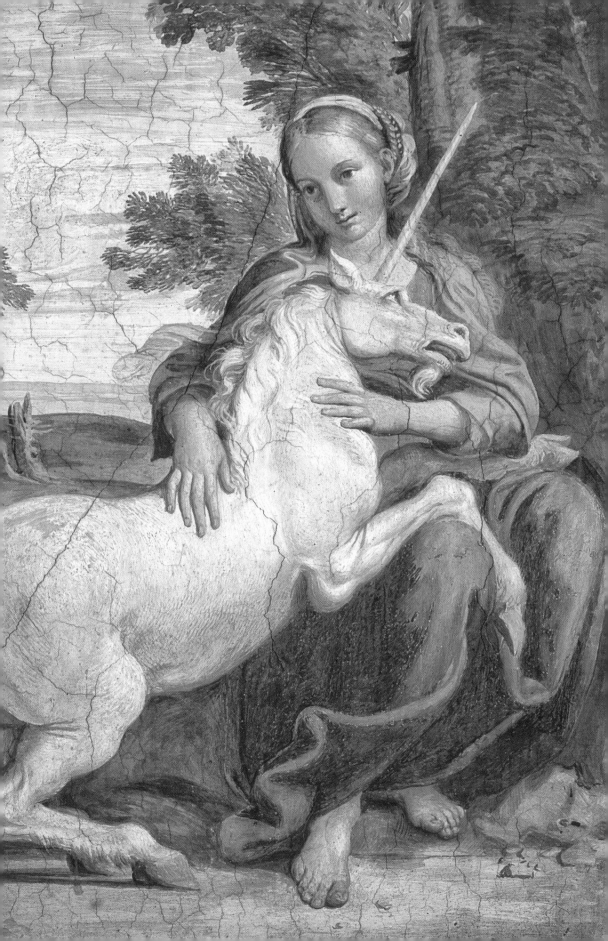

UNICORNS AROUND
the WORLD

HE UNICORN WE KNOW IN THE WEST IS NOT the only rare and wonderful single-horned animal in the world. Unicorns appear in every place, in every culture, in every era. Following is a selection of one-horned animals from cultures around the world and throughout recorded history.

ABOVE: Untitled (women in a park with a qilin), Jiao Bingzhen, Qing Dynasty (1689–1726).
OPPOSITE: A kirin by Aime Humbert from *Il Giro del mondo (World Tour), Journal of geography, travel and costumes*, Volume VIII, Issue 7, August 15, 1867.

QILIN (China) ✳ The qilin has the body of a deer, the tail of an ox, the hooves of a horse, a yellow belly, and a scaly back showing the five sacred Chinese colors: red, yellow, blue, white, and black. And, of course, a single horn on its forehead. Its name is a combination of the two Chinese characters *qi* (male) and *lin* (female).

The qilin is described as wise and powerful but gentle. It walks so softly that it will not crush a blade of grass and takes care not to step on even the tiniest insect. Going beyond even veganism, it eats only vegetation that has died naturally. It prefers solitude and seldom shows itself; it cannot be captured. It is said to live for a thousand years.

The qilin was mentioned in the *Zuo zhuan* (*The Chronicle of Zuo*), a narrative history that describes events in China from 722 to 468 BCE written by an unknown author or authors and completed by about 300 BCE. According to this record, the first Chinese writing system was transcribed around 3000 BCE from the markings on a qilin's back.

Qilin associate only with people they find worthy and can sometimes foretell their birth. In 551 BCE, when Confucious's mother was pregnant with him, she met a qilin in the forest. It coughed up a small inscribed jade tablet that foretold the greatness of her child (jade is a symbol of wisdom) and placed its head in her lap. According to the Asian Art Museum in San Francisco, the hidden meaning of the qilin's appearance is this: "May your son become an illustrious scholar!" Confucius's death was also foreshadowed when a qilin was injured by a charioteer, which happens on occasion.

KIRIN (Japan) ✳ The kirin is related to the qilin and comes in two varieties: the kilin and the sinyou. In its behavior, the kilin is much like the qilin—gentle, vegan to the extreme, timid, and deer-like. The sinyou is a more fearsome animal. It has a shaggy mane like a lion's and the body of a bull and is as bold as both of these animals.

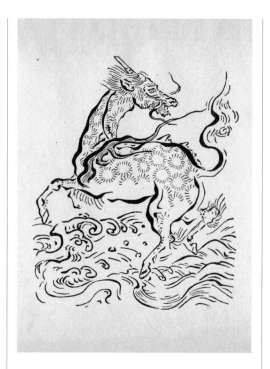

The sinyou knows right from wrong and is able to detect guilt in others. Japanese judges even went so far as to call in a sinyou when they couldn't determine who was the guilty party in a court case. The sinyou would stare at the unfortunate guilty person, affixing him to the spot with its gaze, then pierce him through with its horn.

It's rare to see a kirin, and its appearance typically marks the passing of a great sage or a wise leader. Kirin are traditionally shown with the body of a deer, the head of a dragon, the scales of a fish, the hooves of a horse, the mane of a lion, the tail of an ox, and—of course—a single horn.

CHIRU (Tibet) ✳ In December 1820, a British magazine called *The Quarterly Review* published a letter sent by Major B. Latter, who was stationed in the hill country east of Nepal, to his commanding officer, Lieutenant-Colonel Nichol. Latter wrote:

> In a Thibetan manuscript which I procured the other day from the hills, the unicorn is classed under the head of those animals whose hoofs are divided;

it is called the one-horned tso'po. Upon inquiring what kind of animal it was, to our astonishment the person who brought me the manuscript described exactly the unicorn of the ancients, saying that it was a native of the interior of Thibet, fierce, and extremely wild, seldom ever caught alive, but frequently shot, and that the flesh was used for food. The person who gave me this account has repeatedly seen these animals and eaten flesh of them. They go together in herds, like our wild buffaloes, and are very frequently met with on the borders of the great desert about a month's journey from Lassa, in that part of the country inhabited by the wandering Tartars.

Latter had approached the Sachia Lama, the local religious leader, asking that he send "a perfect skin of the animal, with the head, horn and hoofs." But, he reported, it would be "a long time

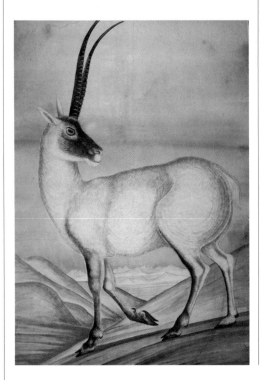

before I can get it down." He was assured, though, that herds of wandering unicorns could be found "about a month's journey from Lhasa." Latter's letter ended up in the private collection of renowned British naturalist Sir Joseph Banks.

These small, fast antelopes are native to both Tibet and Mongolia. Colonel Nikolay Mikhaylovich Przhevalsky, a nineteenth-century Russian geographer and explorer of Central and East Asia, described them in his 1875 book *Mongolia*. He said they were sacred to the Mongols, who called them oronga, and that the lamas would not eat their meat. They also believed oronga horns could be used to see the future.

CAMPHUR (Ethiopia) ✳ The camphur (sometimes written camphruch) is amphibious, like a crocodile. According to *A Book of Creatures*, "It is as big as a doe and has a thick grayish mane around the neck. The single horn on its forehead is three and a half feet long, as thick as a man's arm at its thickest, and is movable like an Indian rooster's comb. The forelegs are cloven deer's hooves. The hindlegs are webbed like those of a goose."

This physical description of the camphur comes from André Thevet, a sixteenth-century French Franciscan friar who traveled extensively and in 1575 published *Cosmographie universelle* (Universal Cosmology), a natural history of everything he had seen, heard, or read about. He said that camphurs swim in both fresh and saltwater and eat fish.

Pierre Pomet, a French physician and pharmacist to Louis XIV, showed a drawing of a camphur in his 1694 book *Histoire générale des drogues* (General History of Drugs). He described it as a type of unicorn—which meant that the camphur's horn is an antidote to poison.

ABOVE: Raj Man Singh, *Chiru*, 1840. + *OPPOSITE, TOP*: Engraved image from the *Histoire générale des drogues* (*General History of Drugs*) by botanist Pierre Pomet, 1694. + *OPPOSITE, BOTTOM*: Sea monster engraving by Bernard Salomon, from *Cosmographie universelle* (Universal Cosmology) by André Thevet, 1554.

De la Licorne.

UTELIF (Africa) ✳ Another water unicorn described by Thevet is the utelif—a fish that swims along the African coast from Guinea to Ethiopia. "It has a three-foot long, four-finger wide saw on its forehead. This weapon is very sharp on both sides. It is much like a killer whale, but its skin is scaly instead of leathery," according to *A Book of Creatures*. The utelif is gray above and white below. And because it is a unicorn, its horn can neutralize poison.

Lest the utelif be mistaken for a sawfish, Thevet included a drawing of it and specifically disparaged other naturalists who had suggested the saw extended from the animal's nose.

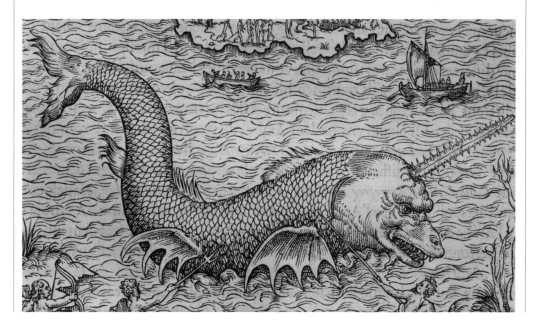

KARKADANN (Persia) ✳ The karkadann is a large strong, dangerous animal that looks like a tragic cross between a buffalo and a rhinoceros, with a single horn that bends upward. It was first described by eleventh-century Muslim scholar al-Biruni, a native of what is now Uzbekistan. Like a unicorn's horn, the karkadann's has healing powers, and al-Biruni said it could cure lameness, epilepsy, and other diseases. Later, Muslim scholars also claimed the horn would sweat in the presence of poison.

The karkadann, like the medieval dragon, is an enemy of the elephant. Unlike dragons, though, who also ate doves, the song of a ringdove is the only thing that can ease the karkadann's temper.

The karkadann was known for its deadly tongue. In *The Unicorn: Studies in Muslim Iconography* (1950), art historian Richard Ettinghausen recounts a tale told by thirteenth-century Islamic scholar al-Gharnati, who wrote "of how the kings of China tortured a person by having him licked by a karkadann, a treatment which separated flesh from the bone." Al-Gharnati's contemporary, explorer Marco Polo, wrote in his journal about the unicorns he saw in Persia: "They have hair like that of a buffalo, feet like those of an elephant, and a horn in the middle of the forehead, which is black and very thick. They do no mischief, however, with the horn, but with the tongue alone; for this is covered all over with long and strong prickles and when savage with anyone they crush him under their knees and then rasp him with their tongue." Scholars have speculated that Polo was describing a rhinoceros, but who knows, it may have been a karkadann.

SINAD (India) ✳ Like the karkadann, the sinad has a deadly tongue—long, thorny, and sharp. The tongue proved to be a liability when giving birth, though. The mother sinad would want to lick her newborn calf clean, but the thorny tongue would have ripped the baby's flesh off its bones. To save itself, the young sinad sticks its head out of its mother's womb, leans down, and begins eating grass on its own while still only partially emerged from its mother's body. When it's strong enough to fully exit the womb and run away, its squirms out and does so.

Many Middle Eastern encyclopedists have mentioned the sinad in books on the natural history of the world, including Muslim scholar al-Jahiz (776–868) in *Book of the Animals* and Persian scholar al-Qazwini (1203–83) in *The Wonders of Creation*. As with so many of these rarely seen animals, descriptions vary greatly. Al-Qazwini says the sinad is "of the same description as the elephant, only smaller in body," but bigger than an ox and with a large horn on its forehead that curves gently backward.

SHADAWAR (Byzantium) ✳ The shadawar is a lovely animal that resembles an antelope. The earliest references to this musical unicorn come from Jabir ibn Hayyan, a ninth-century Persian scholar. But it was al-Qazwini who provided a more complete picture. In *The Unicorn: Studies in Muslim Iconography*, Ettinghausen recounted al-Qazwini's description. "On its single horn are said to be fourty two hollow branches. They form a kind of Aeolian flute because the wind produces cheerful or plaintive sounds when passing through them. They are so pleasant that other animals are attracted by it." Shadawar horns were sometimes given to kings and could be played like flutes or hung up to be played by the wind.

OPPOSITE: An illustration from a Turkish version of Zakariya al-Qazwini's *Aja'ib al-makhluqat* (*The Wonders of Creation*), an Arabic mid-thirteenth-century cosmography by Muhammad ibn Muhammad Shakir Ruzmah-'i Nathani, c.1717.

فرجندن خروج ایدوب برون نفسنه نتاول ایدر وینه دحنه بیکیدر
کیدر تا اول مقدارکه فاجدوع وقت اناسی واصل اولیجنی اوله آذن
صکه خروج ایدر دیرا اناسنڭ سانی دکن کبیدر یاڭاسه هلاک اولام حم
خوفندن ولدی خروج ایمز سن قرالحیم الحیوان فی بطن امّه الحکم انّی حرام
نیل حرام اولدوغی کبی وخواصنده معلوم دکلدرکه تحریر اوله قهرة صورته

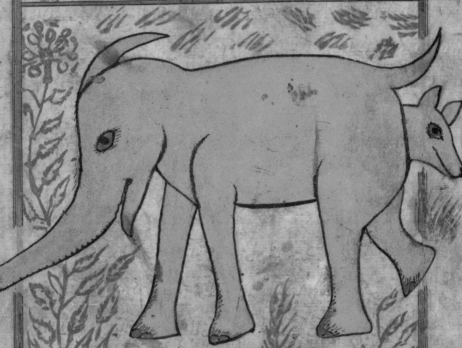

سنور هره دخی کلشدر تورکیده کدی دیلر آن حیواندر اوچ نوعدر
رجال علی وبری یوی وبری ربادیدر اڭیسن حق تعالی انساندن الوف
وتملن ومتواضع خلقی ایتمشدر نجین برمنزلده ساکن اولسه نوعندن بری دخی
اولمغوله دخولدن منع ایدوب محارب ومخاصمه ایدر حیاسی براکه کذی طوع
ولاخذ ایدر نجین برماده سی ویا آخرنسنه سرقه ایدوب نتاول ایشیه قرار
دوکوردن ناصاحب منزلنیان ایدنجه بیده کلوب ثمان آیدر سانه

UNICORNS *and* SEXUALITY

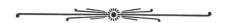

THE RAINBOW FLAG WAS CREATED BY AMERICAN artist Gilbert Baker in 1978 as a joyous symbol of the diversity of the gay community. A year later, Lisa Frank founded her rainbow and unicorn empire (see "Lisa Frank and My Little Pony," page 177), forever linking rainbows with magical creatures. Then, although traditionally all unicorns are male, little girl unicorns started popping up in magical universes like My Little Pony. Gender fluidity had become part of the unicorn universe.

"The unicorn can be a sweet, innocent pony, but there's also this phallic horn and sword out of its head. It's a symbol of freedom to be male and female," psychologist Vivian Diller said in a 2017 interview on the Jezebel website. In other words, the rainbow connection is not the only one between unicorns and the LGBTQ+ community.

"There seems to be a very clear connection between mythical creatures, which ostentatiously mix and match body parts of real creatures into hybrids, and the historical way queer people have also mixed masculine and feminine traits and aesthetics," said Sacha Coward, LGBTQ+ museum worker and writer for *Gay Star News* in the United Kingdom. "The unicorn, appearing at first glance like a 'normal' horse, but adorned with a horn and other gilded and glittery decoration, is the way a lot of LGBTQ+ people want to see themselves—as different and special through taking the basic template for what a person should be and adding to it."

Sometimes it seems the more outrageous and kitschy the unicorn imagery, the more popular it is. "Camp is kitsch seen through a queer lens, and because unicorns, mermaids, fairies are rejected by most adult men for being camp it's not surprising that we embrace them," Coward says. "The queer community throughout history is known for breaking rules, for being 'bohemian' and 'artistic.' Therefore we are drawn to the strange, weird, and overblown as counterparts to the 'other' status we so often occupy in society. Perceived as outsiders, we naturally root for the underdog, so as soon as something falls out of mainstream fashion for being kitsch, we often tend to love it even more!"

OPPOSITE: Alyssa Edwards performs on the Trafalgar Square stage during Pride In London, 2018. *ABOVE:* A crowd of fifty thousand people—and an unspecified number of unicorns—marched in the 2018 gay Pride Parade in New York City.

UNICORN MOVIE STARS

MOVIE STARS ARE BEAUTIFUL BEINGS WHO capture our imagination, and unicorns certainly fit that description. Their physical beauty, grace, and magical possibilities make them a favorite for film directors, though they are rumored to be divas on set.

Perhaps the most famous film with a unicorn star is *Legend* (1985), which also featured Tom Cruise, Mia Sara, and Tim Curry. The plot turns on the idea that darkness will fall upon the world when the last two unicorns, a mare and a stallion, are killed. The Lord of Darkness would like to achieve this, but he cannot approach unicorns because only the pure can find them. Hats off to director Ridley Scott for doing his unicorn research for this film.

The Lord of Darkness's evil henchmen take advantage of the charms of the beautiful Princess Lili to get access to the unicorns, and kill the stallion. Lili's beau, the magical forest boy Jack, teams up with a group of elves to protect the unicorn mare, restore the stallion, and defeat the Lord of Darkness using sunlight, goodness, and the power of love.

The unicorn scenes are exquisite in *Legend*, perhaps because director Ridley Scott had worked with unicorns before—in his 1982 film, *Blade Runner*, a story about a group of fugitive androids known as replicants who escape to Earth to search for their creator. A burned-out blade runner (a replicant hunter) named Rick Deckard reluctantly agrees to hunt them down. This film pitted Harrison Ford as Deckard against Rutger Hauer and Daryl Hannah as the replicants, and it featured Sean Young as Rachael, Deckard's love interest—who is also a replicant.

The nature of life itself is one of the major themes of this film, as is the question of what and who we consider to be real and fully alive. In the director's cut of the film, Deckard has a dream about a white unicorn as he grapples with these questions. At the end of the film, another blade runner, Gaff, who has been at odds with Deckard, leaves an origami unicorn in his apartment building. This unicorn's symbolism has been endlessly debated.

Claire Danes took a turn at costarring with a unicorn in the 2007 film *Stardust*, based on the novel by Neil Gaiman. She plays Yvaine, a fallen star who needs to return to the sky. She's aided by a boy named Tristan from the tiny English village of Wall, who helps her escape through the magical realm of Stormhold. Escape is not easy, because Stormhold is populated by warring princes who seek a jewel that Yvaine carries, as well as flying pirates and three wicked witches who want to cut Yvaine's heart out of her chest and eat it to restore their eternal youth. They fail but do manage to briefly turn Tristan into a mouse.

OPPOSITE: A press still from *Legend* (1985) with Tom Cruise, Mia Sara, and, shockingly, an uncredited unicorn. + *PAGE 173*: Claire Danes in a scene from *Stardust* (2007).

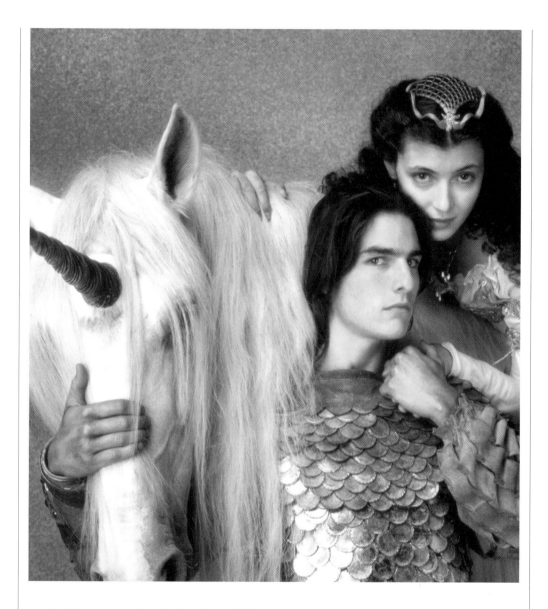

The film also stars Charlie Cox, Sienna Miller, Rupert Everett, Ricky Gervais, Robert De Niro, Michelle Pfeiffer, and Peter O'Toole. But it is the image of Claire Danes riding a unicorn that fans will always remember about this lush movie.

Many unicorn movies have also been made for children, but the ultimate classic is the 1982 animated adaptation of Peter S. Beagle's 1968 novel, *The Last Unicorn*. In it, a unicorn and a magician team up against a villainous king determined to drive all the world's unicorns into the ocean. This is a story about friendship and love.

It features the voices of Alan Arkin, Jeff Bridges, Robert Klein, Tammy Grimes, Mia Farrow, Angela Lansbury, and Christopher Lee. The score was written by Jimmy Webb and performed by the pop group America and the London Symphony Orchestra. The film showcases the exquisite animation talents of Japanese studio Topcraft, which went on to work on Hayao Miyazaki's legendary *Nausicaä of the Valley of the Wind* two years later. The great success of that film led to the founding of Miyazaki's Studio Ghibli in 1985—one of the most acclaimed animation studios in the world.

Charles Vess
Illustrates Stardust

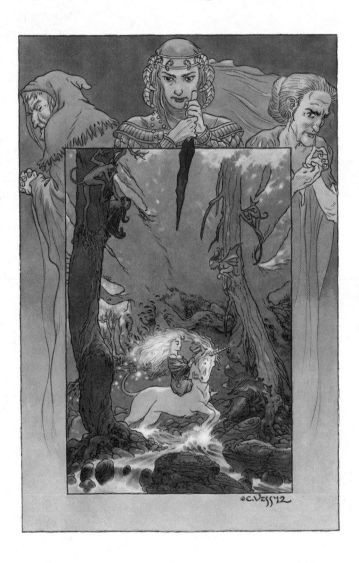

THE PROSE VERSION OF *STARDUST* INCLUDED ORIGINAL illustrations by legendary artist Charles Vess, like this one, *Yvaine on Unicorn*, which was used as the frontispiece for an edition published in 2012. "This image is one of many that I've painted since the release in 1997 of *Stardust, Being a Romance Within the Realms of Faerie*," Vess says, "that were not part of the 175 illustrations included in that original publication. Here, Yvaine, a star that has fallen from the sky into Faerie and thus is transformed into mortal form, rides a unicorn pursued by the three witch queens who seek her heart because the heart of a star is a very powerful thing indeed."

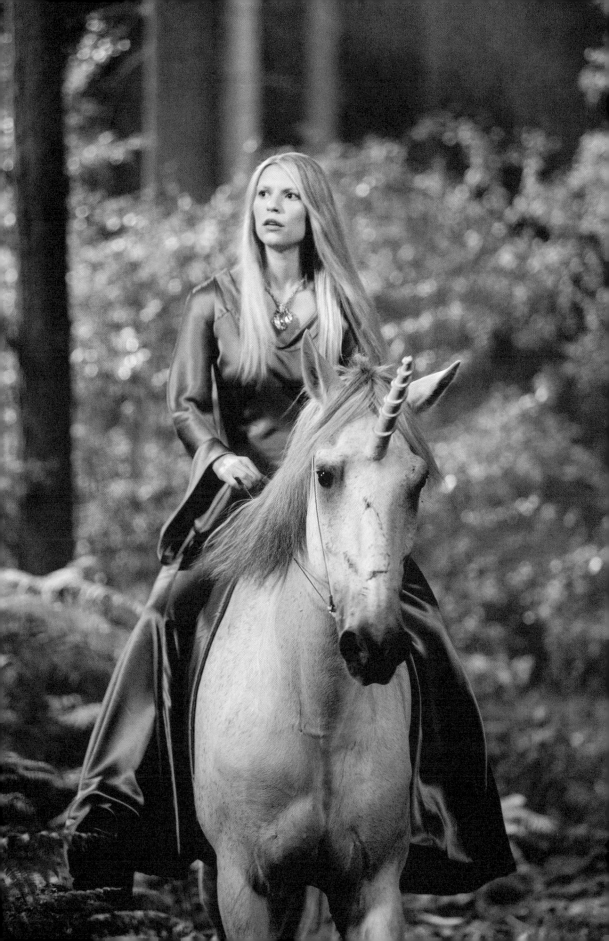

Blade Runner Unicorns

THROUGHOUT *BLADE RUNNER*, THE BLADE runner Gaff, played by Edward James Olmos, makes origami figures through which he passive-aggressively drops hints about his feelings for other characters. *Blade Runner* fan Kenneth Thompson of Michigan has a website devoted to these origami pieces (bladerunnerunicorn.com), on which he gives step-by-step instructions on how to make them (aside from the unicorn, there's also a chicken and a matchstick man). Thompson spent months figuring out how to make the origami unicorn after realizing that no other information existed and then "made the web page so everyone interested in making the unicorn could do so." People have been very grateful, he says. He even offers individual ones that cost $14.99 for those too lazy to make their own.

What is the significance of the unicorn origami in the film? According to Thompson, it depends on which version of *Blade Runner* you watch: "The original theatrical version has no dream sequence," he says. "In this one, I believe the origami unicorn represents Gaff, the maker of all the origami in the movie, telling Deckard he is free to escape with Rachael and maybe 'good luck' in their future. In the director's cut, with the dream sequence, the unicorn would mean Deckard was not human, but a replicant like Rachael. This is because his dream was a memory implant and Gaff would have been able to access that information. Gaff would be telling Deckard 'I know you're a replicant and I'm still letting you and Rachael go free.'"

Outside of the movie, Thompson says he doesn't have much interest in unicorns.

OPPOSITE: One of Kenneth Thompson's origami unicorns. Photograph by Steve Parke.

LISA FRANK *and*
MY LITTLE PONY

F THE MODERN UNICORN IS THE EMBODIMENT OF glitter, rainbows, happiness, and magic, that's thanks to Lisa Frank and My Little Pony. And Instagram.

Lisa Frank, a self-described girly girl, always loved painting, drawing, and making crafts. So after graduating from art school, she founded a company called Sticky Fingers, which made a plastic jewelry line of colorful rainbows, unicorns, and other animals. In 1979, she renamed it Lisa Frank Inc., and the same year she received her first million-dollar order from Spencer Gifts for a line of colorful school supplies, including the now iconic unicorn Trapper Keeper—a hybrid notebook with storage folders. They became so popular that the company did more than $60 million a year in sales during its peak in the late 1990s.

Meanwhile, Hasbro launched a line of toys called My Little Pony in 1982, which expanded into a cartoon series. There are Earth Ponies in the pony universe of Equestria, and also Unicorn Ponies, which have magical powers, including teleportation. When unicorns in Equestria cast magic, it produces a colored aura around their horns and other objects their magic affects. The color of the aura usually matches the color of their eyes or a prominent color of their cutie mark—a unique picturelike symbol on the ponies' flanks or haunches that symbolizes something about their character.

The My Little Pony franchise got a reboot in 2010, with more unicorns plus Pegasus Ponies and Pegasus-Unicorn Ponies called Alicorns. It was the same year that Instagram was launched, with Snapchat following one year later. These very visual ways of sharing our experiences collided with a wave of nostalgia for the 1990s, and the result was rainbow sparkle unicorns everywhere.

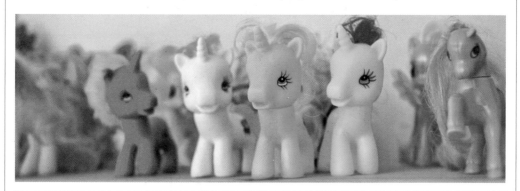

Opposite: A scene from *My Little Pony: The Movie*, 1986. + *Above:* A My Little Pony addiction in full effect.

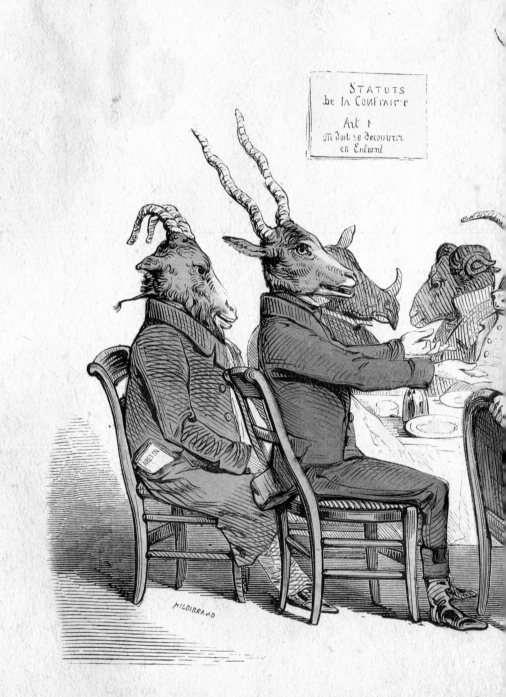

IV. Home, Food & Entertaining

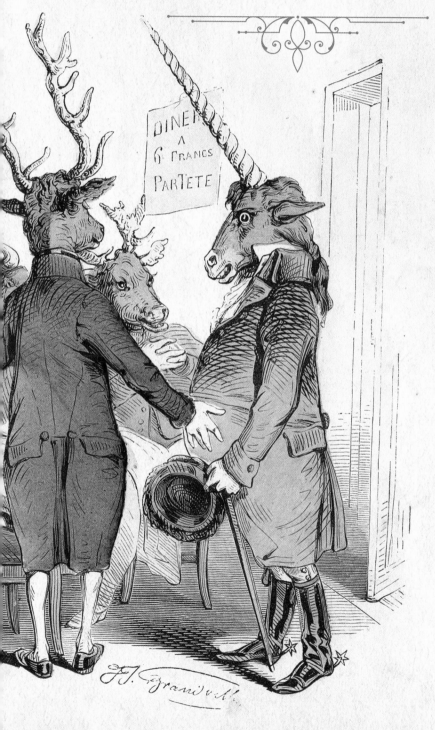

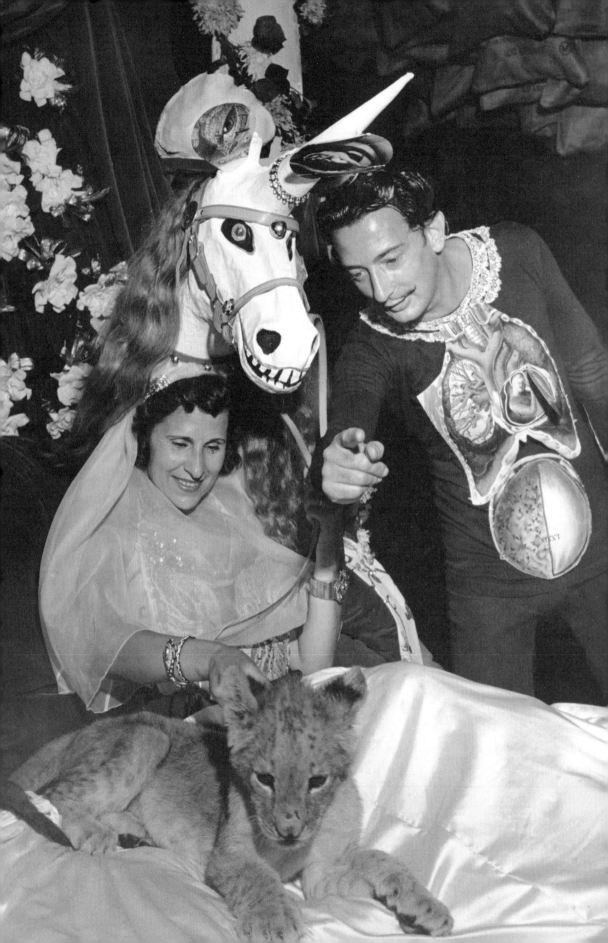

The UNICORN MASQUERADE

HOUGH THEY GUARD THEIR PRIVACY ZEALOUSLY, preferring a quiet evening of solitude in the lair with Walt Whitman's *Leaves of Grass* to the madding crowds filling the latest hot boîtes, the elegant unicorn likes to dip a hoof into pure mad luxury once in a while. Over the centuries, unicorns have graced some of the most opulent and legendary masquerade balls worldwide. As everyone is in disguise—from mask to toe—his true identity is protected, for his magnificence is perceived as a fabrication. And as he prefers to be received as a glimpse or a shimmer, the anonymity is thrilling!

The first masquerade balls were held in Renaissance Italy during the fifteenth century, perhaps most notably in Venice, where they were associated with the annual carnival. Over the years, unicorns have slipped in among the many revelers clad in traditional costume, from the Harlequin to the Columbine, without detection. And the unicorn's look, much to his surprise, has been widely copied. But it is a small price to pay for a night or two of wild freedom during the eighteen-day Carnival of Venice extravaganza.

The Grand Masked Ball of Kamel Ouali at Versailles, first held by Marie-Antoinette in 1799, was a favorite, as the unicorn prefers the verdant grounds and gardens, the veritable regal environment, and dress code—elegant eighteenth-century attire. Proof that the unicorn was present at the balls and his look resonated during the era lies with Mozart, who, according to the 1984 film *Amadeus*, astonished fellow masqueraders in a unicorn head topped with roses.

Perhaps one of the most outrageous masquerade balls ever was held by artist Salvador Dalí and his wife, Gala, in 1941, when they threw a Night in a Surrealist Forest Ball at the Hotel Del Monte in Monterey, California, to raise funds for refugee artists. Guests were asked to wear costumes inspired by their dreams.

Dalí loved unicorns—and had painted many—so it was fitting that Gala's Princess of the Forest costume included an enormous headdress of a smiling white unicorn head with a long golden mane.

PAGES 178–179: An 1854 reproduction of *Dinner at the Club*, a lithograph from J. J. Grandville's *Metamorphoses*, a series of seventy-three political caricatures first published in 1829. *OPPOSITE:* Salvador Dalí and his wife, Gala, hosted the 1941 Night in a Surrealist Forest Ball with a coterie of fauna, including this three-month-old lion cub.

The Dalís hosted the party from a massive red velvet bed, on which Gala fed a lion cub milk from a Coca-Cola bottle. This is how she greeted her guests and the press, as unicorns often do. During the lavish meal, served at a beautifully appointed table piled high with delicacies, guests in animal masks and regalia and a bevy of celebrities—including Alfred Hitchcock and Bob Hope—dined while Gala lounged at the head of the table. Monkeys borrowed from the San Francisco Zoo roamed the room during the evening; Dalí had wanted to borrow a giraffe, too, but the zoo wouldn't let him. The party was fabulous, although Dalí spent so much money on his guests that he didn't raise a penny. In fact, he lost money.

Stepping out with the crème de la crème, the unicorn put in a grand appearance at Truman Capote's legendary Black and White Ball at the Plaza Hotel in New York City in 1966. The fete has been referred to as the "party of the century," and on its fiftieth anniversary the *New York Times* called it "the best party ever." Decorator Billy Baldwin—the legendary interior designer with a top-shelf clientele that included Jacqueline Kennedy Onassis and Diana Vreeland—appeared in an astonishing unicorn mask created by the equally legendary Tiffany window display artist Gene Moore. The *Boston Globe*, in an article titled "Only Everybody Who's Anybody Was a Guest" described the mask as "incredibly handsome" and made of "black and 24 carat gold." It outshone all the other male guests' efforts and prompted Capote himself to exclaim in delight, yet it was crafted of papier mâché with silver tinsel and black tempera paint.

One can always find unicorns wandering about Mardi Gras every year in New Orleans, which provides the perfect environment for the unicorn to let its hair down and go wild while also adorning itself with astonishing amounts of purple, green, and gold beads. Revelers can often spot horned beings, or even groups of them, roaming the crowds, but in 2012 the Mystic Krewe of P. U. E. W. C. (People for the Inclusion of Unicorns, Elves, and Whinebots in Chewbacchus) was officially formed within Chewbacchus, a science-fiction-themed krewe (a social group that puts on a parade during the Carnival season). The group had previously allowed any type of costume except for those of unicorns, elves, and whinebots. However, according to the group's Facebook page, "PUEWC's first season launched with an epic 'PUEWC-test protest' outside Tipitina's where we so dazzled the Chewbacchus Overlords with our beer-soaked cries for equality and glittery horns that we were granted entry into their intergalactic midsts."

In 2017, the fashion brand Christian Dior threw a masked ball in the gardens of the Rodin Museum to celebrate designer Maria Grazia Chiuri's first couture collection for the company. According to Elizabeth Paton for the *New York Times*, "Attendees made their way through the museum and out onto a path of glittering grass, lit by candles, projected shooting stars and a vast paper moon that had been strung up into the January night sky. Next, amid leafy labyrinthine fronds, came courteous jesters on stilts against a backdrop of magic mirrors, a chorus of farmyard animal noises, and a troupe of unicorns, both black and white, which nobly bowed as visitors walked by." Though real unicorns would never bow to mere mortals—except for virgins, of course—the ball was made even more fabulous by the homage to this esteemed one-horned creature. As for whether an actual unicorn was in attendance, perhaps dressed as a high-fashion model or masquerading as an ingenue, one can never know for sure.

Opposite: Renowned interior decorator Billy Baldwin caused a stir at Truman Capote's 1966 Black and White Ball at the Plaza Hotel in New York City when he arrived wearing the most stylish masquerade mask of all time.

Signs That You Might Be a Friend to Unicorns

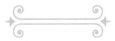

— GRACE NUTH

THOUGH A DEEP LOVE OF UNICORNS CAN MANIFEST itself in numerous ways, this list attempts to narrow them down to a few steadfast signs. If five or more of the following statements are true of you, then you may have a chance at luring a unicorn to your side.

* You first asked for purple or pink streaks in your hair at the age of five.

* When you walk in the forest, you often encounter wild animals who feel no fear toward you.

* Your favorite color is rainbow.

* Objects that shimmer with pearlescent iridescence draw your eye and fill your cupboards.

* You refuse to take horse carriage rides, because you hate to see a horse bridled.

* Your aesthetic runs more toward soft, gentle colors, white lace, and bare feet.

* Deer often visit your yard but never bother your garden.

* Sometimes the cloven marks in your yard at daybreak have a strange glittering shimmer to them, even if there has not been a frost.

* You feel things very deeply, and you wear your emotions on your sleeve.

* You hate to wear even the most delicate of chains against your skin, whether necklaces or bracelets.

* Strangers will sometimes say that you're naive, while friends call you kind-hearted.

* Every week in summer, you gather fresh wildflowers, and fill your home with their fragrance.

* Your friends ask you to play an instrument or sing when they feel stressed.

* You like to embroider and add tiny beads and pearls to the collars of your dresses.

* Dawn is your favorite time of day, when everything is fresh and pure, and the dew on the grass brushes against your ankles.

* The songs from the film *The Last Unicorn* always stir your heart and make you cry.

* If you start to feel overwhelmed with modern living, a run through the woodland, a walk through the trees, or spending time in a favorite natural spot soothes you.

* You wouldn't hurt any living creature.

* No matter your age, you still passionately believe in magic.

OPPOSITE: Annie Stegg, *Among the Flowers*, 2015.

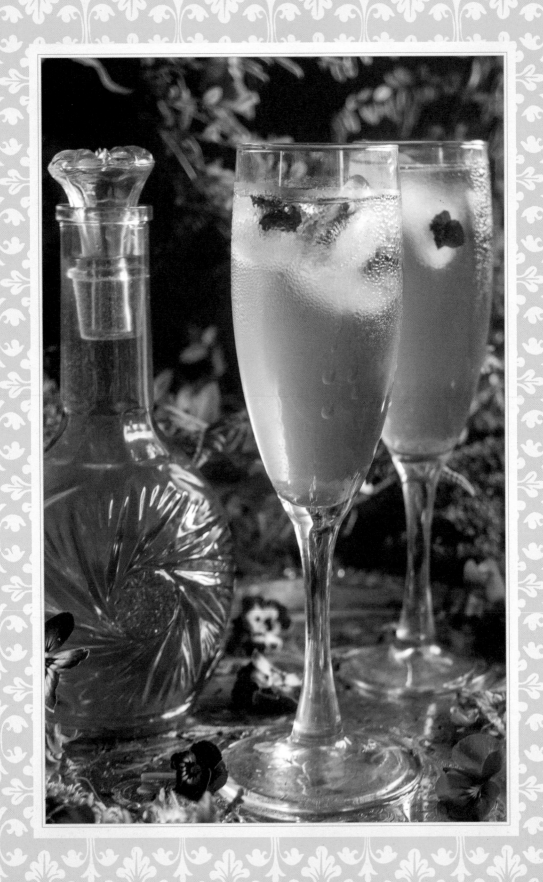

Magical Violet Cordial

—DANIELLE PROHOM OLSON

INDULGE IN A LITTLE OLD-WORLD ROMANCE WITH VIOLET cordial—just a couple of tablespoons stirred into a glass will transform your next drink into an enchanted lavender libation! In this recipe, the blossoms are steeped in spirits and rich simple syrup, both of which absorb their floral flavors, nutrients, and medicinal benefits. Infusing the liquor with the blossoms takes two to three weeks, though, so plan ahead.

Makes about 3 cups

TOOLS AND MATERIALS

- **Mason jar**
- **Fork**
- **Fine-mesh sieve**
- **Saucepan**
- **Stirrer**
- **Pint jar, or decorative bottle**

INGREDIENTS

- **1 ½ cups fresh violet (*Viola odorata*) blossoms, lightly rinsed, gently dried, and coarsely chopped**
- **½ cup spirit of choice, such as vodka, rum, brandy, or gin**
- **1 recipe Violet-Infused Simple Syrup** (recipe below)

Violet-Infused Simple Syrup

INGREDIENTS

- **2 cups granulated sugar**
- **1 cup water**
- **1 ½ cups fresh violet (*Viola odorata*) blossoms, lightly rinsed, gently dried, and coarsely chopped**

DIRECTIONS

Infusion

Place the blossoms in a pint-size mason jar and pour over your alcohol of choice. Press down with a fork until the blossoms are fully submerged in the liquid. Seal the jar and let it sit in a cool, dark place for two to three weeks. Once ready, strain the liquid through a fine-mesh sieve and discard the blossoms. Return the liquid to the jar.

Syrup

Combine the sugar and water in a small saucepan. Bring to a boil, stirring until the sugar is completely dissolved. Remove from the heat and add the blossoms. Stir well, cover, and let sit out overnight. The next day, strain the syrup and discard the blossoms. Transfer the syrup to a small glass jar, seal, and store in the refrigerator until you're ready to complete the cordial.

Completing the Cordial

Combine the strained infusion and the syrup and transfer to a sterilized pint jar or decorative bottle. The alcohol acts as a preservative, giving the cordial a longer shelf life of up to a year. If you prefer to make just the flavored syrup, keep it stored in the refrigerator for three to four weeks. You can also make a cordial by combining the violet blossoms with other edible flowers, like pansies or roses.

Your violet cordial is ready to serve!

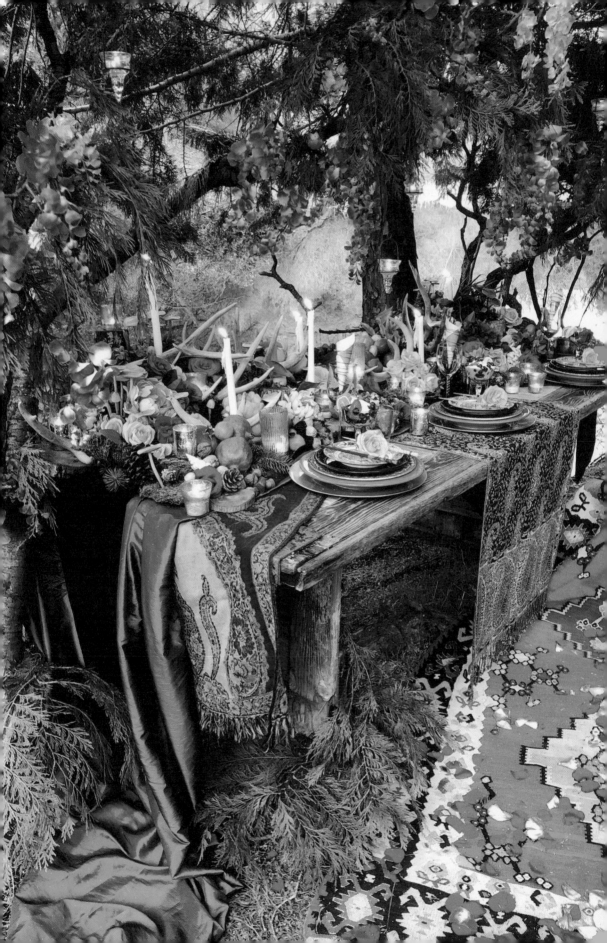

THROW *a* UNICORN
GARDEN PARTY

— *Tricia Saroya*

HE FAMOUS UNICORN TAPESTRIES CREATED IN Europe during the late Middle Ages provide ample inspiration for unicorn-themed entertaining. (For more on the medieval tapestries, see pages 133 and 144.)

The rich saturated colors in the tableau on the opposite page are both a nod to *The Lady and the Unicorn*'s red background and a representation of passionate love. The tapestry's sumptuous millefleur design offers lots of ideas for foliage, flowers, fruits, and nuts. The use of walnuts, pine boughs and cones, citrus, blackberries, acorns, pomegranates, apples, and even insects are all specific references to the tapestry's hyperrealism and lush beauty. Carefully study the tapestry and you will find all the keys you need for creating your own fantastic environment.

However you choose to represent unicorns in your table display, remember to play and have fun! After all, unicorns are a symbol of innocence and romance—chivalry, fair maidens, myths, and a belief in magic.

General Instructions *

The key to designing your own fabulous unicorn table is to create a feeling of abundance through the layering of materials. Refer to the photograph here for inspiration, but use your own imagination to conjure a unique environment for your garden party. There's no need to break the bank, as you can use a table you already own, forage your yard or a local park, and raid your own cupboards and linen closet for much of what you'll need. One trip to the grocery store or farmers' market for fruits and flowers and you'll be ready to host this regal outdoor event.

Here are a couple of tips to make prep work easier: First, be sure to have some pruners on hand for cutting branches and flower stems. Second, limit your color palette to three or four colors inspired by the tapestry. A cohesive color story, from the linens you use to the flowers, dishes, glasses, and china, helps create a unified look, which is key when working with so many elements. The base cloth in the photograph, for example, is burgundy, but because unicorns are often depicted as white, another

Opposite: When it comes to unicorns, less is not more. Use this tableau for inspiration to create your own enchanted garden party.

189

effective design choice would be all-white flowers enhanced with flocked foliage and glittery gold and silver details.

PREP WORK ✳ Gather your natural materials. What's available will depend, of course, on where you live and the season, but oak, hawthorn, citrus, holly, pine branches, and even date palm fronds, for example, are all represented in the actual tapestries. A good place to start is your own backyard or a local park or woods. Bringing along bags to carry sturdier and more fragile things separately, take a walk to find fallen lichen-covered branches, small logs, moss, pine cones, and other natural ephemera. Gather large enough quantities that you have an ample amount to work with for an abundant display.

Keeping your color palette in mind, see what you've got at home for tablecloths, table runners, napkins, wine glasses, plates, trays, cutlery, candlesticks, candles and votives, and a couple of colorful patterned rugs that work with your color theme. Include any tapestry fabrics, exotic shawls, or other elements that have special meaning to you, such as a bit of tartan fabric as a nod to Scotland, as shown on page 195. (Unicorns were considered fierce fighters and could never be taken alive, which the Scots proudly identify with.) Include surprises for your guests, such as beautiful crystals or botanical or unicorn-related treasures you might have saved.

Grab a couple of flat cardboard or wooden boxes that you can use to create different levels when you set up your tablescape.

Add fruits, nuts, and flowers. Use a bounty of fruit to create a lavish look. Pomegranates and grapes evoke a feeling of abundance. Nuts in their shells add to the cornucopia look, while mushrooms give a woodland touch. If you use mushrooms, buy them from the grocery store; do not use foraged mushrooms, as many are quite poisonous. Check out a local farmers' market for bushels of apples and other fruit in season. Look for flowers that are within your color palette. Roses, ranunculus, peonies, and seeded eucalyptus all contribute to the lush vibe.

SETUP ✳ Choose an outdoor spot that feels conducive to unicorn sightings, possibly by a stream or lake. Set up a vintage farm table or picnic table under a tree. Add some mismatched chairs—either painted or upholstered—for your guests' comfort.

Create various heights in your display by placing different-size flat boxes under the tablecloth or fabric to place things on, as opposed to laying out everything on the table at the same level. Be careful to not go above the sight line of your guests if they will be sitting across from each other.

Once you have the fabrics in place, start layering the foliage, branches, fruits, and flowers, using the photographs on pages 188, 195, and 197 for reference. The layering of the foliage will help create visual depth. Use pruners to cut off any long stems.

Add a bounty of candles and votives to the tabletop. (See page 196 for directions for making Antler Candlesticks too.)

Create lavish place settings by stacking plates of different sizes, colors, and patterns together. Consider playing with lots of references to horns by choosing twisted-stem wineglasses, cone-shaped shells, or Unicorn Horn Utensils (page 194)—chopsticks wrapped with colored wire. Add other glassware as well as unicorn-themed favors, such as Unicorn Horn Table Favors (page 193), if desired.

Add more foliage and flowers as needed to fill out the tablescape until you've achieved the desired lushness.

OPPOSITE: Precisely arranged to give a casual, almost thrown-together effect, these candles of all shapes and sizes enhance the natural enchantment of this table setting.

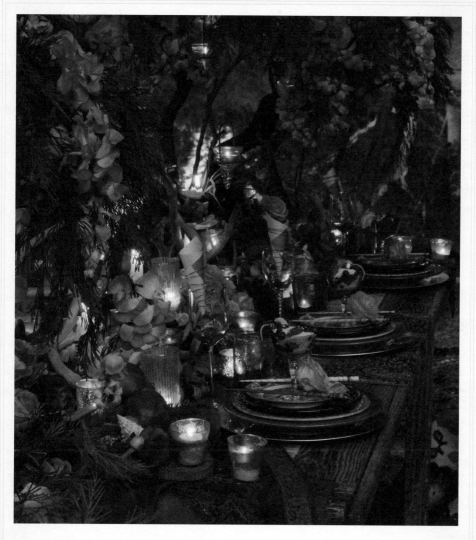

DESIGNER'S TIPS

✻ As a nod to taste, one of the five senses depicted in the tapestries, try serving a tempting dessert featuring an old-fashioned champagne glass filled with fruit sprinkled with sparkling coarse white sugar crystals. Tuck in a mascarpone mushroom and place a couple of sugared jelly fruit slices on the edge of the glass for added magic. As a variation, you could add an egg-and-sugar wash on some pieces of fruit and tuck them into the centerpiece to give some added sparkle.

✻ You might also want to include crystal bowls of water with floating flowers and candles as a reference to the unicorn's ability to purify water with its horn. You could also create small mystical pools on the table by filling shallow glass trays with water and placing foliage around the edges to cover them.

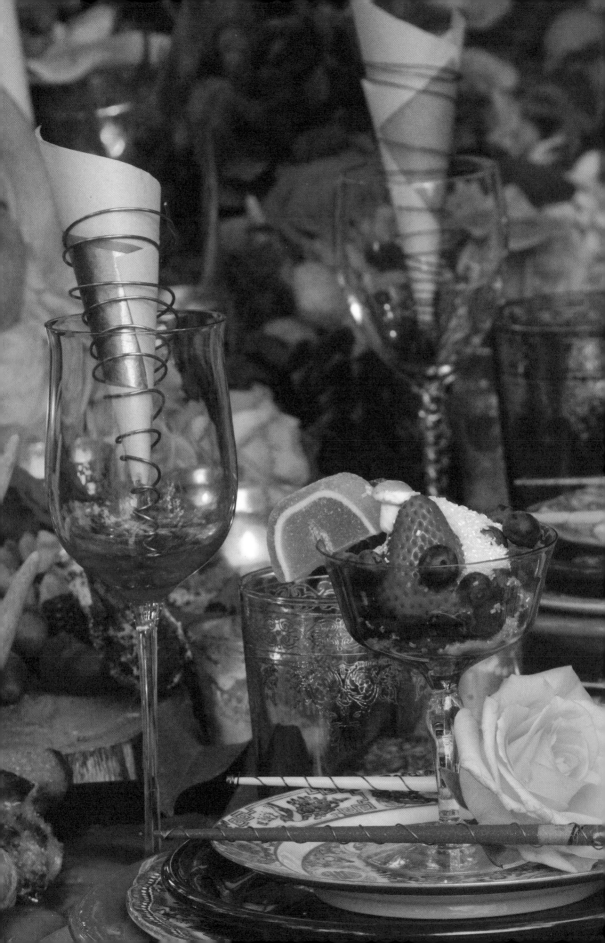

Unicorn Horn Table Favors

—TRICIA SAROYA

I T'S EASY TO CRAFT THESE UNICORN-THEMED FAVORS FOR party guests using colorful papers, poetry, and wire.

TOOLS AND MATERIALS

- **One piece flexible cardboard or cardstock, cut to approximately 6 inches square, to make one cone form**

- **Transparent tape**

- **Wire snips**

- **20- to 22-gauge jewelers' wire or Zebra Wire in assorted colors** (You will need about 24 inches for each guest.)

- **One 6 × ¼-inch dowel or wood pencil**

- **Fountain or calligraphy pens or nontoxic colored fine markers**

- **Favorite poems or literary passages referencing unicorns**

- **Assorted decorative papers in various colors, cut into approximately 5-inch squares.** (You will need about one 5-inch square per guest.)

DIRECTIONS

For each cone favor

1. Roll a piece of cardboard into a cone shape and tape the edge to secure. Set aside to use as a form for rolling your wire and poetry papers.

2. Snip a length of wire 24 inches long. Using the dowel and one of the wire spools, wrap the wire around the dowel several times, creating a coil. Slide the wire coil off the dowel. Slip the coil onto the narrow, pointed end of the paper cone. Continue to wrap the wire up the cone toward the wider end, making sure not to wrap it too tightly to avoid crushing the cone.

3. Gently slide the wire off the cone and wrap the wire around itself at both ends, securing it so it doesn't uncoil. Set aside.

4. Using the fountain pen, transcribe poetry passages onto the decorative paper squares.

5. Wrap the poem-decorated paper around the cardboard cone to get the proper shape. Do *not* secure with tape. Simply slide it off your cardboard form and then insert the paper cone into the wire cone. Your guests can then remove the poem easily, unfurl it, and read.

Unicorn Horn Utensils

REATE UNIQUE UTENSILS THAT RESEMBLE UNICORN horns using rainbow-hued chopsticks and colorful wire.

TOOLS AND MATERIALS

+ **A package of assorted colored plastic chopsticks or single-use wooden chopsticks, the more fanciful the better**

+ **Nontoxic, permanent colored markers** (optional)

+ **Wire snips**

+ **20- to 22-gauge jewelers' wire or Zebra Wire in assorted colors**

+ **Hot-glue gun and glue sticks**

DIRECTIONS

For each utensil

1. If using wooden chopsticks, color spiral patterns on them with the markers.

2. Snip a 15-inch length of wire, bend one end, and hold it against the base of the chopstick with your finger and thumb. Wrap the wire over the bent end several times to secure it to the chopstick.

3. Continue to wrap the wire around the chopstick down to the narrow tip, ending with several wraps around the small end to secure it. Trim any excess wire.

4. Add a dab of hot glue onto the wire at the base and tip of the chopstick so it doesn't unravel.

5. Let the glue harden thoroughly before using.

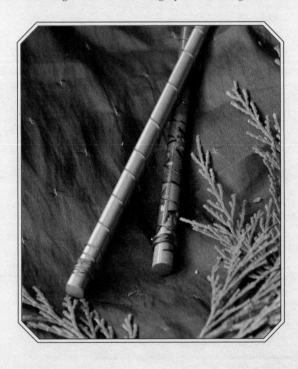

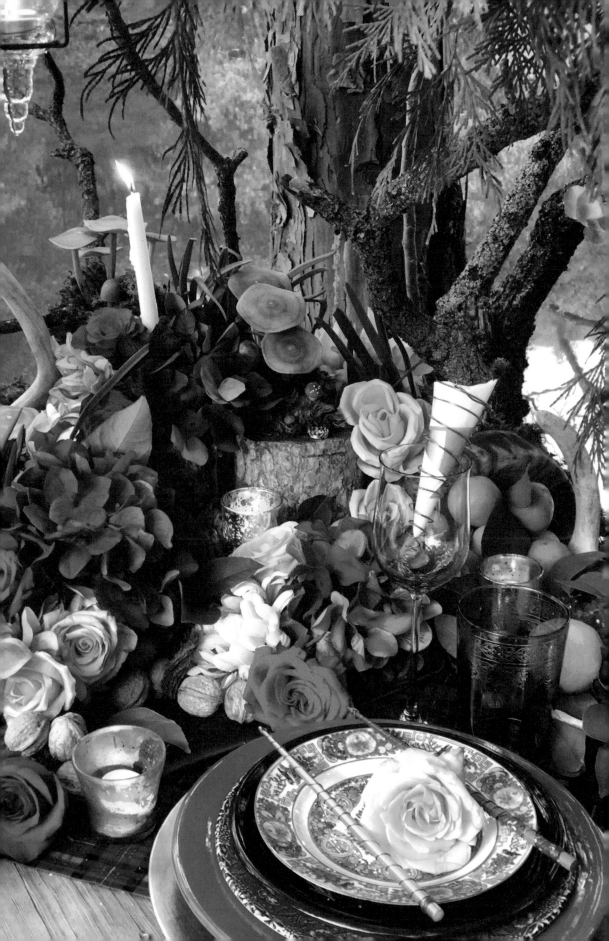

Antler Candlesticks

OU PROBABLY WON'T FIND ANY UNICORN HORNS IN THE woods around your home, but you can collect shed deer antlers in the wild. Or you can purchase real-looking faux antlers to create rustic antler candelabras for your tableau.

TOOLS AND MATERIALS

* **Several real shed deer antlers or faux antlers** (available on Amazon and Etsy or in craft stores)

* **Silver or gold spray glitter** (optional)

* **Nonpermanent marker**

* **Power drill with a bit slightly larger than the nail width**

* **Hot-glue gun and glue sticks**

* **1-inch box nails to secure the candles, 1 per candlestick**

* **Flat-bottomed taper candles, 1 per antler**

NOTE: Nail should be about ¼ inch longer than thickness of antler.

DIRECTIONS

For each candlestick

You will be drilling a hole through the antler in the spot where you want the candle to be, then inserting the nail through the hole from the bottom. The candle will rest on the nail.

1. Start by placing the antler on a flat surface to see how it naturally lies in a stable manner. If desired, spray the antler with a light dusting of glitter for an added touch of magic.

2. Mark where you want the candle to be located.

3. Carefully and slowly drill a hole all the way through the antler where you marked.

4. Add a dab of hot glue to the underside of the hole.

5. Before the glue hardens, insert a nail through the hole you just made, from the bottom, leaving about ¼ inch of the nail exposed on the top side to secure the candle.

6. When the glue has hardened, affix the candle to the nail by carefully pushing the bottom of the candle onto the nail.

The moonlight fades from flower and rose

And the stars dim one by one;

The tale is told, the song is sung,

And the Fairy feast is done.

—LOUISA MAY ALCOTT,
"Fairy Song," from *Flower Fables*, 1855

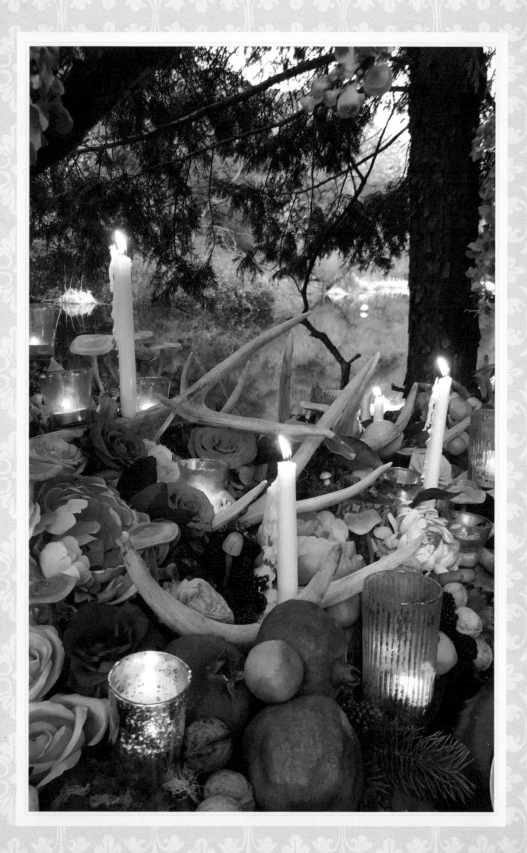

CERTAIN REQUIREMENTS
of the UNICORN GENTLEMAN

— Virginia Hankins and Lillian Rose

OU'VE PREPARED YOURSELF, ENTERED THE enchanted wood and lured a unicorn to you, cradled his stately head in your lap, and then taken him home. . . . Now what? Don't presume that just because you've caught a unicorn, you'll keep him. It is a challenge to keep this dignified fellow happy, for his taste is exemplary; his temperament, quixotic; and his tolerance for inauthenticity, extremely low.

Never treat the unicorn like a horse; his needs and personal preferences are as unique as he is and must be tended to fastidiously. Be sure you've set up proper accommodations for him before you set out on your quest, because if anything displeases him upon his arrival at the manse, he may vanish just as suddenly as he appeared.

Overall, the unicorn is especially averse to anything horn-shaped and/or involving horse-hair. Anything and everything provided for him must be crafted from organic, pure materials. There is no fooling him: he is a keen detector of synthetics, synthetic blends, artificial flavors and scents, and all matter that has been unethically sourced. Here are some additional tips for keeping him content in the fold:

❋ Stock up on handmade grooming brushes fashioned of polished hardwood as well as silk ribbons and fresh flowers to entwine through his long mane, of which he is proud and fond of tossing back and forth.

❋ Provide a horn polishing kit in a sterling silver box lined with velvet in his armoire.

❋ The unicorn's active mind should be fed with a steady diet of diverse reading material: Walt Whitman's *Leaves of Grass*, Thoreau's *Walden*, illuminated bestiaries, anything by Robert Frost, most things Arthurian, John Muir's writings on environmentalism, and the short stories of Saki and the like will please him. Of course, you'll also want to stock up on courtly love poetry as well as sonnets by Petrarch and Shakespeare. Many unicorns also have a deep affection for Baudelaire.

❋ Think *The Great Gatsby*. Just as Jay Gatsby had a wardrobe brimming with bespoke shirts that were so beautiful they made Daisy Buchanan cry, the unicorn will take great pleasure in your installation of an antique mahogany armoire, filled with a perfectly folded assortment of the finest monogrammed Scottish cashmere blankets and expertly woven tartan throws.

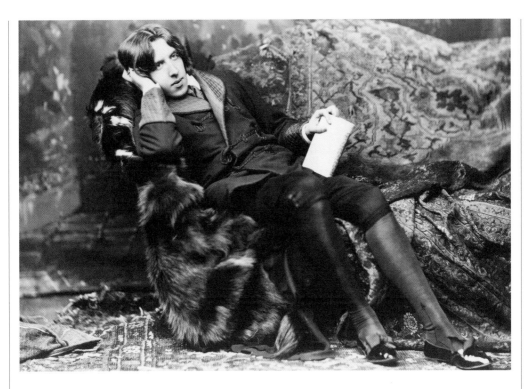

* Commission a custom-concocted cologne, perhaps a scent redolent of pine with a hit of mushroom and cool ash; crushed almond blended with just-mown grass, damp from last evening's rain; Spanish moss tinged with vetiver, oak leaves, and a virgin's tears; or perhaps a cypress, sandalwood, and poinsettia blend. In a pinch, go for Eau Sauvage by Christian Dior; it's a classic, with lemon giving it olfactory sparkle!

* Provide a range of gentlemanly and discreet disguises he can use for his rare public appearances. Custom-made suits from Savile Row's H. Huntsman & Sons, Henry Poole & Co., and Anderson & Sheppard are perfect for the aristocratic unicorn, along with a chapeau or deux from London's oldest hat maker, Lock & Co. Hatters. And while you're going for bespoke, G. J. Cleverley & Co. will shoe his divine hoofs most expertly with sublime leathers.

* When taking him on daily constitutionals, dress to impress him. But remember, a lady only walks or canters merrily while riding aside—only fools and trolls attempt to bounce around at a trot while gowned. And never use a lead or hold on to his horn, as he will perceive this as a lack of skill on your part.

* For movie night at home, keep on hand *The Last Unicorn*, *War and Peace*, *The Princess Bride*, and *Seven Samurai*. Some unicorns have shown a deep affection for *Sixteen Candles*, old romances starring Cary Grant, and the occasional James Bond classic. Avoid horse movies, especially westerns.

* Keep anything involving the Unicorn Tapestries—and indeed almost any piece of classic unicorn art—out of his domain, as most of this art and literature involves unicorn hunts, which he will, understandably, find upsetting.

ABOVE: The unicorn's poetic soulmate is no doubt the impeccably dressed playwright Oscar Wilde, who is often credited with this unicornian bon mot, "Be yourself; everyone else is already taken." This 1882 image of Wilde was taken in New York by photographer Napoleon Sarony.

UNICORN FOOD FIGHT

OR THE PAST SEVERAL YEARS THERE SEEMS TO have been a disturbing consensus on social media that unicorns and those who love them are sugar addicts. Modern-day unicorns seem to subsist solely on unicorn macarons, cakes, cupcakes, cookies, hot cocoas, and every other sugary confection you can think of—many of them in rainbow colors, enhanced by dramatic eyelashes and/or lustrous, delectable horns.

Jessie Oleson Moore, author of *Stuff Unicorns Love*, claims that unicorns primarily use their horns as a donut holder and that they "survive and thrive on cupcakes, cookies, cotton candy, and other sweets." This glucose-infused trend was spurred in 2012, when Los Angeles amateur baker Kristy Therrien posted a sugar cookie recipe on the do-it-yourself website Instructables that used food coloring and sugar sprinkles to create a colorful confection she eventually trademarked as unicorn poop. Unicorn foods then took off, but the colors were mostly artificial and sugar based.

Everyone knows that a real unicorn dines mainly on milky oats, flowers, seeds, and greens—well, almost everyone.

In 2017, the End, a hipster coffee shop in Brooklyn, filed a $10 million lawsuit against Starbucks, claiming the megachain's Unicorn Frappuccino infringed upon the End's Unicorn Latte, which had been launched months earlier. (Starbucks claimed the suit was "without merit," but the two parties settled the dispute in August 2017 for an unspecified amount). This unicorn food fight exemplifies the opposing contemporary visions of the unicorn that we live with today: The End's Unicorn Latte is made with healthful ingredients like ginger, spirulina, and maca root—a reflection of the medieval unicorn as a symbol of purity and goodness that appeals to the more organically oriented. The Unicorn Frappuccino is made with mango syrup, sour blue powder, whipped cream, and lots and lots of sugar—a colorful, glittery, and sweet confection that appeals to those with an uber-pop sensibility, or a love of *kawaii* (the Japanese word for "super cute"), a term that would definitely apply to Hello Kitty, who was created in 1974 and has been featured riding a unicorn. "What's cuter than Hello Kitty and unicorns?" the Sanrio online store asks. "Hello Kitty riding a unicorn!"

The healthier unicorn food trend took hold when food stylist Adeline Waugh shared her unicorn toast—spread with cream cheese dyed with natural plant pigments—on Instagram in 2016. Suddenly there was healthier pastel unicorn ramen, nut milks, lassi, and salads. Kat Odell's 2018 tome *Unicorn Food* is full of sumptuous recipes for beautiful, healthful, rainbow-colored dishes like sweet-and-sour rainbow radish tacos or a probiotic brekkie bowl that brings together coconut-matcha custard, spiced purple yam custard, and orange

blossom-clove custard with vanilla almond milk, strawberry-vanilla chia jam, hemp seeds, pistachios, papaya, kiwi, berries, and dragon fruit. A section titled "How to Unicorn Your Food" is divided into colorful and healthful foods in pink and red (beets, dried goji berries, pitaya powder, rose petals); purple (purple cabbage); yellow (bee pollen, turmeric); green (matcha powder, pistachios, spirulina); and blue (Blue Majik algae powder, blueberries) so that you can eat nutritious foods that span the rainbow.

Above: **This colorful probiotic brekkie bowl from Kat Odell's book *Unicorn Food* just might be too pretty to eat.**

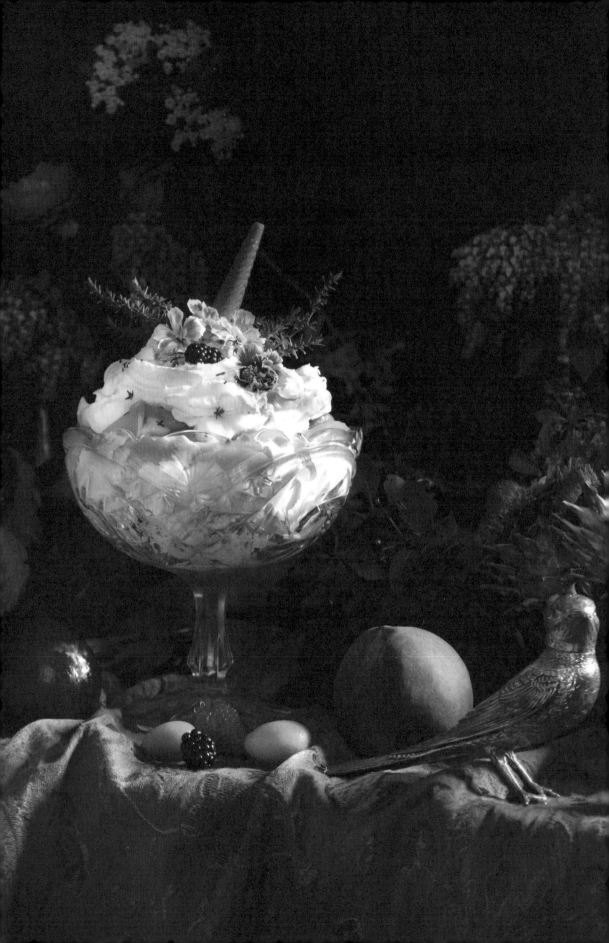

MILLEFLEUR TRIFLES
in HONOR *of* THE LADY *and the* UNICORN

— DANIELLE PROHOM OLSON

HESE THREE MILLEFLEUR TRIFLES ARE A culinary tribute to *The Lady and the Unicorn* tapestries, which shimmer with superbly detailed images of the blossoms, herbs, fruit-bearing trees, and berries found in the lavish gardens of aristocratic ladies, everything from roses to dianthus, plums, peaches, strawberries, blackberries, and even tropical fruits like figs, oranges, and pomegranates.

Made with plenty of fresh fruit, cake doused with spirits, and mounds of cream, the trifle's name originates from the old French word *trufle,* which roughly translates "whimsical indulgence." The first recipe appeared in the late fourteenth century, approximately the same time period as the creation of the tapestries, and calls for thick cream flavored with sugar, ginger, and rosewater.

When creating a culinary homage in the form of a trifle, self-denial and renunciation have no part. That's also why there is more than one trifle recipe here. From a towering spring celebration of berries and flowers with lemon custard, to a golden summer version with peaches, thyme, and slightly spiced dianthus cream, to an exotic kumquat and pomegranate version layered with rose cream, these trifles are filled with the sacred flowers, fruits, and berries of the tapestries. While none of the trifles may be historically accurate, all were created in classic form, with layers of sponge cake soaked in brandy and sherry, fresh succulent fruit, and liberal helpings of custard and cream. And, of course, you can top them with sugar cones in honor of the unicorn's horn, if desired.

A few words on the trifle recipes: Though a trifle presents as an extravagant, labor-intensive dessert, it's quite easy to assemble using store-bought ingredients. In these recipes, we recommend starting with store-bought cake that's left out on the counter for at least a day or two to dry out so it will hold all that custard and cream. Recipes for the custards are included, but you can also use a ready-made custard or mix. Whip the cream yourself or spritz it from a can. What's most important is to create an artful, abundant confection that is as much a delight to the eye as to the palate.

LEMONY BERRY TRIFLE

Makes 8 servings

TOOLS AND MATERIALS

- **Large bowl**
- **Zester**
- **Knife**
- **Trifle bowl: a large glass bowl, sometimes footed, with straight sides and flat bottom**

INGREDIENTS

- **1 pound assorted fresh strawberries, hulled and halved, blueberries, and blackberries, plus more for garnish**
- **⅓ cup sherry**
- **Zest and juice of 1 lemon**
- **⅓ cup rose jam**
- **1 store-bought 9-inch sponge cake, left to dry out on the counter, uncovered, for at least one day**
- **⅓ cup brandy**
- **Handful of fresh edible blossoms, such as pansy (*Viola tricolor*), daisy (*Bellis perennis*), and rose petals (*Rosa*, any variety), plus more for garnish**
- **1 recipe Vanilla Custard, chilled** (recipe on opposite page)
- **1 cup whipped cream**
- **Sugar cone, for decoration** (optional)

DIRECTIONS

1. Toss the fruit with the sherry, lemon zest, and juice and set aside to macerate.

2. Spread the rose jam on the cake. Cut the cake into 1-inch chunks and fit half the pieces snugly together to line the bottom of the trifle bowl, jam side up.

3. Drizzle the cake with the brandy.

4. Tuck a layer of flower petals along the outer edges of the cake, pressing them up against the glass.

5. Layer half the fruit over the cake and spread half the custard on top.

6. Repeat with another layer of cake chunks, flowers, berries, and custard.

7. Top with the whipped cream and garnish with edible blossoms and fresh berries.

8. Chill well before serving.

9. Display with an inverted sugar cone as a unicorn horn before serving, if desired.

Vanilla Custard

Makes 3 cups

Tools and Materials

+ **Saucepan**
+ **Large bowl**
+ **Spatula**
+ **Whisk, or wooden spoons**
+ **Fine-mesh sieve**
+ **Medium bowl**

Ingredients

+ **2 cups whole milk**
+ **2 cups heavy cream**
+ **1 vanilla pod, split and scraped**
+ **6 large egg yolks**
+ **¾ cup granulated sugar**
+ **2 tablespoons cornstarch**

Directions

1. In a medium saucepan, combine the milk, cream, and vanilla pod and seeds. Bring to a boil and then remove from the heat.

2. In a large bowl, whisk the yolks with the sugar and cornstarch until smooth and pale.

3. Slowly pour the boiled cream mixture over the egg yolks, whisking all the time, to temper the eggs.

4. Return the mixture to the saucepan over low heat, whisking or stirring with a wooden spoon for about 30 to 45 minutes, until it thickens sufficiently to coat the back of a spoon. Never boil the custard! Once it's done, strain the custard through a fine-mesh sieve to make it extra silky. Place in a covered medium bowl in the refrigerator until cold.

POMEGRANATE, KUMQUAT, AND FIG TRIFLE

Makes 8 servings

TOOLS AND MATERIALS

* **Small bowl**
* **Fine-mesh sieve**
* **Airtight container**
* **Large bowl**
* **Knife**
* **Trifle bowl** (see page 204)
* **Spatula**
* **Whisk, or hand-held mixer**

INGREDIENTS

* **Handful of rose petals (*Rosa*, any variety), fresh or dried**
* **½ cup whipping cream**
* **1 pint fresh kumquats, halved, or sections of blood orange or tangerine**
* **Arils (seeds) from 1 pomegranate, a small handful reserved for garnish**
* **3 fresh figs, cubed**
* **1 tablespoon diced candied ginger, plus more for garnish**
* **1 teaspoon ground cardamom**
* **⅓ cup sherry**
* **½ cup orange marmalade or fig jam**
* **1 store-bought 9-inch angel food cake, left to dry out on the counter, uncovered, for at least one day**
* **⅓ cup brandy**
* **3 cups Vanilla Custard** (page 205)
* **1 cup store-bought meringue cookies, crumbled**
* **1 fresh fig, thinly sliced, for garnish**
* **Sugar cone, for decoration** (optional)

DIRECTIONS

1. The day before serving, combine the rose petals and the whipping cream in a small bowl. Cover and infuse overnight in the refrigerator. Strain the mixture through a fine-mesh sieve, discarding the blossoms. Store the infused cream in an airtight container in the refrigerator.

2. In a large bowl, toss together the kumquats, pomegranate arils, cubed figs, diced candied ginger, cardamom, and sherry and set aside to macerate.

3. Spread the marmalade on the cake. Cut the cake into 1-inch chunks and fit half the pieces snugly together to line the bottom of the trifle bowl, jam side up.

4. Drizzle the cake with the brandy.

5. Layer half the fruit mixture on top of the cake layer and top with half the custard.

6. Add a layer of the crumbled meringue cookies on top.

7. Repeat with the remaining cake, fruit, and custard.

8. Whip the infused cream with a whisk or hand-held mixer and spread on top of the trifle.

9. Garnish with the remaining pomegranate arils, sliced fig, and a sprinkle of candied ginger.

10. Chill well before serving.

11. Display with an inverted sugar cone as a unicorn horn before serving, if desired.

PEACH AND BUTTERSCOTCH TRIFLE

Makes 8 servings

TOOLS AND MATERIALS

+ **Small bowl**
+ **Fine-mesh sieve**
+ **Airtight container**
+ **Medium bowl**
+ **Knife**
+ **Trifle bowl** (see page 204)
+ **Spatula**
+ **Whisk, or hand-held mixer**

INGREDIENTS

+ **Handful of fresh dianthus (*Dianthus plumarius*) or carnation blossoms (*Dianthus caryophyllus*)**
+ **½ cup whipping cream**
+ **1 pound fresh peaches, sliced, or one 16-ounce can of peaches, drained**
+ **1 teaspoon minced fresh thyme**
+ **1 teaspoon ground cardamom**
+ **⅓ cup sherry**
+ **⅓ cup apricot jam**
+ **1 store-bought 9-inch yellow cake, left to dry out on the counter, uncovered, for at least one day**
+ **⅓ cup brandy**
+ **1 cup Vanilla Custard, chilled** (page 205)
+ **1 cup Butterscotch Pudding, chilled** (recipe on opposite page)
+ **Handful of fresh berries, such as blueberries, blackberries and/or raspberries, for garnish**
+ **Thyme sprigs, for garnish**
+ **Sugar cone, for decoration** (optional)

DIRECTIONS

1. The day before serving, combine the blossoms with the whipping cream in a small bowl. Cover and infuse overnight in the refrigerator.

2. Pass the mixture through a fine-mesh sieve, discarding the blossoms. Store the infused cream in an airtight container in the refrigerator until ready to use.

3. In a medium bowl, mix together the peaches, minced thyme, cardamom, and sherry. Set aside to macerate.

4. Spread the apricot jam on the cake. Cut the cake into 1-inch chunks and fit half the pieces snugly together to line the bottom of the trifle bowl, jam side up.

5. Drizzle the cake with the brandy.

6. Layer half the fruit on top of the cake layer and top with the vanilla custard.

7. Repeat with another layer of cake and fruit; then, top with the butterscotch pudding.

8. Whip the infused cream with a whisk or hand-held mixer and spread it on top of the trifle.

9. Garnish with fresh berries and sprigs of thyme.

10. Chill before serving.

11. Display with an inverted sugar cone as a unicorn horn before serving, if desired.

BUTTERSCOTCH PUDDING

Makes 2 cups

TOOLS AND MATERIALS

- **Nonstick saucepan**
- **Whisk**
- **Small bowl**
- **Medium bowl**
- **Plate or saucer, to cover medium bowl**

INGREDIENTS

- **¾ cup packed light brown sugar**
- **2 tablespoons cornstarch**
- **¼ teaspoon sea salt**
- **1½ cups whole milk**
- **2 large egg yolks**
- **2 tablespoons unsalted butter**

DIRECTIONS

1. In a medium nonstick saucepan, whisk together the brown sugar, cornstarch, and salt.

2. In a small bowl, whisk together the milk and egg yolks. Add to the pan and stir to combine over medium heat. Cook, stirring gently, until the mixture thickens, about 8 minutes. Stir in the butter, removing from the heat once it's incorporated.

3. Transfer the mixture to a medium bowl, cover with a plate or saucer and place in the refrigerator to chill.

The Unicorn's Looking-Glass Cake

—Danielle Prohom Olson

LEWIS CARROLL'S FAMOUS CLASSICS *ALICE'S ADVENTURES in Wonderland* and *Alice Through the Looking-Glass* are filled with references to magical food. There is the Queen of Hearts famous jam tart, Bread-and-Butterfly pudding, and the Looking-Glass Cake Alice serves to the Lion and the Unicorn.

In *Through the Looking-Glass*, the Lion and the Unicorn take a break from fighting and settle down for a snack. The White King calls out, "Ten minutes allowed for refreshments!" and immediately trays of white and brown bread are produced. The Unicorn turns to the White King and demands, "Come, fetch out the plum-cake, old man! None of your brown bread for me!"

When the cake is presented, Alice tries to cut it up, but it remains stubbornly whole. The Unicorn tells Alice she does not know how to manage Looking-Glass Cakes and instructs her to "carry it round first, and cut it up afterwards," after which it magically divides itself into pieces!

Plum cake in the nineteenth century had no plums (a Looking-Glass Cake indeed) and was really a fancy fruit cake, usually served at weddings and special holidays like Christmas. The recipe for this plum cake was adapted from one found in the out-of-print gem *The Alice in Wonderland Cookbook: A Culinary Diversion*. While this is a classic recipe for old English plum cake, it now includes more of the fruits and nuts that unicorns are reputed to love. These include apples and hazelnuts, the fruit of trees under which the unicorn is said to be found.

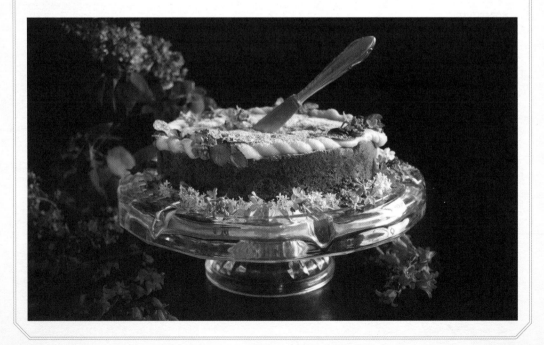

Makes one 8-inch round cake

TOOLS AND MATERIALS

- **One 8-inch cake pan**
- **Parchment paper**
- **Large bowl**
- **Small bowl**
- **Whisk**
- **Medium bowl**
- **Spatula**
- **Wire rack**
- **Knife**

INGREDIENTS

- **½ pound unsalted butter, softened**
- **½ pound superfine sugar**
- **3 large eggs**
- **2 ¼ cups all-purpose flour**
- **2 teaspoons baking powder**
- **½ cup dried apple slices**
- **½ cup currants (or substitute golden raisins)**
- **½ cup mixed candied citrus peel**
- **6 tablespoons raisins**
- **4 tablespoons whole or halved hazelnuts**
- **4 tablespoons walnut pieces**
- **1 teaspoon ground cinnamon**
- **1 teaspoon ground allspice**
- **⅓ cup brandy**

1. Preheat the oven to 300° F. Line a round 8-inch cake pan with parchment paper and set aside.

2. In a large bowl, cream together the butter and sugar until fluffy.

3. In a small bowl, beat together the eggs with a whisk. Gradually whisk them into the creamed butter-sugar mixture.

4. In a medium bowl, sift together the flour and baking powder. Then, into the wet ingredients add the dry mixture in increments until dry and wet ingredients are incorporated.

5. Fold in the fruit, raisins, nuts, and spices. Mix in the brandy.

6. Transfer the batter to the prepared cake pan. Bake in the oven for 1 hour at 300° F. Reduce heat to 250° F and bake another two hours (or until a toothpick inserted into the center emerges clean).

7. Remove cake from the oven and let it cool in the pan on a wire rack.

8. When the cake is cool, turn it out, cut it into slices, and pass around.

PAGES 212–213: Only plum cake can bring together formidable foes the lion and the unicorn in this illustration by John Tenniel from Lewis Carroll's *Alice Through the Looking-Glass*, 1871.

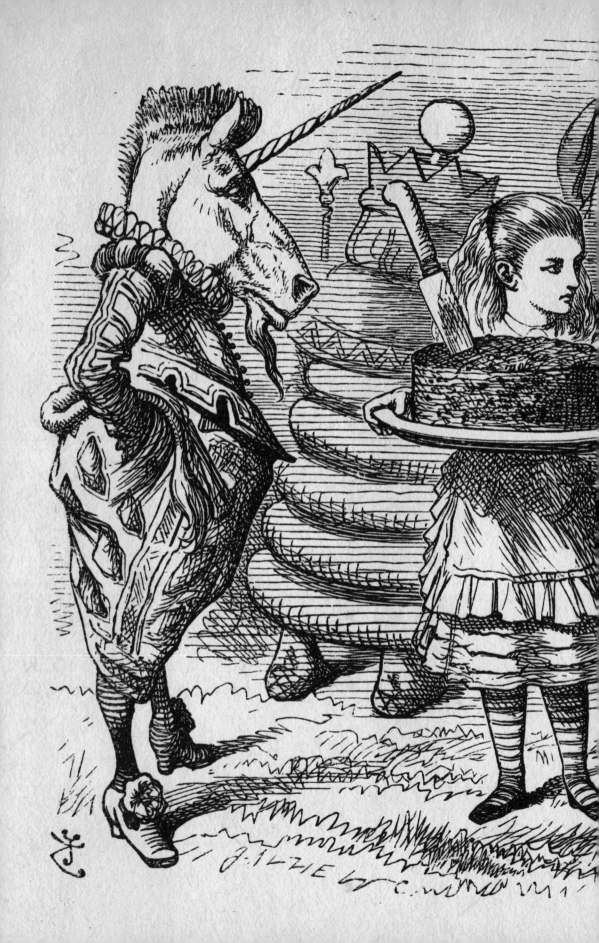

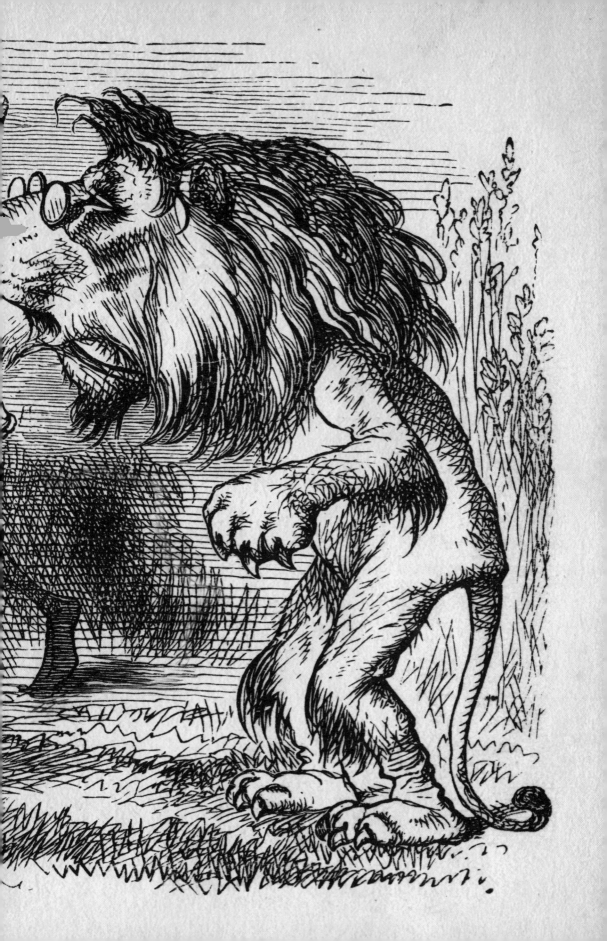

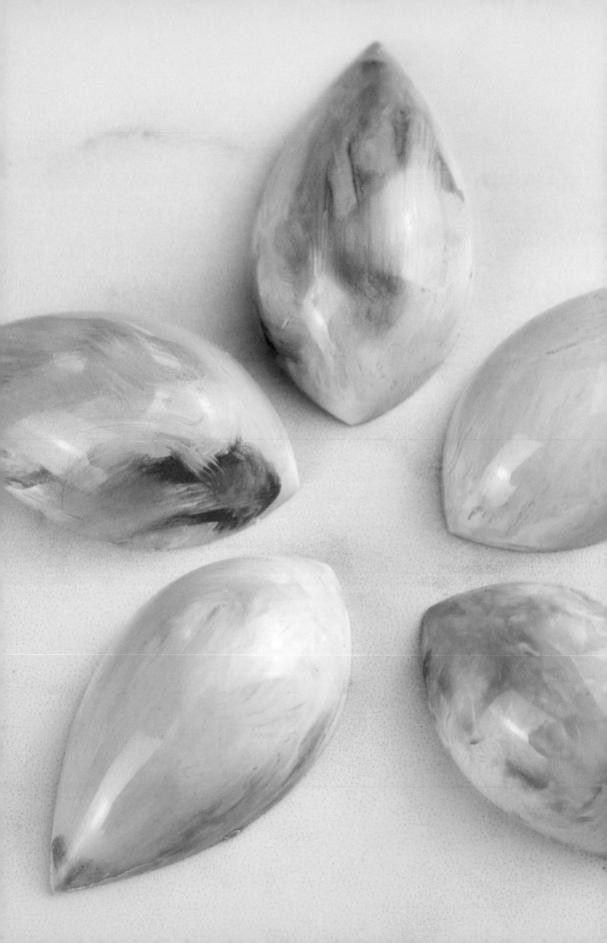

Unicorn Bonbons

—Anne Boulley

Although you can use whatever shape you like, choosing teardrop-shaped molds for these iridescent white chocolate confections results in a special tribute to unicorn tears. These smooth, glossy treats are easy to make with colored cocoa butters and fruit-flavored oils. Read through the directions first and follow them carefully to produce only tears of joy!

Makes 16 bonbons

TOOLS AND MATERIALS

For Preparing the Molds

- **Teardrop- or lotus-shaped chocolate molds** (polycarbonate professional molds are best, like those from Goldbaking)

- **Candy thermometer**

- **Small soft paintbrushes or kitchen gloves**

For Preparing the Chocolate

- **Metal or glass bowl**

- **Large saucepan**

- **Wooden spoon**

- **Fine Microplane grater**

- **Plate, for grated cocoa butter**

- **Flat knife, or spatula**

- **Parchment paper, or paper towels**

- **Airtight container**

INGREDIENTS

- **1.7-ounce colored cocoa butters in a variety of colors, including white for blending:** White Diamond, Aquamarine, Green Peridot, Yellow Citrine and Pink Quartz *(available at Chefrubber.com)*

- **1 pound white chocolate**

- **Flavored oils: raspberry, lemon, and vanilla**

- **1 teaspoon 100 percent pure cocoa butter, grated off a larger chunk**

DIRECTIONS

Prepare the Molds

1. Make sure the molds are very clean—shiny and smudge-free. The chocolate will come out shiny only if the molds are shiny. Wash the molds in hot water with a mild dish soap and carefully dry them. Rub the impressions dry with cotton balls or cotton makeup-remover pads to avoid scratching and streaking.

2. Melt the colored cocoa butters in their original containers in the microwave in 30-second increments. Every 30 seconds, pull out the bottles and shake them. Keep heating until you can hear the cocoa butter has liquefied— don't heat beyond that point. The temperature should be between 80° F and 90° F—when they're liquid but feel cooler than body temperature.

3. Using paintbrushes or gloved fingertips, add a small streak of each color (except for white) to each mold (3A). Then go back over with white to blend softly (3B). For example: dab a spot of yellow and smear it, dab a dot of blue and smear it thin, and then add another color, and then add in white and blend so that the colors look almost like opal. The ratio of color to white depends on how much you blend and how much color you use. Allow to set until dry.

6A

6B

Prepare the Chocolate

4. Using a metal or glass bowl, create a double boiler. Bring about an inch of water to a simmer in a large saucepan and place the bowl on top. Add the white chocolate and 4 drops of each flavored oil. Stir occasionally to prevent burning. Don't let any steam or water come into contact with the chocolate or it won't be usable.

5. Once the chocolate is melted, grate the cocoa butter onto a plate. When the chocolate temperature reaches 93° F, stir in the grated cocoa butter. Continue to stir for a few minutes to completely incorporate the cocoa butter into the chocolate.

6. When the chocolate temperature reaches 85° F, carefully pour it into the molds (6A). Use a flat knife or spatula to scrape off any excess (6B). Transfer molds to the refrigerator and cool for 15 to 20 minutes to harden. Remove the molds and flip upside down, placing the chocolates onto a plate lined with parchment paper or paper towels.

7. Use gloves to pick up the bonbons from their sides to avoid fingerprints. You can store them in an airtight container for several weeks at room temperature.

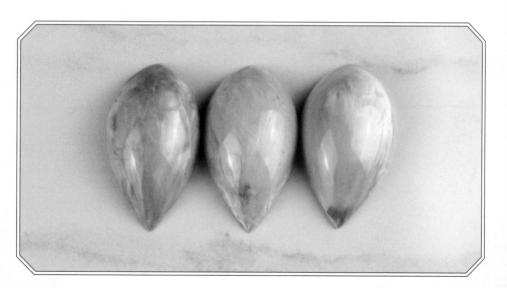

UNICORN TEARS: A TINCTURE *and* SOME TASTY TREATS

—The Wondersmith

NICORN TEARS ARE KNOWN TO HAVE MAGICAL properties, which make them a potent ingredient in potions and elixirs. Calming and uplifting, these tears carry the power to soothe humans through moments of trauma.

Harvesting unicorn tears is a dangerous and unethical proposition (though if you are lucky, you may come across a few drops on a flower petal or blade of grass in an enchanted wood), but you can make an equally soothing elixir instead using milky oats (*Avena sativa*), mimosa flowers (*Albizia julibrissin*), and vegetable glycerin.

The unicorn's diet is thought to be one reason why their tears have such immense power. They're particularly drawn to milky oats, the green oat heads before they ripen into the grain. These milky oats are gluten-free and a gentle nervine; they are used by herbalists to soothe frazzled nerves and calm the mind and body during times of stress or grief. Milky oats are different from mature oats used in cooked food; for a very short window before they ripen, oats exude a white "milk" when you pinch them. It is at this stage that they're at the height of their medicinal power.

While milky oats are the basis for a unicorn's diet, we're fairly certain that unicorns dine on mimosa flowers for dessert. These ethereal puffs of bright pink grace the most delicate-looking trees and fill the air with an intoxicating fragrance that is sweet, with just a hint of ripe guava. The flower is thought to decrease anxiety and bring a sense of peace to both mind and body.

The following tincture (a medication that is typically made by extracting the beneficial properties of a plant in alcohol) uses vegetable glycerin, rather than the more traditional vodka or grain alcohol to preserve and concentrate the milky oats, along with mimosa flower and a little luster dust. Glycerin is a great alternative for preserving herbal benefits for those who can't or don't want to have any alcohol at all, and its thick syrupy texture helps to hold the shimmery luster dust in suspension, making the tincture swirl with the silver shimmer of real unicorn tears. Just be sure to use this tincture within six months, as glycerites (infusions made with glycerin) don't last as long as those made with alcohol.

Unicorn Tears

with Milky Oats and Mimosa Flowers

Makes about two cups to fill eight 2-ounce dropper bottles

Adult dose: one to three dropperfuls three times daily;

Child dose: ½ dropperful, up to three times daily

TOOLS AND MATERIALS

+ **Blender**
+ **Glass jar with lid**
+ **Fine-mesh sieve**
+ **Cheesecloth**
+ **Spoon**
+ **8 dropper bottles, or glass container with lid**

INGREDIENTS

+ **1 cup fresh milky oat (*Avena sativa*) tops** (they should ooze a white latex substance when squeezed)
+ **1 cup fresh mimosa (*Albizia julibrissin*) flowers**
+ **2 cups vegetable glycerin**
+ **¼ teaspoon edible silver luster dust**

> **NOTE:** Though there is no evidence of this in any Chinese sources, some herbalists have observed that *Albizia julibrissin* may provoke a manic reaction in people susceptible to mania. As with anything, it's best to try just a little bit at first to see how your body reacts.

DIRECTIONS

1. Place the milky oats, mimosa flowers, and glycerin in a blender and whirl on low speed for twenty to thirty seconds. Pour into a sterilized glass jar and seal.

2. Let the mixture infuse in a cool, dark place for at least six weeks.

3. Strain the mixture through a fine-mesh sieve, discard the solids, and then run the infusion through a double layer of cheesecloth to remove any additional matter. Stir in the luster dust to add a silvery sparkle and transfer to clear glass dropper bottles, using a funnel if needed. You can either make eight bottles' worth or store any extra elixir in a sealed glass container. Store it in a dark, cool place and use within six months.

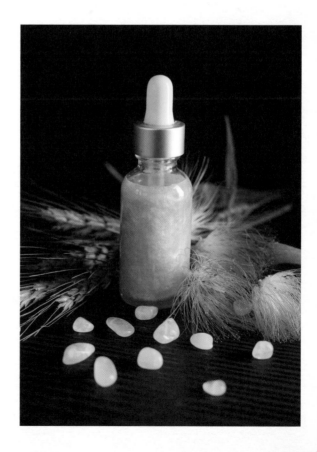

Unicorn Funfetti Treats

FTER A UNICORN SHARES ITS TEARS WITH YOU, it's only fair to show it some comfort and appreciation. These treats are suitable for unicorn or human consumption. They also contain the soothing and healing properties of oats in their dried state and a little dried apple for flavor and sustenance. They're a healthful treat, and they're also good for grief. These oat bars are gentle on the stomach and are vegan, gluten-free, and low in refined sugar. The bananas are a good source of potassium, too. They taste like a cross between two childhood favorites—flapjacks and banana bread—and take just minutes to prepare. The addition of sprinkles, reminiscent of the childhood favorite Funfetti cake, makes them a festive treat. Indulge in some nourishing comfort and escapism.

Makes sixteen 2-inch squares

TOOLS AND MATERIALS

- **One 8 × 8-inch square pan**
- **Parchment paper**
- **Food processor, or blender**
- **Large bowl**
- **Spoon**
- **Flat knife, or spatula**
- **Airtight container**

INGREDIENTS

- **Butter, to grease the parchment paper**
- **2 cups rolled oats**
- **Pinch of salt**
- **1 teaspoon baking powder**
- **¼ cup molasses or honey**
- **1 cup mashed ripe bananas (about 2 medium)**
- **1 teaspoon pure vanilla extract**
- **3 tablespoons natural sprinkles** (available at specialty baking shops or online)
- **¾ teaspoon orange zest**
- **⅓ cup chopped dried apple slices**
- **Bright pink icing** (optional; recipe on opposite page)

DIRECTIONS

1. Preheat the oven to 350° F. Line an 8 × 8-inch baking dish with greased parchment paper and set aside.

2. Using a food processor or blender, grind 1 cup of the oats into a fine flour. Place it in a large bowl along with the remaining oats, salt, and baking powder.

3. Make a well in the center and add the molasses, mashed bananas, and vanilla extract. Mix until well combined. Stir in 2 tablespoons of the sprinkles, the orange zest, and the chopped dried apple.

4. Press the dough evenly into the baking pan, patting the top flat. Scatter the rest of the sprinkles on top and firmly press them in.

5. Bake for 20 to 25 minutes, until the edges are just golden. Remove from the oven and allow to cool fully before cutting into squares.

6. Decorate with the bright pink icing, if desired.

7. Store the Funfetti squares in an airtight container and refrigerate for up to 1 week.

Bright Pink Icing

GETTING STUNNING COLORS FROM NATURE IS EASIER THAN you might think. All this frosting needs to achieve its mimosa-pink color are a few beets. The beets lend an earthy sweetness as well, which pairs nicely with the banana and orange flavor of the bars.

TOOLS AND MATERIALS

- **Juicer**
- **Aluminum foil**
- **Blender**
- **Cheesecloth, or fine-mesh sieve**
- **Small bowl**
- **Spatula**

INGREDIENTS

- **3 small beets, trimmed and peeled**
- **1 to 2 cups powdered sugar, depending on texture desired**
- **Unsweetened dried coconut flakes, for garnish** (optional)

DIRECTIONS

1. Juice the beets in a juicer. If you don't have a juicer, wrap them in aluminum foil and roast them at 350° F for 30 minutes, or until soft. Then place the beets and 1 cup of water in a blender and process until smooth. Strain the mixture through cheesecloth or a fine-mesh sieve to remove any pulp.

2. Put 1 tablespoon of the beet juice in a small bowl and add the powdered sugar, a little at a time, until you have a smooth and slightly runny icing. Gently spread on the cooled bars and top with a sprinkle of dried coconut, if desired.

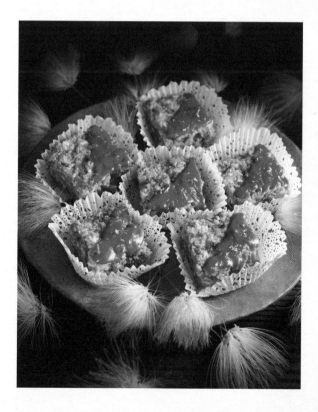

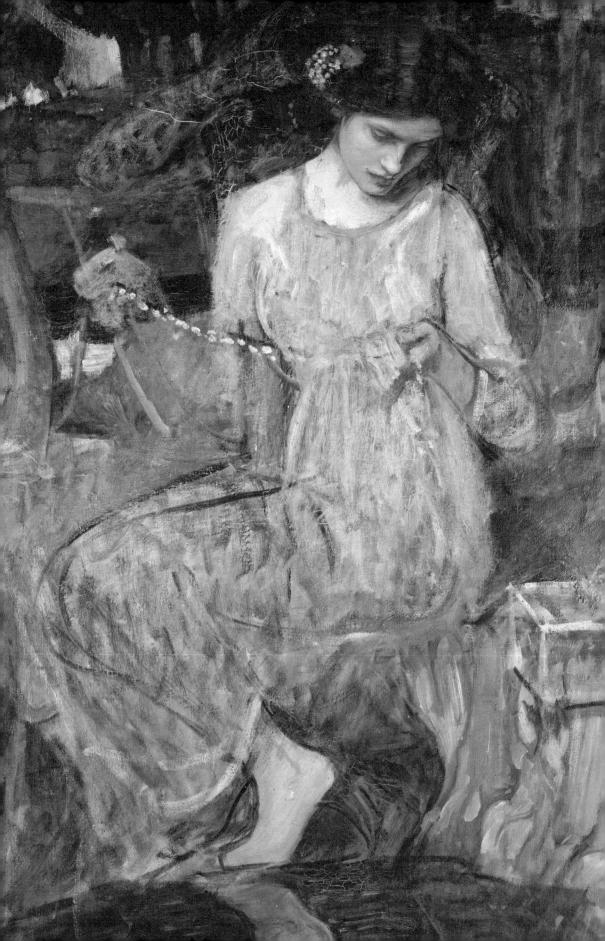

Unicorn Box

—SUE RAWLEY

WHEN ON A UNICORN QUEST IN THE ENCHANTED wood, you might on occasion receive a gift or find a memento—a twig, a flower, a unicorn tear, or the like. Create a dedicated box in which to save these treasures, decorated with bits of broken vintage china, mosaic tiles, seashells, and even a unicorn horn shell, charm, or cameo.

OPPOSITE: John William Waterhouse, *The Necklace*, c. 1909.

TOOLS AND MATERIALS

- 1 tube white, pink, or desired shade of acrylic paint to cover box
- 1 medium paintbrush, for painting box
- 1 unpainted, smooth wooden box approximately 7 × 5 × 3 inches (available at craft-supply stores)
- Tile nipper
- Small glass and/or ceramic tiles, pieces of china, and/or shells or 1 packet of sixty precut ¾-inch mosaic tiles (available at craft-supply stores)
- Small paintbrush, for applying glue
- PVA glue
- 1 unicorn cameo, about 1 ¼ × 1 ½ inches (available at jewelry- or craft-supply stores)
- Epoxy glue
- Unsanded mosaic grout in white or neutral shade
- Small grout spreader
- Damp cloth
- One 24-inch-square piece of embossed wallpaper or decorative paper, or enough to cover the inside and outside of the box
- Cutting mat, ruler, and knife
- Cutout picture of a unicorn, about 2 × 1 ½ inches
- 1 dark pink medium-tip nontoxic permanent marker (optional)
- 1 large *Rhinoclavis* "unicorn horn" shell, about 1 ½ inches long
- 1 smaller cameo, about 1 × ¾ inches (optional)
- Sewing needle and white thread
- Piece of lace, 2 feet long by 4 inches wide, for lining inside of box
- Scissors
- Glitter glue (optional)

DIRECTIONS

1. Using acrylic paint and the medium paintbrush, paint the box inside and out. Let dry overnight.

2. With the tile nipper, cut tiles into pieces. You will decide how many you want. You're adding them to the china pieces and/or shells, so you'll need enough to cover the top surface of the box.

3. Lay out the tiles in a pleasing design on top of the box. Using the small paintbrush and PVA glue, affix each piece to box. Glue the larger unicorn cameo on top of the tiles with epoxy glue. Let dry for at least four hours.

4. When the tiles and cameo are firmly adhered, apply a small amount of grout between each tile to fill in the gaps and to give the box a clean, finished look. Be careful not to use too much grout or it will look messy and be hard to clean up. Wipe and clean up excess grout, then let it dry according to manufacturer's instructions and polish tiles with a damp cloth.

5. To decorate the rest of the outside of the box, measure each surface (four sides of the lid rim and four sides of box bottom) to determine the sizes of paper you will need to cut. Line up the wallpaper on the cutting mat, using the ruler and knife to get a straight edge. Adhere the paper to the outside of the box with PVA glue.

6. Measure the inside of the top and inside bottom of the box and cut the wallpaper to fit, as in step 5, and glue the wallpaper to the inside top. Glue the unicorn picture onto the wallpaper, as shown. Glue a wallpaper piece to the bottom inside of the box. If desired, use marker to decorate the inside rim of box, as shown.

7. On the front of the outside of the lid, use epoxy glue to adhere the horn shell as a handle for the lid and a smaller cameo on the front of the base, if desired. Let dry overnight.

8. Sew a running stitch along one long edge of the lace to gather it (8A), so that it fits snugly into the inside of the box, as shown. Trim any loose threads. Secure the lace to the box with PVA glue (8B).

9. If desired, use glitter glue to add extra sparkle to the box.

3

7

4

8A

6

8B

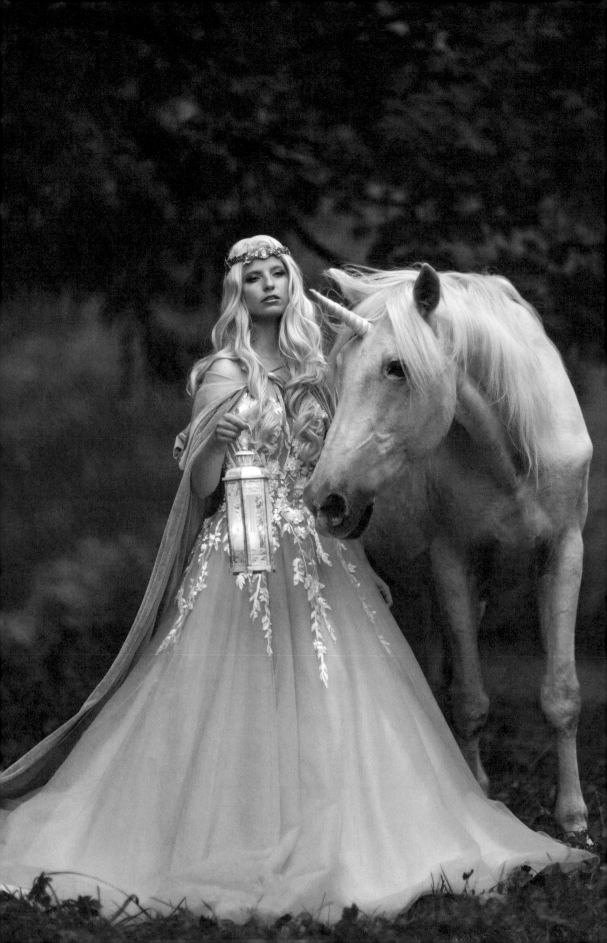

HOW *to* MEET
the QUEEN *of* BEASTS

—*Lord Whimsy*

 LOVE TO VISIT THE CLOISTERS. PERCHED ON AN outcropping of stone at the top of Manhattan Island, it overlooks the Palisades: a high lip of basaltic rock on the far side of the Hudson River that marks the very point where North America split from northwestern Africa millions of years ago.

The Cloisters is a treasure trove of medieval art that puts the lie to the notion that the Middle Ages were nothing more than a period when the faculties of humanity slept, and darkness reigned. The delicacy of the illuminations, the detail in the embroidery, and the graceful forms in the High Gothic stonework quickly dispel such blithe prejudices. The curation is also inspired: While walking through the Cloisters in late winter, one is cheered by the sight of potted citrus plants and herbs sitting next to stands holding illuminated texts of the very same species. Art and nature dance together through these vaulted corridors of stone.

I was there to take in a musical recital of *Beowulf* in the original Anglo Saxon: in other words, a typical Sunday. On my way to the great hall, I braced myself as I entered what has remained one of the most emotionally confusing rooms I've ever encountered. It is a dim room,

and it holds the greatest surviving series of Late Medieval tapestries in the world. The sheer craft of the seven large woven spells looming in this stony space enthralls the eye, but the series of acts that are depicted in these works appall the mind.

The tapestries depict the hunting, killing, and imprisonment of a unicorn. Horrible? Yes. But they depict this horrible act beautifully.

Naturally, I find the hunting of such a unique creature—and all the hounds, horns, and spears that go with it—to be the height of savagery. Being the product of their age, our dung-clad, mouth-breathing forebears may not have known any better, but I like to think that readers like yourself, who have benefited from a lifetime of literacy and regular bathing, would abhor such heartless pursuits. (I tend to err on the side of optimism in these matters, but I consider this the only viable choice. Pessimism, in my experience,

Opposite: A unicorn and maiden on a casual stroll through an enchanted wood.
Photograph by Marketa Novak.

only leads to despair—and as we all know, despair leads to sweatpants.)

At this point you may ask, "But Whimsy, how else might I catch a glimpse of such a creature, whose very name is synonymous with elusiveness and rarity?"

Reader, I cannot overstate the difficulty of such an undertaking, nor can I exaggerate the burden that such knowledge exerts on the mortal mind. Are you sure you're ready to know the very same secrets that have occasionally driven the crowned heads of Europe mad? Very well, then: read on.

First, I would suggest that we all set our hunting spears aside and remove the knives from our clenched teeth.

Second, we should consider the mind of our intended quarry: This creature is ancient. It has dozed in the Hanging Gardens of Babylon. It watched with serene indifference as the great empires of old rose, fell, and slowly turned to dust. The unicorn's sensibilities match its age and position, so great care must be taken. After all: one doesn't offer Queen Elizabeth a high five upon meeting her.

Before you dismiss such thoughts as trivial, consider this: there have been plenty of queens over the ages, but there is only one unicorn (trust me, I've investigated this). Compared to a unicorn, a queen is just a lady with a very expensive hat. So, if you must be on your best behavior while in the presence of a queen, imagine how profoundly on-point your manners must be to attract a unicorn!

To meet this challenge, I would suggest a hearty diet of reading material from the Middle Ages and Renaissance on proper deportment and etiquette. Armando di Rossino's *The Courtier of Grace* might be a good start. The famous Letters of Lord Highmoor to his Son and Heir may strike a modern reader as excessively stuffy if not downright obtuse, but there are some bits of good advice here and there on proper behavior when in the regal company of a magical being. Finally, the icy maxims of the infamous "carpet knight" Robert Du Quintain will adorn you with a mordant wit that will keep the jaded, worldly unicorn entertained. The unicorn will have heard these witticisms before, but Du Quintain's maxims can act as a kind of password: they portray humans as they are, rather than how they like to be seen. This candor will endear you to the unicorn, who sees humans in the same cold but forgiving light.

But I've charged ahead of myself: How does one attract such a singular creature?

Well, I would offer the same advice as I give those who are seeking companionship of any kind. In short: The world doesn't owe you a thing, so you must make yourself over to it if you wish to thrive. In other words: stop asking "How do I get a companion?" and instead ask yourself, "How do I become the kind of person others want to be around?"

The key to all this is "virginity." One shouldn't interpret this literally: Medieval texts are full of figurative language and symbolism. Whether or not one is a virgin is beside the point. In this case, the word merely implies purity of intentions. This is not as hard as one might imagine: Find a setting that resembles the world when it was young and unsullied. This threadbare world still has such places in it, even if many of them are man-made, like a botanical garden or conservatory. Such places coax innocence from those who visit them; they elicit wonder and joy, for what is the living world but the world of the divine?

When you begin to feel the divine permeate your mind, and the pain and worry of life fades from your thoughts, close your eyes, breathe deeply, and bow your head. Now lift your head and open your eyes.

Please tell her I said hello.

OPPOSITE: A wild unicorn is captured for a moment in this photograph by Marketa Novak.
PAGE 230: The Bakahasten, Annie Stegg, 2017.

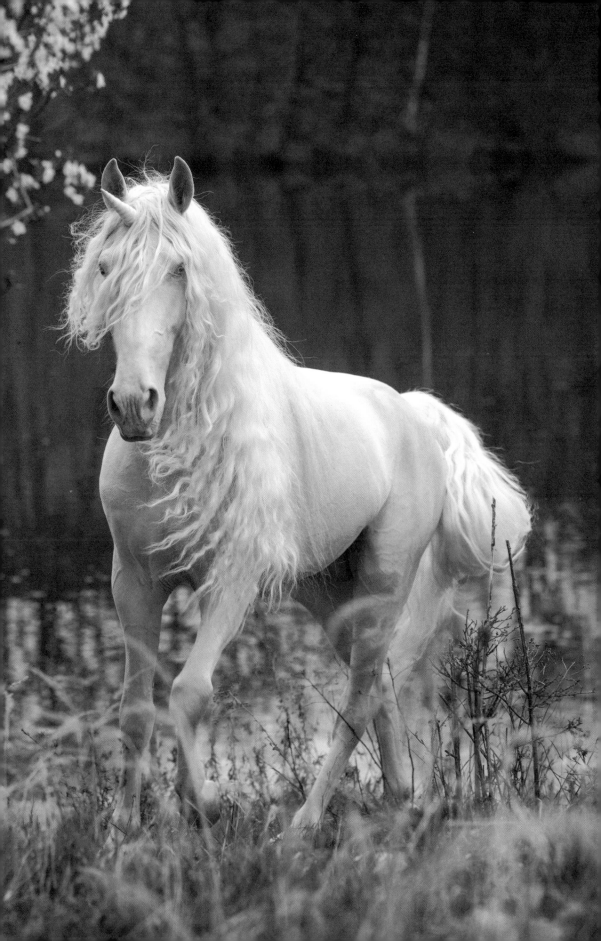

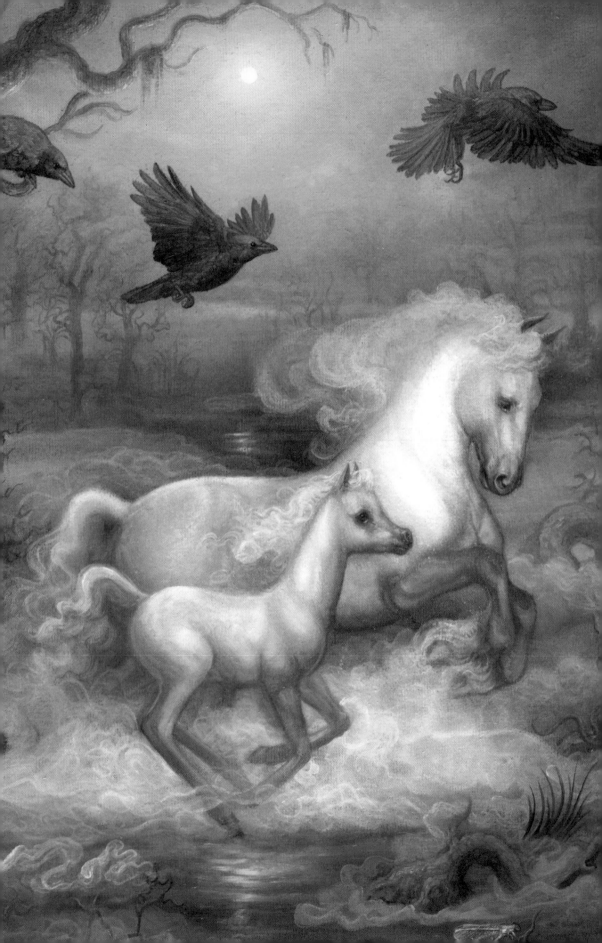

SEVENTH TAPESTRY

Oh, in the morning, when we came
out to go walking, and saw him blaze
up from the field like a shout of praise,
shining and shining and shining,
too bright, too living, to have a name.
Pepée started barking and running in circles, and I—
Oh, then I did cry.

All in the morning, there he lay,
collared and kept with a silver chain,
red with the pomegranates' sugary rain,
shining and shining and shining,
with a fence like a ribbon to make him stay.
His horn was all sunset and spindrift, all rainbow and rose—
Pepée licked his nose.

All in the morning, feeling his breath
play in my hair as he stamped and blew,
just for a moment I knew what he knew,
shining and shining and shining—
that nothing could hold him, not even death;
that no collars, no chains, no fences, as strong as they seem,
can hold a dream.

—PETER S. BEAGLE, "The Unicorn Tapestries"
From *We Never Talk About My Brother*, 2009

ACKNOWLEDGMENTS

I want to thank Elizabeth Viscott Sullivan at HarperCollins for agreeing to take on such a shimmering, romantic subject as the unicorn and for being such a sharp editor: she elevates and glamorizes everything she touches. I'd also like to thank the incredibly talented team at Harper Design: art director Lynne Yeamans, designer Raphael Geroni, and production director Susan Kosko.

I want to thank Beth Adelman for all her help in bringing this book together and for becoming a unicorn expert in her own right and Jeff Kleinman for making it all happen; Steve Parke for the tireless image and baby goat/unicorn wrangling for the book cover portrait; Tom Dearstine of Emma's Daisyhill Farm; Jill Andrews; Sarah Bentman; and my one true love, Mario the baby goat. Many thanks to Laura Silverman and Karin Strom for helping whip the recipes and tutorials into shape.

Thank you also to all the gorgeous contributors who added their dazzle to this tome: Allen Crawford/Lord Whimsy, Rona Berg, Danielle Prohom Olson, Grace Nuth, Nikki Verdecchia, Jewel Andrews, Tricia Saroya, The Wondersmith, Virginia Hankins, Jill Gleeson, JoEllen Elam Conway, Alise Marie, Vanessa Walton, Sue Rawley, Anne Boulley, and Lillian Rose.

Thank you to all those who love unicorns and who *are* unicorns in a world full of mares.

Thank you, as always, to my father, mother, and sister.

And thank you, of course, to Peter S. Beagle for filling our imaginations with such beauty—the careless color of sea foam, the color of snow falling on a moonlit night—and letting us know that the unicorns are not all gone yet.

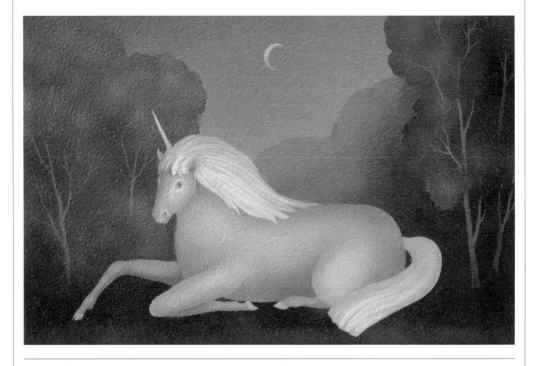

Above: Igor Galanin, *Unicorn*, date unknown.

SELECT BIBLIOGRAPHY

BOOKS

Alcott, Louisa May. *Flower Fables.* Boston: George W. Briggs, 1855.

Alexander, Skye. *Unicorns: The Myth, Legends & Lore.* Avon, MA: Adams Media, 2015.

Asimov, Isaac. *Asimov's Guide to the Bible: Volume One—The Old Testament.* New York: Avon, 1968.

Beagle, Peter S. *The Last Unicorn.* New York: Viking Press, 1968.

——. *We Never Talk About My Brother.* San Francisco: Tachyon, 2009.

Bell, Esther, ed. *Sublime Beauty: Raphael's Portrait of a Lady with a Unicorn.* Cincinnati: Cincinnati Art Museum, 2015.

Briggs-Anderson, Barbara. *Salvador Dalí's "A Surrealistic Night in an Enchanted Forest."* Kindle, 2012.

Brown, Robert. *Unicorn: A Mythological Investigation.* London: Spottswoode, 1881.

Carroll, Lewis, and John Tenniel. *Through the Looking-Glass and What Alice Found There.* London: Macmillan, 1899.

Cavallo, Adolfo Salvatore. *The Unicorn Tapestries at the Metropolitan Museum of Art.* New York: Metropolitan Museum of Art, 1998.

Ettinghausen, Richard. *The Unicorn: Studies in Muslim Iconography.* Washington, DC: Freer Gallery, Studies in Muslim Iconography, 1950.

Freeman, Margaret B. *The Unicorn Tapestries.* New York: Metropolitan Museum of Art, 1976.

Gaiman, Neil. *Stardust.* New York: Spike, 1999.

Gaiman, Neil, and Charles Vess. *Stardust.* New York: Vertigo, DC Comics, 1998.

Hathaway, Nancy. *The Unicorn.* New York: Random House, 1987.

Hinds, Kathryn. *Creatures of Fantasy: Unicorns.* New York: Cavendish Square, 2013.

Lavers, Chris. *The Natural History of Unicorns.* London: Harper Perennial, 2009.

Moore, Jessie Oleson. *Stuff Unicorns Love.* Avon, MA: Adams Media, 2017.

Morelli, Giovanni. *Italian Painters; Critical Studies of Their Works.* London: John Murray, 1892–1893.

Odell, Kat. *Unicorn Food: Beautiful Plant-Based Recipes to Nurture Your Inner Magical Beast.* New York: Workman, 2018.

Rabelais, François. *Gargantua and His Son Pantagruel.* Translated by Sir Thomas Urquhart from the 1653 edition. Project Gutenberg. https://www.gutenberg.org/files/1200/1200-h/1200-h.htm#link52HCH0030.

Shepard, Odell. *The Lore of the Unicorn: Folklore, Evidence and Reported Sightings.* Boston and New York: Houghton Mifflin, 1930.

Wood, Juliet. *Fantastic Creatures in Mythology and Folklore.* London: Bloomsbury, 2018.

ARTICLES

Aarons, Leroy F. "The Downpour Stops for Capote's Party." *The Boston Globe,* November 29, 1966.

Abad Santos, Alex. "The Inescapable Unicorn Trend, Explained." *Vox,* May 17, 2017. https://www.vox.com/culture/2017/5/17/15597954/unicorn-trend-explained.

Abelman, Devon. "Models Wear 'Anti-Unicorn Hair' at Marc Jacobs Spring 2019 Show." *Allure,* September 12, 2018. https://www.allure.com/story/marc-jacobs-spring-2019-anti-unicorn-hair-makeup.

Addington, Catherine. "The Fashion of This World Passeth Away." *Weekly Standard,* August 12, 2018. https://www.weeklystandard.com/catherine-addington/review-of-heavenly-bodies-exhibition-at-the-met-the-fashion-of-this-world-passeth-away.

Alexander, Ella. "Glitter Boots: 10 Best Pairs to Party in This Season." *Harper's Bazaar,* November 10, 2017. https://www.harpersbazaar.com/uk/fashion/what-to-wear/g13027630/glitter-boots-10-best-boots-to-party-in-this-season/.

Andrews, Amy. "Lady Gaga Is Obsessed with Unicorns." *IrishCentral,* March 7, 2011. https://www.irishcentral.com/opinion/amyandrews/lady-gaga-is-obsessed-with-unicorns-117514458-238073911.

Balfour, Hamish. "Ham Says Noah's Ark Also Contained Unicorns." *Business Standard News,* May 11, 2016. https://bizstandardnews.com/2016/05/11/hamm-said-noahs-ark-also-contained-unicorns/.

Beccia, Carlyn. "Elizabeth I's Magical Unicorn." *On the Tudor Trail,* October 20, 2010. http://onthetudortrail.com/Blog/2010/10/20/elizabeth-is-magical-unicorn-by-carlyn-beccia/.

Bjelica, Petra. "The Mystery of Europe's Oldest Throne Room in the Cretian Palace of Knossos." *Walls with Stories,* August 7, 2017. http://www.wallswithstories.com/ancient/the-mystery-of-europes-oldest-throne-room-in-the-cretian-palace-of-knossos.html.

Blaha-Black, Caroline. "10 Unicorns Around the World You Might Not Know Of." *Listverse,* December 30, 2015. https://listverse.com/2015/12/30/10-unicorns-around-the-world-you-might-not-know-of/.

Brand, Matt. "Unicorns: 'Fierce and Extremely Wild?'" *Adam Matthew,* September 14, 2018. https://www.amdigital.co.uk/about/blog/item/unicorns-fierce-and-extremely-wild.

Brown, Alan K. "The Firedrake in *Beowulf*." *Neophilologus* 64, no. 3 (July 1980): 439–60. https://doi.org/10.1007/BF01513838.

Byrd, Deborah. "See the Unicorn on Dark January Nights." EarthSky, January 26, 2019. https://earthsky.org/tonight/find-monoceros-the-constellation-of-the-unicorn-within-winter-triangle.

Cain, Fraser. "Where Is the Closest Black Hole?" Phys.org, March 21, 2016. https://phys.org/news/2016-03-closest-black-hole.html.

"Cara Delevingne Reveals Her Perfect Christmas Party Outfit." *Harper's Bazaar*, November 9, 2017. https://www.harpersbazaar.com/uk/fashion/fashion-news/a13456730/cara-delevingne-reveals-her-perfect-christmas-party-outfit/.

Cembalest, Robin. "Chasing Unicorns in Art Across the Ages." *ARTnews*, May 23, 2013. http://www.artnews.com/2013/05/23/unicorns-in-art/.

Davis, Arianna. "What's Really Behind Unicorn Fever." Refinery29, May 8, 2017. https://www.refinery29.com/en-us/2017/05/152423/unicorn-trend-explanation-history.

Delaney, Brigid. "Lady and the Unicorn: Mona Lisa of the Middle Ages Weaves a New Spell." *Guardian*, February 12, 2018. https://www.theguardian.com/artanddesign/2018/feb/13/lady-and-the-unicorn-mona-lisa-of-the-middle-ages-weaves-a-new-spell.

Desmarais, Charles. "The Enigma of 'Portrait of a Lady with a Unicorn.'" *SFGate*, January 12, 2016. https://www.sfgate.com/art/article/A-fresh-look-at-Raphael-s-Portrait-of-a-Lady-6746977.php.

De Vitis, Mark. "Explainer: The Symbolism of The Lady and the Unicorn Tapestry Cycle." The Conversation, February 7, 2018. https://theconversation.com/explainer-the-symbolism-of-the-lady-and-the-unicorn-tapestry-cycle-91325.

Donadio, Rachel. "'Lady and the Unicorn' Tapestries Return to View in France." *New York Times*, January 9, 2014. https://artsbeat.blogs.nytimes.com/2014/01/09/lady-and-the-unicorn-tapestries-return-to-view-in-france/.

Ewbank, Anne. "The Strange History of Royals Testing Food for Poison with Unicorn Horn." *Atlas Obscura*, April 5, 2018. https://www.atlasobscura.com/articles/unicorn-horn-poison.

Farago, Jason. "'Heavenly Bodies' Brings the Fabric of Faith to the Met." *New York Times*, May 9, 2018. https://www.nytimes.com/2018/05/09/arts/design/heavenly-bodies-met-costumes.html.

Feltman, Rachel. "Did 'Unicorns' Co-Exist with Humans? Yes, but They Were Just Rhinos." *Washington Post*, March 29, 2016. https://www.washingtonpost.com/news/speaking-of-science/wp/2016/03/29/did-unicorns-co-exist-with-humans-yes-but-they-were-just-rhinos.

Findley, James. "The Unicorn in Clariodus." History Mash, July 24, 2016. https://historymash.com/2016/07/24/the-unicorn-in-clariodus/.

Fisher, Lauren Alexis. "A Unicorn Walked the Runway at Thom Browne's Spring 2018 Show." *Harper's Bazaar*, October 3, 2017. https://www.harpersbazaar.com/fashion/fashion-week/a12773338/thom-browne-spring-2018-unicorn/.

"Five Things You Need to Know About the Lady and the Unicorn." University of Sydney, Faculty of Arts and Sciences, March 19, 2018. https://sydney.edu.au/arts/news-and-events/news/unpublished/the-lady-and-the-unicorn.html.

Følgere. "Mary the Maiden, Christ the Unicorn." *My Albion*, June 18, 2016. http://my-albion.blogspot.com/2016/06/mary-maiden-christ-unicorn.html.

Friedman, Vanessa. "The Curtain Falls on Valentino's Double Act." *New York Times*, July 7, 2016. https://www.nytimes.com/2016/07/09/fashion/couture-valentino-gaultier.html.

Gabriel, Judith. "Among the Norse Tribes: The Remarkable Account of Ibn Fadlan." *Saudi Aramco World*, November/December 1999. https://web.archive.org/web/20100113133305/http://saudi-aramcoworld.com/issue/199906/among.the.norse.tribes-the.remarkable.account.of.ibn.fadlan.htm.

Geddo, Benedetta. "Life Is Always Rainbows and Unicorns at This Bangkok Cafe." Lonely Planet, July 28, 2018. https://www.lonelyplanet.com/news/2018/07/28/unicorn-cafe-bangkok/.

"Giant Siberian Rhinoceros Lived Alongside Early Modern Humans." *Sci-News.com*, November 28, 2018. http://www.sci-news.com/paleontology/elasmotherium-sibericum-06653.html.

Gleeson, Jill. "Secret Gardens: The Story Behind the Medieval Landscapes of the Cloisters." *Faerie Magazine*, Winter 2017, 22–26.

Godbey, Allen H. "The Unicorn in the Old Testament." *The American Journal of Semitic Languages and Literatures* 56, no. 3 (July 1939): 256–296.

Graham-Dixon, Andrew. "For Sale, a Piece of Medieval Magic." *Independent*, June 7, 1994. https://www.independent.co.uk/life-style/for-sale-a-piece-of-medieval-magic-its-not-often-that-the-horn-of-a-unicorn-comes-up-for-auction-1420976.html.

Iversen, Kristin. "Why Millennials' Obsession with Mermaids, Unicorns, and the Color Pink Matters." *Nylon*, June 6, 2017. https://nylon.com/articles/mermaids-unicorns-millennial-pink-lgbtq-queer-culture.

Jackson, William. "The Use of Unicorn Horn in Medicine." *Pharmaceutical Journal* no. 273 (December 2004): 925–927.

Jacobs, Emma. "The Poison-Detecting Secret Weapon of the Middle Ages: Unicorn Horn." *Mental Floss*, December 7, 2018. http://mentalfloss.com/article/566289/unicorn-horn-poison.

Jacobs, Laura. "'Heavenly Bodies: Fashion and the Catholic Imagination' Review: A Gift from the Sartorial Gods." *Wall Street Journal*, May 10, 2018. https://www.wsj.com/articles/heavenly-bodies-fashion-and-the-catholic-imagination-review-a-gift-from-the-sartorial-gods-1525907633.

234

Jacques, Susan. "Sublime Beauty: Raphael's Portrait of a Lady with a Unicorn." *Huffington Post*, January 8, 2016. https://www.huffpost.com /entry/sublime-beauty-raphaels -p_b_8934098.

Jow, Tiffany. "Why the Mystery of the Met's Unicorn Tapestries Remains Unsolved." Artsy, July 27, 2017. https://www.artsy.net/article/artsy -editorial-mystery-mets-unicorn -tapestries-remains-unsolved.

Kaplish, Lalita. "How the Fate of the Rhino Is Tied to Medicine." *Wellcome Library*, May 6, 2016. http://blog .wellcomelibrary.org/2016/06 /how-the-fate-of-the-rhino-is-tied -to-medicine/.

Karsen, Shira. "10 Unicorn-Inspired Beauty Products to Help You Master the Trend for Coachella." *Billboard*, April 7, 2017. https://www.billboard .com/photos/7752457/unicorn -inspired-beauty-products-to-help -you-master-the-trend-this-coachella.

Krentcil, Faran. "A Definitive Timeline of How and Why the Beauty Industry Reached Peak Unicorn." *Elle*, April 20, 2017. https://www.elle.com/beauty /a44554/timeline-of-the-unicorn/.

Lindsay, Kitty. "My Little Pony Made a High-Fashion Appearance on the Runway at Milan Fashion Week." Hello Giggles, September 23, 2017. https://hellogiggles.com/fashion /my-little-pony-fashion/.

MacQueen, Douglas. "Unicorn as the Symbol of Scotland in Heraldry." *Transceltic*, April 10, 2017. https:// www.transceltic.com/blog/unicorn -symbol-of-scotland-heraldry.

Mangum, Douglas. "Chasing Unicorns in the Bible." *Bible Study Magazine*, February 7, 2017. http:// www.biblestudymagazine.com /bible-study-magazine-blog/2017/2/7 /chasing-unicorns-in-the-bible.

McNamara, Natasha. "Unicorns DO Exist. Six Films That Celebrate the Mythical Beast We All Love." *Glamour*, March 31, 2016. https:// www.glamourmagazine.co.uk/gallery /unicorns-in-movies.

Meltzer, Marisa. "Updating the Gold Standard to Platinum." *New York Times*, June 25, 2014. https://www .nytimes.com/2014/06/26/fashion /white-blonde-hairstyle.html?_r=0.

Middleton, Paul. "Poisons, Potions and Unicorn Horns." *Early Modern Medicine*, November 12, 2013. https:// earlymodernmedicine.com/poisons -potions-and-unicorn-horns/.

Miller, Andrea. "Chanel's Take on Unicorn Makeup Trend Fit for a French Girl." Flare, July 6, 2017. https://www.flare.com/beauty /chanel-unicorn-makeup/.

Oliver, Elizabeth. "Unicorns in Medieval Manuscripts." *Printed Pearls: Discovering Literary Treasures*, April 9, 2018. http://printedpearls .com/unicorns-in-medieval -manuscripts.

"Paris Hilton's Favorite Beauty Products Are by, You Guessed It, Paris Hilton." Yahoo Lifestyle, May 22, 2019. https://www.yahoo.com/now /surprising-drugstore-beauty -product-paris-230000543.html.

Parkes, Veronica. "The Last of the Siberian Unicorns: What Happened to the Mammoth-Sized One-Horned Beasts of Legend?" Ancient Origins, February 22, 2017. https://www.ancient-origins .net/unexplained-phenomena /last-siberian-unicorns-what -happened-mammoth-sized-one -horned-beasts-legend-021239.

Paton, Elizabeth. "From Dior, a Mystical Masked Ball." *New York Times*, January 24, 2017. https://www .nytimes.com/2017/01/24/fashion /couture-christian-dior-ball.html.

Perez, Christal. "The Little-Known Tale of the Medieval Unicorn." *The Iris: Behind the Scenes at the Getty*, May 12, 2018. http://blogs.getty.edu /iris/the-little-known-tale-of-the -medieval-unicorn/.

Phelan, Hayley. "Sophia Webster Fall 2013: Holographic Unicorns." Fashionista, April 10, 2014. https:// fashionista.com/2013/02/sophia -webster-fall-2013-holographic -unicorns.

Prendergast, Curt. "Tucson's Lisa Frank Sues to Protect Her Empire of Rainbow Unicorns, Surfing Dolphins."

Tuscon.com, May 18, 2018. https:// tucson.com/news/local/tucson-s-lisa -frank-sues-to-protect-her-empire-of /article_fad5698d-8792-5a4a-a902 -5da47baca992.html.

Preston, Richard. "Capturing the Unicorn: How Two Mathematicians Came to the Aid of the Met." *The New Yorker*, April 3, 2005. https://www .newyorker.com/magazine/2005 /04/11/capturing-the-unicorn.

Prinzivalli, Leah. "The Beauty Industry Has a Unicorn Problem." Jezebel, March 30, 2017. https:// jezebel.com/the-beauty-industry-has -a-unicorn-problem-1793721177.

Ramey, Corinne. "Starbucks and Brooklyn Cafe Settle Unicorn-Drink Lawsuit." *Wall Street Journal*, September 5, 2017. https://www .wsj.com/articles/starbucks-and -brooklyn-cafe-settle-unicorn-drink -lawsuit-1504643905.

Schuster, Clayton. "Portrait of Young Woman with Unicorn." *Sartle*. https://www.sartle.com/artwork /young-woman-with-unicorn-raphael.

Segran, Elizabeth. "The Unicorn Craze, Explained." *Fast Company*, May 23, 2017. https://www. fastcompany.com/40421599/inside -the-unicorn-economy.

Shah, Khushbu. "How Unicorn Foods Took Over the Internet." Thrillist, April 28, 2017. https://www .thrillist.com/eat/nation/unicorn -food-instagram-trend-starbucks -frappuccino-superfoods.

Simon, Matt. "Fantastically Wrong: The Weird, Kinda Perverted History of the Unicorn." *Wired*, February 4, 2015. https://www.wired.com/2015/02 /fantastically-wrong-unicorn/.

Sooke, Alastair. "Why We've Always Loved Unicorns." BBC, December 17, 2018. http://www.bbc.com/culture /story/20181214-why-weve-always -loved-unicorns.

Stevenson, Cait. "Seven Things You Didn't Know About Medieval Dragons." Medievalists.net. http:// www.medievalists.net/2017/04 /seven-things-didnt-know-medieval -dragons/.

Stover, Laren. "The Unicorn Tapestries: Peter S. Beagle's Musings on Seven Medieval Marvels," *Faerie Magazine*, Winter 2017, 29–30.

Suter, Hadley. "Unicorns, a Chef-Designed Bikini, and More Things Editors Are into Right Now." *T: The New York Times Style Magazine*, July 27, 2018. https://www.nytimes.com/2018/07/27/t-magazine/regime-des-fleurs-unicorns-everything-is-alive-editors-picks.html.

"Unicorns, East and West." American Museum of Natural History. https://www.amnh.org/exhibitions/mythic-creatures/land/unicorns-west-and-east.

"Unicorns in the Bible." *Experimental Theology*, June 22, 2015. http://experimentaltheology.blogspot.com/2015/06/unicorns-in-bible.html.

"The Unicorn of the Land." *The Unicorn Found* exhibit, March 11–July 31, 2015, Brown University Library. https://library.brown.edu/create/unicornfound/unicorn-of-the-land/.

Van Godtsenhoven, Karen. "Heavenly Bodies: In New York, a Striking Exhibition Takes a Look at the Creative Ties Between Catholicism and High Fashion." Interwoven: The Fabric of Things. http://kvadratinterwoven.com/heavenly-bodies.

Waters, Elyse. "Zoological Analysis of the Unicorn as Described by Classical Authors," *Archaeometry Workshop* 10, no. 3 (2013): 231–236.

Weisberger, Mindy. "Ice Age 'Unicorn' May Have Lived Alongside Modern Humans." Live Science, December 1, 2018. https: livescience.com/64209-elasmotherium-siberian-unicorn-ice-age.html.

———. "'Unicorns' Lumbered Across Siberia 29,000 Years Ago." Live Science, March 29, 2016. https://www.livescience.com/54219-unicorns-once-lumbered-across-siberia.html.

Winick, Stephen D. "Believing in Unicorns: An Exultation of Mythical Beasts." https://www.stevewinick.com/unicorns.

Wriglesworth, Chad. "Myth Maker, Unicorn Maker: C. S. Lewis and the Reshaping of Medieval Thought."

Mythlore 25, no. 1 (Fall/Winter 2006): 29–40. https://dc.swosu.edu/mythlore/vol25/iss1/3.

INTERVIEWS

Beagle, Peter S. Phone interview, June 21, 2019.

Coward, Sacha. Email interview, January 31, 2019.

Leech, Caleb. Phone interview, October 5, 2017.

McMyne, Mary. In-person interview, April 3, 2019.

Shibley, John. Email interview, March 1, 2019.

Still, Carly. Phone interview, October 5, 2017.

Thompson, Kenneth. Email interview, March 25, 2019.

WEBSITES

All About Unicorns. Accessed June 27, 2019. https://www.allaboutunicorns.com/heraldry.php.

American Oil & Gas Historical Society. Accessed June 25, 2019. https://aoghs.org/petroleum-art/high-flying-trademark/.

Ancient History Encyclopedia. Accessed June 25, 2019. https://www.ancient.eu/.

Asian Art Museum. Accessed June 25, 2019. http://www.asianart.org.

A Book of Creatures. Accessed June 27, 2019. https://abookofcreatures.com.

Constellation Guide. Accessed June 27, 2019. https://www.constellation-guide.com.

Dictionary.com. Accessed June 27, 2019. https://www.dictionary.com/.

Encyclopaedia Brittanica. Accessed June 26, 2019. https://www.britannica.com.

Exxon. Accessed June 25, 2019. https://www.exxon.com/en/history.

Fandom. Accessed June 27, 2019. https://mlp.fandom.com/wiki/Unicorns.

Greek Mythology. Accessed June 27, 2019. https://www.greekmythology.com.

Heraldry for Kids. Accessed June 27, 2019. http://www.heraldryforkids.com.

Ian Ridpath's Star Tales. Accessed June 26, 2019. http://www.ianridpath.com/startales.

IMDb. https://www.imdb.com/.

The Iris: Behind the Scenes at the Getty. Book of Beasts. Accessed June 26, 2019. http://blogs.getty.edu/iris/series/book-of-beasts/.

Japanese Mythology & Folklore. Accessed June 27, 2019. https://japanesemythology.wordpress.com.

Lake Superior State University Unicorn Hunters. Accessed April 7, 2019. https://www.lssu.edu/banished-words-list/unicorn-hunters/.

The Medieval Bestiary: Animals of the Middle Ages. Accessed June 26, 2019. http://bestiary.ca/.

Merriam-Webster. Accessed June 26, 2019. https://www.merriam-webster.com.

Musée National Gustave Moreau. Accessed June 27, 2019. https://en.musee-moreau.fr/object/unicorns-les-licornes.

Orthodox Church in America. Accessed June 26, 2019. https://oca.org/saints/lives/2011/04/24/101199-st-elizabeth-the-wonderworker-of-constantinople.

Sea and Sky. Accessed June 26, 2019. http://www.seasky.org.

Unknown Explorers: Unicorn. Accessed June 26, 2019. http://www.unknownexplorers.com/unicorn.php.

Urban Dictionary. Accessed June 26, 2019. https://www.urbandictionary.com.

ABOUT THE CONTRIBUTORS

RONA BERG is a writer, editor, and wellness and sustainable lifestyle expert. She has served as editorial director of *Elle* and deputy lifestyle editor of the *New York Times Magazine*. Currently editorial director of Organic Spa Media, she is the author of the bestselling books *Beauty: The New Basics* and *Fast Beauty: 1,000 Quick Fixes*. She sits on the board of directors for the Green Spa Network and the advisory board of *Shape* magazine and is a contributor to *Enchanted Living*.

ANNE BOULLEY is the owner and chef of Artisanne Chocolatier in Bay City, Michigan, where she sells chocolate and teaches workshops.

JOELLEN ELAM CONWAY is a fantasy costume designer who specializes in couture bridal gowns and accessories through her label, Firefly Path. She is based in Los Angeles.

ALLEN CRAWFORD wrote, designed, and illustrated *The Affected Provincial's Companion*, vol. I, under the nom de plume Lord Breaulove Swells Whimsy, and illustrated his award-winning book, *Whitman Illuminated: Song of Myself*.

JILL GLEESON is a travel journalist and the travel editor of *Enchanted Living*. Her work has appeared in *Woman's Day*, *Good Housekeeping*, *Country Living*, *Gothamist*, *Washingtonian*, *Canadian Traveller*, *Country Woman*, *Curve*; on EDGE Media Network; and elsewhere.

VIRGINIA HANKINS is the author of *Be a Real-Life Mermaid* and founder of Sheroes Entertainment, a Los Angeles–based party character and themed event provider for birthday and holiday parties as well as corporate events.

ALISE MARIE is a contributor to and columnist for *Enchanted Living*. The author of *The Beauty Witch Grimoire*, she has been crafting plant-based, cruelty-free beauty and wellness potions in harmony with the lunar and planetary cycles for more than thirty years.

GRACE NUTH is senior editor of *Enchanted Living* and cowriter of *The Faerie Handbook*. An artist and librarian, she lives in central Ohio with her husband, two black cats, and a garden full of fairies.

DANIELLE PROHOM OLSON is a writer, recipe developer, photographer, and award-winning filmmaker. Her passions for ancestral foods, wildcrafting, herbalism, women's food history, goddess lore, and the ancient mysteries of food magic are at the heart of her website Gather Victoria.

STEVE PARKE is an award-winning illustrator, designer, and photographer as well as the photo editor of *Enchanted Living*. His photography work of Prince has been published in numerous magazines, including *People*, *Rolling Stone*, and *Vogue*. His book *Picturing Prince* was published in 2017.

SUE RAWLEY is a designer who works with metal and mosaics. Based in London, she sells in galleries and by private commission. She has been filmed by BBC, ITV4 UK, and Fuji TV Japan.

LILLIAN ROSE (nom de plume) is an editor and writer living in Brooklyn, New York.

TRICIA SAROYA is a California-based fine artist whose work is represented by several galleries. She is also a floral and event designer.

NIKKI VERDECCHIA has been styling and coloring hair for more than twenty years. She is the owner of NV Salon Collective in Baltimore.

VANESSA WALTON is a designer of bespoke fairy-tale-inspired gowns and costumes for her company Creature of Habit. Her work has been featured in film, publications, and galleries across the globe.

THE WONDERSMITH is a writer, wildcrafter, and artist who shares surprise immersive gatherings with strangers all over the Pacific Northwest.

PHOTOGRAPHY *and* ILLUSTRATION CREDITS

Alamy: 20: Marmaduke St. John/Alamy Stock Photo; 32: The History Collection/Alamy Stock Photo; 37: The Picture Art Collection/Alamy Stock Photo; 39: Science History Images/Alamy Stock Photo; 45: Album/Alamy Stock Photo; 47: Chronicle/Alamy Stock Photo; 48: Lebrecht Music & Arts/Alamy Stock Photo; 52: Peter van Evert/Alamy Stock Photo; 67: MediaPunch Inc./Alamy Stock Photo; 70–71: Allstar Picture Library/Alamy Stock Photo; 75: colaimages/Alamy Stock Photo; 131: Tomas Abad/Alamy Stock Photo; 141: Everett Collection, Inc./Alamy Stock Photo; 165, top: The Picture Art Collection/Alamy Stock Photo; 169: Terese Loeb Kreuzer/Alamy Stock Photo; 173: Moviestore Collection Ltd./Alamy Stock Photo; 176: RGR Collection/Alamy Stock Photo; 177: Milton Cogheil/Alamy Stock Photo; 204: Maria Kalashnik/Alamy Stock Photo; 208: Channarong Pherngjanda/Alamy Stock Vector; 212–213: Bridgeman Images.

Baker, Charlotte: 22, 24–25.

Borggreve, Ellen: 28–29.

Boulley, Anne: 214–217.

Bridgeman Images: 12–13: Rafael Valls Gallery, London, UK/Bridgeman Images; 14: Bridgeman Images; 17: Bridgeman Images; 23: Look and Learn/Bridgeman Images; 26: Alinari/Bridgeman Images; 31: Bridgeman Images; 33: British Library Board. All Rights Reserved/Bridgeman Images; 34: British Library Board. All Rights Reserved/Bridgeman Images; 35: British Library Board. All Rights Reserved/Bridgeman Images; 36: Giancarlo Costa/Bridgeman Images; 38: British Library Board. All Rights Reserved/Bridgeman Images; 40: Pictures from History/Bridgeman Images; 41: British Library Board. All Rights Reserved/Bridgeman Images; 42: British Library Board. All Rights Reserved/Bridgeman Images; 43: British Library Board. All Rights Reserved/Bridgeman Images; 50–51: The Maas Gallery, London/Bridgeman Images; 54: National Geographic Image Collection/Bridgeman Images; 55: De Agostini Picture Library/Bridgeman Images; 59: The Stapleton Collection/Bridgeman Images; 63: © Kelley Gallery, Pasadena, California/Bridgeman Images; 74: Bridgeman Images; 120–121: © A. De Gregorio/De Agostini Picture Library/Bridgeman Images; 122: Universal History Archive/UIG/Bridgeman Images; 124–125: Bridgeman Images; 126: Bridgeman Images; 128–129: De Agostini Picture Library/G. Nimatallah/Bridgeman Images; 132–139: Bridgeman Images; 145–151: Bridgeman Images; 153: Bridgeman Images; 155: Bridgeman Images; 157: © CSG CIC Glasgow Museums Collection/Bridgeman Images; 158: © Look and Learn/Bridgeman Images; 160–161: Mondadori Portfolio/Electa/Sergio Anelli/Bridgeman Images; 162: Pictures from History/Bridgeman Images; 163: De Agostini Picture Library/Bridgeman Images; 164: Bridgeman Images; 165, bottom: © A. Dagli Orti/De Agostini Picture Library/Bridgeman Images; 171: Bridgeman Images; 178–179: Archives Charmet/Bridgeman Images; 199: Bridgeman Images; 222: Photo © Christie's Images/Bridgeman Images; 232: © Igor Galanin/Bridgeman Images.

Bridges, Savannah Kate: 50.

Conway, JoEllen Elam: 11, 110–111.

Crawford, Allen: 57.

Elder, Elizabeth: 4–5, 84, 92, 94–95, 113–115.

Getty Images: 73: ODD ANDERSEN/Staff; 168: Mike Marsland/Contributor; 180: Hansel Mieth/Contributor.Jaine, Danniella: 78.

Judith Leiber Couture: 69: Courtesy of Judith Leiber Couture.

Kerper, Candace: 83.

Kotak, Bella: 64–65, 90, 93, 116, 118.

Lake Superior State University: 61: Courtesy of Lake Superior University.

Marie, Alise: 101,104–105.

Meeker, AJ: 201: Courtesy of Workman Publishing.

Meisel, Steven, Outtake from the Anna Sui Fantasia Fragrance Campaign: 80–81: Courtesy of Anna Sui.

Mirage, Maria: 85.

Novak, Marketa: 2,143, 226, 229.

Nevett, Helen: 99.Parke, Steve: 19, 21, 77, 86, 89, 97, 175, 223.

Prohom Olson, Danielle: 186, 202, 205, 207, 209, 210–211.

Rawley, Sue: 225.

Saroya, Tricia: 188–197.

Shutterstock: 182: Fairchild Archive/Penske Media/Shutterstock.

Simms, Anthea: 66, 68.

Simply Savannah Art: 106–107.

Sneeden, Guinevere von: 159.

Stegg, Annie: 8, 185, 230.

Vess, Charles: 172.

The Walters Art Museum: 167.

The Wondersmith: 27, 219, 221.

Ziff, Brian: 109.

First published in 2020 by
Harper Design
An Imprint of HarperCollins *Publishers*
195 Broadway
New York, NY 10007
Tel: (212) 207-7000
Fax: (855) 746-6023

harperdesign@harpercollins.com
www.hc.com

Distributed throughout the world by
HarperCollins *Publishers*
195 Broadway
New York, NY 10007

ISBN 978-0-06-290525-3
Library of Congress Control Number: 2018965714

Book design by Raphael Geroni
Cover photograph by Steve Parke

Printed in Malaysia

First Printing, 2020

About the Author

CAROLYN TURGEON has been editor in chief of *Enchanted Living* (formerly *Faerie Magazine*) since 2013. She is the author of *The Faerie Handbook, The Mermaid Handbook*, and five novels: *Rain Village, Godmother, Mermaid, The Next Full Moon*, and *The Fairest of Them All*. Her books, published in the United Kingdom, Brazil, China, Japan, Korea, Russia, Spain, and Portugal, have been optioned for film by Sony Pictures, Random House Films/Focus Features, and Gaumont Film Company. She has published short fiction in *Fairy Tale Review* and the anthology *Haunted Legends* as well as essays in *Allure*, the *Hairpin*, and the *New Inquiry*, among other publications. She lives in Baltimore, Maryland. Learn more at www.carolynturgeon.com.